EVE'S DAUGHTER/*MODERN WOMAN*

EVE'S DAUGHTER/*MODERN WOMAN*

A Mural by Mary Cassatt

SALLY WEBSTER

UNIVERSITY OF ILLINOIS PRESS

URBANA AND CHICAGO

♾ This book is printed on acid-free paper.

Library of Congress Cataloging-in-Publication Data

Webster, Sally.

Eve's daughter/Modern woman : a mural by Mary Cassatt / Sally Webster.

p. cm.

Includes bibliographical references and index.

ISBN 0-252-02906-2 (cloth : alk. paper)

1. Cassatt, Mary, 1844–1926. Modern woman.

2. Cassatt, Mary, 1844–1926—Criticism and interpretation.

3. Mural painting and decoration, American—Illinois—Chicago—19th century.

4. Women in art. 5. World's Columbian Exposition (1893 : Chicago, Ill.)

I. Cassatt, Mary, 1844–1926. II. Title.

ND237.C3A69 2004

759.13—dc22 2003019682

TO NICK

CONTENTS

ILLUSTRATIONS

ACKNOWLEDGMENTS

I pay tribute in the prologue to the women of the Heresies Collective who supported and encouraged my investigation of women artists and their history. My association with these women is also a reminder that I have been working on this project for many years. So there are many people to thank. I owe gratitude to my colleagues at City University of New York, William H. Gerdts, George Corbin, Herbert Broderick, Harriet F. Senie, Patricia Mainardi, and Kevin Murphy.

Carolyn Kinder Carr helped provide funding for a month's research trip to the Smithsonian Institution, where she facilitated my study of the microfilmed archives of William M. R. French. She also served as coauthor for our resulting article (parts of which appear in this text by permission). The University Committee on Research Awards, CUNY, enabled my research in Chicago to study the archives of the Woman's Board of Lady Managers at the Chicago Historical Society and the archives of the Art Institute of Chicago. The committee also funded my trip to conduct research at the Victoria and Albert Museum, London, and at the Durand-Ruel Archive in Paris. I am grateful to the many Cassatt scholars who have given me help and advice over the years, especially Nancy Mowll Mathews, Charlene Garfinkle, and Judith Barter. There are also many other scholars whose work has been key to my own: Linda Nochlin, Wanda Corn, Anne Higonnet, Erica Hirshler, Jeanne Weimann, Kathleen McCarthy, Elisabeth Griffith, and William Leach.

I have been fortunate in that there exists a strong secondary literature concerning Cassatt, including Nancy Mowll Mathews's biographies and edited letters of the artist. Charlene Garfinkle's 1999 dissertation on the Woman's Building and its decoration remains the definitive study on that topic. Garfinkle's work is an accurate chronicle that supersede's Jeanne Weimann's earlier *The Fair Women*. However, Weimann's volume remains invaluable for her delineation of the history of the Chicago women's organizational involvement at the fair. Finally, there is the excellent and exhaustive exhibition catalogue *Mary Cassatt: Modern Woman* (1998), by Judith Barter et al., which remains the single best reference on Cassatt.

I first published my ideas about Cassatt's mural in 1979. Since then I have had the privilege of presenting aspects of my research in Chicago at an annual meeting

of the College Art Association; at the Mary Cassatt Symposium in Vancouver, British Columbia; at Columbia University's Woman and Society Seminar; to the Antiquarian Society of the Art Institute of Chicago; and at a Midwest Art History Society conference in Minneapolis. To all those who facilitated these presentations—Judith Mastai, Patricia Mainardi, Gabriel Weisberg, and Judith Barter—I am in your debt.

I am grateful to my family in so many ways. I thank my son, Albert, and his wife, Kristina, and their three children, Karl, Lilly, and Eric, for cheering me on. My daughter, Kate, offered words of encouragement that were very important to me during the early phases of research. My beloved husband, Nick Webster, provided help with the editing of the manuscript and the securing of photographs and permissions. Most of all, he gave me loving support that got me through the rough patches.

EVE'S DAUGHTER/*MODERN WOMAN*

When I began to write this book, my husband, quite by accident, found a poster from Miriam Schapiro's *Collaboration Series: Mary Cassatt and Me* (figure 1) that I had bought years earlier. His discovery became an inspiring talisman, reminding me of the time when I first met Schapiro as a member of Heresies, a fledgling feminist publishing collective that met regularly in Soho in the late 1970s. For me, her print commemorates that moment when women artists and art historians came together not only in New York but across the country and began to define new ways of understanding and defining women's participation in the visual arts.

In the 1970s our first task was to exhume the lost histories of women artists. As an artist, Schapiro responded to this enterprise by placing a reproduction of Cassatt's *Girl Arranging Her Hair* (figure 2) within a frame of layered, patterned cloth scraps evoking a quiltlike grid and women's fabric work. Schapiro's practice was to collage bits of cloth—sometimes from old handkerchiefs or aprons—onto her paintings as a tribute to work by women and women's collective artistic efforts, such as quilting bees. She called this new approach *femmage*.

The print also contained two other tributes, both in the form of photographs. Below and to the left of the Cassatt image is a photograph of the art historian Linda Nochlin's mother and daughter taken at the time when Nochlin was organizing the landmark exhibition *Women Artists: 1550–1950* (1976).[1] In partial response to Nochlin's earlier battle cry, "Why have there been no great women artists?" she and Ann Sutherland Harris galvanized a number of us to help resurrect the works and careers of forgotten women artists.[2]

The late 1970s were also a time when women critics, as well as art historians, gave voice to the ideas and struggles of contemporary women artists. These battles, which many of us recognized as often internal, are abstracted by Schapiro in a photograph of an inflamed, woundlike form that appears to the right. Such a symbol refers to the concerns of any number of contemporary women artists—Hannah Wilke, Joan Snyder, Judy Chicago—who substituted the vagina for the phallus as the instrument of empowerment.

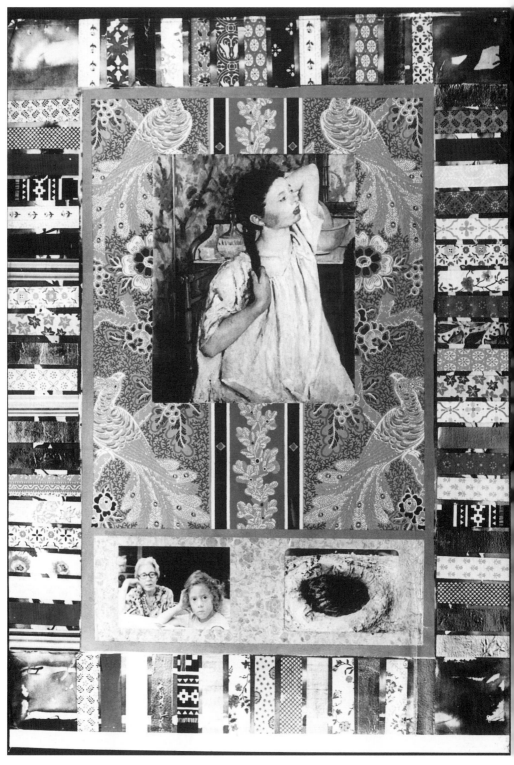

Figure 1. Miriam Schapiro, *Collaborations*, 1976. Poster, 24 × 17 in. Collection of the author.

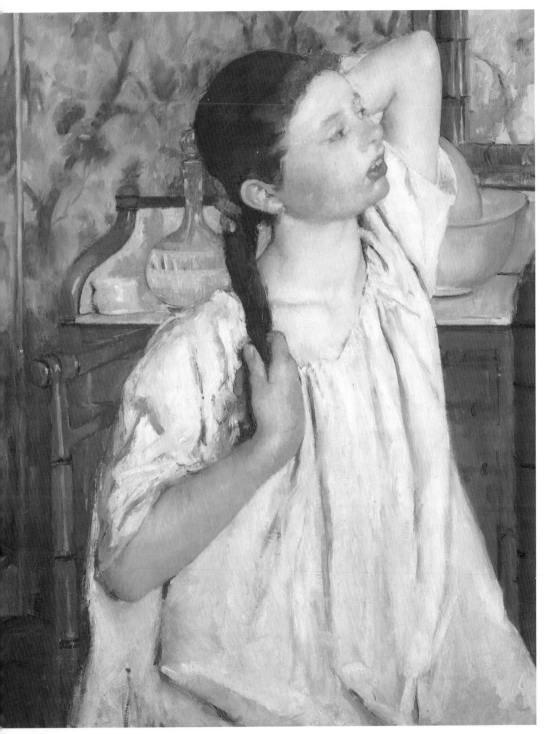

Figure 2. Mary Cassatt, *Girl Arranging Her Hair,* 1886. Oil on canvas, 29 5/8 × 24 5/8 in. National Gallery of Art, Washington, D.C. Chester Dale Collection. Photograph © Board of Trustees, National Gallery of Art.

Finding and reclaiming Schapiro's print after all these years helped me reconnect to my own feminist history, for it was as a member of the Heresies Collective that I first began my investigation of Cassatt's mural *Modern Woman*.[3] Collaborative practice was the ideal that inspired the collective, and basic to its philosophy was the commitment that each issue of our journal have a separate theme and editorial board. Schapiro, Joyce Kozloff, Valerie Jaudon, and I (among others) worked together on the fourth issue of *Heresies*, entitled "Women's Traditional Arts: The Politics of Aesthetics" (Winter 1978).[4] It was in Schapiro's studio that I came upon a reproduction of *Modern Woman* in her copy of Maud Howe Elliott's *Art and Handicraft in the Woman's Building* (1893).[5] In the late 1970s our knowledge of the Woman's Building at the 1893 World's Columbian Exposition in Chicago, a historic undertaking in which socialites, reformers, and artists organized a celebration of women's contributions to the world's work, was scant but we were inspired and intrigued by its example. However, I was chagrined. As a graduate student in nineteenth-century art, I had no idea that Cassatt had painted a mural and I knew nothing about the Woman's Building. I began to research the mural's history, tying it to other works by Cassatt and, continuing the time-honored art historical methodology, interpreting its allegorical meaning.[6] I also became captivated by the romance of the World's Columbian Exposition and the story of the Woman's Building. Most of all, I was impressed by Cassatt's ability to enlist traditional allegories in the service of women. Since then I have continued my interest in the mural, linking its allegories to the still hidden history of the nineteenth-century women's rights movement.[7] I also spent a year looking for it.[8]

Today it is hard to imagine the low esteem in which Cassatt was once held. Through the efforts of art historians and artists such as Schapiro, her work now has an honored place among the impressionists and within the history of modern art. My present desire is to tell the full story of the mural, connecting its meaning to Cassatt's life as a woman artist and as a member of the Parisian avant-garde, and to the history of women's emancipation. I also want to add my voice to those of others who continue to seek ways to interpret and elevate women's artistic practice.

Notes

1. At the time, this exhibition, organized by Ann Sutherland Harris and Nochlin for the Los Angeles County Museum in 1976, was wildly controversial. Its scholarly catalogue became and remains an enduring resource for all subsequent work on historic women artists.

2. First published in *Art News* in January 1971, Nochlin's essay "Why Have There Been No Great Women Artists?" has been widely reprinted. See, for example, Thomas B. Hess and Elizabeth C. Baker, eds., *Art and Sexual Politics, Women's Liberation, Women Artists, and Art History*, Art News Series (New York: Macmillan, 1973), 1–39.

3. Members of the collective in 1978 were Ida Applebroog, Patsy Beckert, Joan Braderman, Mary Beth Edelson, Su Friedrich, Janet Froelich, Harmony Hammond, Sue Heinemann, Elizabeth Hess, Joyce Kozloff, Arlene Ladden, Lucy Lippard, Marty Pottenger, Miriam Schapiro, Amy Sillman, Joan Snyder, Elke Solomon, Pat Steir, May Stevens, Elizabeth Weatherford, and myself.

4. Other members of the editorial board for the fourth issue were Martha Edelheit, Melissa Meyer, Carrie Rickey, Elizabeth Sacre, and Elizabeth Weatherford.

5. See Elliott, *Art and Handicraft in the Woman's Building,* 25.

6. See, for example, Webster, "Mary Cassatt's Allegory of Modern Woman."

7. I presented this work as a paper titled "The 'Ultra' Feminism of Mary Cassatt: A Mural for the 1893 Woman's Building" at the College Art Association annual meeting, February 1992, in Chicago.

8. See Carr and Webster, "Mary Cassatt and Mary Fairchild MacMonnies."

Mary Cassatt's mural *Modern Woman* (figure 3) was created for the Woman's Building of the 1893 World's Columbian Exposition in Chicago. When it was completed the painting was one of two large-scale murals (14 × 58 feet) placed in the building's Hall of Honor. Installed in an arched space, or tympanum, sixty feet above the floor, it faced Mary MacMonnies's *Primitive Woman* (figure 4) at the other end of the hall. Although lost today, *Modern Woman* is known through reproductions and written descriptions. It should be noted, however, that there are discrepancies between Cassatt's design of the border as it appears in this illustration, published in Maud Howe Elliott's *Art and Handicraft in the Woman's Building* (the image most often reproduced), and the way it appears in the photograph in Bancroft's *Book of the Fair*, which shows the mural installed (see figure 25). Nonetheless, the mural remains a powerful allegory of the radical transformation that took place in women's lives during the nineteenth century. It also attests to and symbolizes Cassatt's experience as a successful woman artist and is her most important work.

Mural painting was a new endeavor for Cassatt when, in 1892, she received the mural commission. By then she was forty-eight years old and had lived nearly twenty years in Paris. There she exhibited to critical acclaim in four of the impressionist exhibitions and was represented by one of the leading dealers in contemporary art, Durand-Ruel.

Earlier in her career Cassatt had traveled and studied in Italy, where she learned the complex enterprise of Renaissance mural painting. In *Modern Woman* she combined knowledge of this time-honored tradition with new ideas she gleaned from the Japanese, the innovations of the modern French muralist Puvis de Chavannes, and the decorative aesthetic then being articulated by the Nabis and the postimpressionists. The final result was an eclectic mix that received poor reviews when the mural was unveiled in Chicago. Today it is hard to evaluate the mural's success on aesthetic grounds, because it is now known only through prints and reproductions. Even so, *Modern Woman* remains Cassatt's most ambitious and personal work and its meaning sheds light on her entire career.

Cassatt's mural is painted in oil on canvas and divided into three sections, each

Figure 3. Mary Cassatt, *Modern Woman,* 1892–93. Oil on canvas, 15 × 64 ½ ft. (with border). Mural decoration for the Woman's Building, World's Columbian Exposition, Chicago, 1893. From Elliott, *Art and Handicraft in the Woman's Building,* 25.

.

Figure 4. Mary Fairchild MacMonnies, *Primitive Woman,* 1892–93. Oil on canvas, 15 × 64 ½ ft. (with border). Mural decoration for the Woman's Building, World's Columbian Exposition, Chicago, 1893. From Elliott, *Art and Handicraft in the Woman's Building,* 24

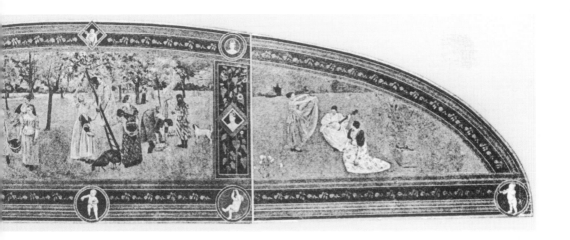

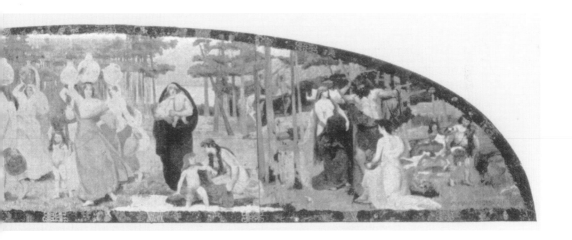

with a separate title.[1] The central and largest panel is called *Young Women Plucking the Fruits of Knowledge or Science;* the left-hand panel is titled *Young Girls Pursuing Fame;* the right, *Arts, Music, and Dancing.* In the mural's central section, women in loose-fitting modern dress are shown picking apples in an orchard, an allusion to the Garden of Eden. In *Young Girls Pursuing Fame,* a group of what appear to be ten-year-olds races through a meadow in pursuit of an airborne personification of fame. Even though fame in the nineteenth century meant renown, not celebrity, this is still a provocative image for it was considered unladylike to pursue such recognition. The evidence of her own life suggests that Cassatt believed the pursuit of fame to be honorable, and she represents in the right-hand panel the attainment of such success. Here three mature women in modern dress are depicted as personifications of Art, Music, and Dancing. Not acting as muses for male creativity, they are themselves artists, musicians, and dancers entertaining one another on a present-day Mount Parnassus.

Cassatt's message is expressed most explicitly in the mural's central panel, *Young Women Plucking the Fruits of Knowledge or Science,* in which she constructs, in a genteel manner, a transgressive interpretation of the Genesis legend. For Cassatt the attainment of knowledge is not a sin but an essential step in woman's move toward equality. Awareness of this heretical program alters our perception of Cassatt as a sentimental painter of compliant mothers and children. In her easel paintings she conveys a genuine feeling of their intimacy along with a certain restlessness and awkwardness. Infants wiggle and squirm (*The Caress,* 1902, Smithsonian American Art Museum), a little girl sprawls in an overstuffed chair (*Little Girl in a Blue Armchair,* 1878, National Gallery of Art), and a teenager with an ungracious profile pulls her hair back in a heavy braid (*Girl Arranging Her Hair,* 1886, National Gallery of Art). A number of her most important paintings depict women in independent circumstances—at the theater, reading the newspaper, driving a carriage. The consistent themes of her paintings, from the time she began exhibiting with the impressionists in the late 1870s, were the public and private aspects of a modern woman's life.

Born in Allegheny City (now part of Pittsburgh), Pennsylvania, in 1844 but raised largely in the Philadelphia area, Cassatt spent her entire professional life in France, never returning to America to live. Nonetheless, *Modern Woman* was commissioned for an American, primarily female, audience. The mural would be seen only in Chicago, where the overwhelming majority of visitors would be from the United States. Given this exposure, Cassatt hoped the mural would help promote her career in the States and increase the value of her paintings and prints.

These were important considerations, for after the last impressionist exhibition, in 1886, there were few venues in which to exhibit her work. A resurgence of French nationalism also made it difficult for non-French artists to showcase and sell their art. Cassatt experienced such discrimination when in 1891 she and Camille Pissarro were excluded from exhibiting their prints with the Société des peintres-graveurs français. The society was committed to elevating the status of the print and included

many members of the impressionist group. However, its bylaws expressly forbade the entry of works by artists of foreign birth (Pissarro was born in the Virgin Islands). Since the exhibition was held in the galleries of Durand-Ruel, who was the dealer for both Cassatt and Pissarro, the two persuaded him to organize simultaneously a separate venue for their prints. Pissarro in a letter to his son Lucien anticipated that "the patriots . . . are going to be furious when they discover right next to their exhibition a show of rare and exquisite work."[2]

Because of her ongoing desire and need to expand her audience, Cassatt began to court American collectors. Her decision to accept the Chicago mural commission can be seen as a ploy to promote her American reputation.[3] Even though her mural did not receive the acclaim it deserved, it did elicit attention and publicity that contributed to her later critical and commercial success in the United States, beginning with her one-woman exhibition at Durand-Ruel's New York gallery, in 1895.[4]

Cassatt maintained strong ties to the United States through her brothers, sisters-in-law, patrons, friends, and colleagues. Her brother Alexander (Aleck) was the well-to-do president of the Pennsylvania Railroad. Under his sister's tutelage he became a reluctant yet influential Philadelphia collector of impressionism.[5] Her other brother, Joseph Gardner, known as Gard, and his wife, Eugenia, and their children, Joseph Gardner Jr., Ellen Mary Cassatt Hare, and Eugenia Cassatt Madeira, were also Mary's champions, and her nieces and nephew were named her heirs. In the early 1890s her American friends included Sara Hallowell, an influential exhibition organizer and art adviser based in Chicago and Paris, and the collectors Bertha Palmer and Louisine Havemeyer, the latter Mary's trusted friend. Mary's mother, in particular, provided important emotional support. Mrs. Cassatt spoke and read French and often accompanied Mary on her European travels. One need only consult Cassatt's *Reading Le Figaro* (1878, private collection), in which she depicts her mother absorbed in the worldly task of reading a newspaper, to perceive the high regard in which she held her mother.

In contrast, she did not receive encouragement from French women artists. While she had a supportive, professional relationship with the French painter Berthe Morisot, she was not part of Morisot's intimate social circle in Paris.[6] Cassatt was not active in the newly formed Union des femmes peintres et sculpteurs and did not exhibit with its members in the Salon des femmes.[7] At the same time, Cassatt wrote Louisine Havemeyer that in France, "women do not have to fight for recognition . . . if they do serious work."[8]

Cassatt presumably was supportive of the enormous changes in women's lives in France, particularly during the 1880s when important legislation was instituted that greatly affected women's education, labor, and welfare.[9] Similar changes in women's lives were occurring in the United States. For both professional and personal reasons, Cassatt constructed her mural program to appeal to an American audience. The content of her mural—women's education, dress reform, and professional advancement—was largely American, not French, in inspiration. At the same time, her awareness of contemporary events affecting the lives of French women would have vali-

dated a commitment to creating an allegory of modern woman that had universal significance.

Cassatt was committed to bringing important works of art to the United States so that American art students would not face the same frustrations she faced in having no first-rate European works to study.[10] As Erica Hirshler writes: "Cassatt's correspondence . . . clearly reveals her unfailing ambition to place important pictures in the hands of her compatriots."[11] This is why Cassatt did not support the purchase of Manet's *Olympia* by the French state. She wrote to Pissarro: "As to the Manet subscription I declined to contribute. M. Eugène Manet told me that an American had wished to buy the picture & it was to prevent its leaving France that the subscription was opened. I wish it had gone to America."[12]

Such a sentiment underscores that Cassatt's true passion was art—that of her contemporaries and the great masters of the past, as well as her own. The art that she bought for herself and recommended to others was art of the most challenging nature. As she wrote to Louisine Havemeyer, the works she prized most were not for the uneducated but "for painters and connoisseurs."[13] It was not the sweet, prettified images of Renoir but awkward, complex, sometimes unfinished works such as Degas's gouache and pastel *Rehearsal of the Ballet* (c. 1876, Nelson-Atkins Museum of Art) which Cassatt encouraged Louisine Elder (later Havemeyer) to buy in 1877. The artists whose works Cassatt counseled Havemeyer and other American collectors to acquire included Gustave Courbet (of which Cassatt eventually owned five and Louisine Havemeyer more than thirty), Edgar Degas (Louisine was to own over sixty-five), Camille Pissarro, and Edouard Manet. Cassatt promoted paintings by Claude Monet to less adventuresome collectors, such as her brother Alexander, as good investments.[14] The works that Cassatt recommended to Havemeyer and her husband in particular today form the core of the Metropolitan Museum of Art's distinguished nineteenth-century European art collection.[15]

Other important collectors who sought Cassatt's advice were the Potter Palmers.[16] The Palmers were among the leading citizens of Chicago and were active in the promotion of the city's 1893 World's Columbian Exposition. Mrs. Palmer, as president of the Board of Lady Managers, oversaw the construction and decoration of the Woman's Building and was directly responsible for commissioning Cassatt's *Modern Woman*. The exposition became a landmark in American history and established Chicago's preeminence as the mercantile and cultural capital of the Midwest. It also celebrated the moment when women fully emerged as a force for civic betterment. As noted by Reid Badger, author of *The Great American Fair*, women were given "unprecedented official recognition at the exposition. . . . just as Columbus had once discovered America, the Columbian Exposition now discovered women."[17]

The history of women's participation at the fair and the evolution of the Woman's Building is a rich one, full of both triumphs and defeats.[18] In the early 1890s Susan B. Anthony was still a strong and powerful voice for women's rights and suffrage. She lobbied hard to have women represented equally on the fair's board of directors. This demand was not met, but women were allowed to create a separate Board of Lady

Managers and were allotted funds to construct their own building. Under the leadership of Mrs. Palmer, the doyenne of Chicago society, they proceeded to hire as architect Sophia Hayden, the first female architecture graduate of the Massachusetts Institute of Technology. The planning of the building's interior, which contained a number of murals and painted decorations, including Cassatt's, was overseen by Mrs. Palmer herself.[19]

Yet if there is a patron saint of the Woman's Building and the women's emancipation movement, it is Eve. At the turn of the twentieth century she was an equivocal figure. For the symbolists, she was a femme fatale. For Cassatt and other enlightened women, Eve was a transgressor who broke with male authority.

Progressive women in the nineteenth century who challenged the patriarchal order were Eve's daughters. As Eve defied God's injunction not to eat from the Tree of Knowledge, so too did her modern daughters contest social norms to gain higher education, the vote, and personal autonomy. American women in particular, as noted by Pamela Norris in her biography of Eve, recast Eve in a positive role: "some of Eve's staunchest supporters were American women writing in the nineteenth century, early voices in the fledgling women's movement which assert a new independence in their confident revision of familiar Biblical texts."[20] These American daughters of Eve conceived the Woman's Building for the Columbian Exposition and were the audience for Cassatt's mural *Modern Woman*.[21] As Maud Howe Elliott noted in her guidebook to the Woman's Building: "we have eaten of the fruit of the tree of knowledge and the Eden of idleness is hateful to us. We claim our inheritance, and are become workers, not cumberers of the earth."[22] The story of Eve is the leitmotif of Cassatt's mural.

Cassatt was an emancipated woman, with all the bluestocking overtones this epithet implies. (I find the term "emancipated woman" more appropriate to describe Cassatt and her cohort, rather than using the modern terms "women's liberationist" or "feminist." It is also a term that is broader and more inclusive than "suffragist.") Cassatt was a devoted daughter and sister of an upper-class American family. She dressed fashionably and may have been chaste. At the same time, she was a passionate connoisseur, an adventurous traveler (except by boat), and an ambitious and gifted artist. As a young woman she had a keen awareness of the training and experience she needed to be a successful artist. She left a comfortable life in Philadelphia to study in Europe. She traveled by herself in Italy and Spain and eventually established herself as a single woman living in Paris. Although she was soon joined there by her sister and parents, there is little evidence that she was impeded in her artistic ambitions by the presence of her family. Her parents relied upon her late in their lives for support, financially and emotionally, but she accepted these responsibilities without rancor. In her letters to friends and other relatives at the deaths of her parents, she deeply mourned their passing.

Historically, Cassatt lived through an eventful era that witnessed the birth of the women's suffrage movement. In 1848, four years after she was born, the Women's Rights Convention was held in Seneca Falls, New York. Lucretia Mott, one of the

convention's organizers, was a prominent Quaker abolitionist from Philadelphia and her involvement in the women's rights movement was widely known at the time Cassatt was living there.[23] The reforms advocated by Mott and others affected the domestic and professional lives of women and dominated discussions of women's role in society throughout the second half of the nineteenth century. By 1890 women had made important inroads into various professions—law, medicine, theology, literature, and the arts—and had become leaders, particularly in the fields of education and social reform.[24] Cassatt's success paralleled that of other professional American women, particularly educated, privileged women such as she. While these women had not yet achieved the right to vote, they had gained access to higher education and were active in many professional areas of modern life. Advances had been made in so many areas and on so many levels that women's push toward equality could not be ignored. Their success was derided and vilified but not denied. Legally, there were and still are many barriers to woman's full emancipation, yet in the late nineteenth century the public achievements of women were notable and were celebrated in the Woman's Building by Eve's daughters.

Notes

1. These "subtitles" were supplied by Cassatt and included in a letter to Mrs. Palmer dated October 11 [1892]. Reprinted in Mathews, *Cassatt and Her Circle*, 238.

2. Rewald, *Camille Pissarro Letters*, 158.

3. Ibid., 179.

4. Her first one-woman exhibition, which opened in Paris in November 1893, was organized by Durand-Ruel. With ninety-eight works, it was an early retrospective.

5. See Lindsay, *Mary Cassatt and Philadelphia*, 13–15.

6. As Anne Higonnet noted in *Berthe Morisot's Images of Women*, "Cassatt and Morisot never became close friends" (182).

7. Garb, *Sisters of the Brush*, does not mention Cassatt's participation.

8. Quoted in Mathews, *Cassatt and Her Circle*, 254.

9. For an important contemporary survey in English of women's issues in France, see Theodore Stanton, *The Women Question in Europe*, 234–309. Stanton was the son of Elizabeth Cady Stanton. For a contemporary assessment see Claire Goldberg Moses, *French Feminism in the Nineteenth Century* (Albany: State University of New York, 1984).

10. See Erica Hirshler, "Helping 'Fine Things across the Atlantic': Mary Cassatt and Art Collecting in the United States," in Barter et al., *Mary Cassatt: Modern Woman*, 177–78.

11. Ibid, 198.

12. November 27, [1889], in Mathews, *Cassatt and Her Circle*, 213.

13. Quoted in Hirshler, "Helping 'Fine Things,'" 183.

14. For discussion of Cassatt as an adviser to the Havemeyers, see Weitzenhoffer, *The Havemeyers*.

15. For discussion of the amassing of the collection, see *Splendid Legacy*.

16. According to Hirshler, "certain works in the Palmer collection . . . are typical of the sort of painting Cassatt most frequently advocated" ("Helping 'Fine Things,'" 200–201).

17. Badger, *Great American Fair*, 120.

18. For discussion of women's involvement in the fair and the Woman's Building, see Weimann, *Fair Women*.

19. For a detailed description of the building's decor and exhibits see Elliott, *Art and Handicraft in the Woman's Building*.

20. Norris, *Eve*, 359. These commentators included Sarah Grimké, Sarah Josepha Hale, and Elizabeth Cady Stanton.

21. Madame (Marie-Thérèse) Blanc, a well-respected French writer, in her report on the fair described the women in Cassatt's mural as "the daughters of Eve." *The Condition of Women in the United States: A Traveller's Notes*, trans. Abby Landgon Alger (Boston: Roberts, 1895), 36.

22. Elliott, *Art and Handicraft in the Woman's Building*, 23. Hutton makes similar points in his article "Picking Fruit."

23. For discussion of Mott's life and career, see Margaret Hope Bacon, *Valiant Friend: The Life of Lucretia Mott* (New York: Walker, 1980).

24. Olympia Brown became the first ordained woman minister in the United States, in June 1863. Earlier, in 1849, Elizabeth Blackwell had become the first woman to graduate from a medical school in the United States. See Phebe A. Hanaford, *Daughters of America or Women of the Century* (Augusta, Me.: True and Company, c. 1882).

THE MAKING OF A MODERN ARTIST

When Cassatt decided to leave Philadelphia for art training abroad at age twenty-one, she was a forceful and determined young woman. It is evident from her correspondence that she had an active social life, an admiring family, and many friends. She was single-minded and quite clear about her goals. Throughout her life, she actively pursued the means to achieve them, whether as a student at the Pennsylvania Academy of the Fine Arts, the foremost academy for art instruction in the country; a participant in the French impressionist exhibitions in the late 1870s and 1880s; or a contributor to the 1915 suffrage benefit exhibition at the Knoedler Gallery in New York when she was seventy-one.

Cassatt was not yet sixteen when, in the spring of 1860, she enrolled in the antique class for the fall semester at the Pennsylvania Academy. Unlike the art schools of Europe, the academy had neither a planned curriculum nor a regular roster of teachers; instruction there, as at the few art schools elsewhere in the United States, was barely adequate. Its teaching tools were copies of European old master paintings, casts of antique sculptures, and paintings by American artists such as Benjamin West, Washington Allston, the Peale family, and Thomas Sully. To obtain the fundamentals of drawing the figure, students studied casts and attended lectures on anatomy by a local physician. No instruction was offered in the use and importance of color except what could be gleaned from paintings in the collection. Mainly students learned from each other. Yet Cassatt was lucky to be in Philadelphia since the academy, historically, had been supportive of women artists both as students and as professionals.[1] She studied there for six years and it is at the Pennsylvania Academy that Cassatt's ambition to become a professional artist crystallized. To achieve this goal Cassatt knew she needed to study in Europe. She became part of the first wave of American artists who, after the Civil War, sought advanced training in Paris. Undaunted by the knowledge that women were not allowed to study at France's premiere art institution, the Ecole des Beaux-Arts, Cassatt created her own curriculum, copying old masters at the Louvre and seeking the personal advice of Jean-Léon Gérôme, one of the leading academic painters of the day and the teacher of her Philadelphia contemporary Thomas Eakins.[2]

In the fall of 1866 she joined her friend Eliza Haldeman in the atelier of the fashionable portrait painter Charles Chaplin.[3] Important for Haldeman's family, and perhaps for Cassatt's, Chaplin was regarded "as a gentleman of good antecedents and respectable background [who] could provide his students with an 'ambiance' of which no parent could complain."[4]

Cassatt was not ready to remain with one style or master, and she and Haldeman spent February 1867 in the rural village of Courances. As had other American artists, they sought an alternative to the studio experience and traditional academic subject matter, choosing to live in a rural area near Barbizon and the Fontainebleau forest.

Since the early 1850s, when the Boston painter William Morris Hunt had studied with Jean-François Millet, this region had been popular with American art students.[5] While Cassatt and Haldeman maintained their Parisian lodgings and occasionally returned to Chaplin for advice, according to Nancy Mathews, "they were learning more in Courances than [they] could in Paris" and over the summer the two women moved to another rural village, Ecouen, where they stayed for a year (April 1867 to May 1868).[6]

At the time, Ecouen was as celebrated as Barbizon by Americans who sought training and contact with the admired French genre painter Pierre Edouard Frère. However, Cassatt studied with the lesser-known Paul Constant Soyer, a wood engraver and etcher. It was Soyer who encouraged her to work in a new, more realistic manner, a course of study that was rewarded when her earliest known painting, a dark-hued figure study entitled *A Mandolin Player* (1868, private collection), was accepted for exhibition at the Salon of 1868. Exhibiting under the name Mary Stevenson, she listed herself as the pupil of Chaplin and Soyer.[7]

Up until recently, Americans' participation in the Paris salons has been difficult to ascertain, and modern scholars have denigrated the Salon as a nonprogressive institution.[8] In reality, almost until the end of the nineteenth century, acceptance at the Salon was deemed important by many artists. Certainly for young American artists, it was a real mark of approval. For the most part, at least until she moved permanently to Paris in 1874, Cassatt exhibited picturesque Italian and Spanish genre pieces that by the 1860s had won acceptance in the Salons. It is notable that Cassatt gained entrance to the Salon seven years before Eakins (1875), who was her exact age.[9]

Linda Nochlin is one of the few scholars to examine the parallels between the careers of Eakins and Cassatt. Her essay "Issues of Gender in Cassatt and Eakins," included in a survey book of nineteenth-century art, provides an overview of contemporary gender issues and a thoughtful summary of the several ways both artists' work has been discussed over the past twenty years by art historians.[10] Its value has been to imbue Cassatt with a stature equal to that of Eakins in American art. For most of the twentieth century, however, it was Eakins who, along with Winslow Homer, stood as the exemplary American artist, with Cassatt relegated to the status of expatriate along with John Singer Sargent and James McNeill Whistler.[11] Eakins never was a member of an international avant-garde and neither Whistler nor Sargent was

invited to exhibit with the impressionists. Today, thanks to the work of Nochlin and other scholars—particularly Nancy Mathews, Griselda Pollock, and Judith Barter—it is hard to say who is more revered, Eakins or Cassatt.

In her early works Cassatt's commitment to realism emerged in the form of sentimental or romantic renderings of picturesque figures, often in urban settings. An interest in such subjects was influenced by her study with Thomas Couture in the summer of 1868. Instead of returning to Ecouen, Cassatt took a room in nearby Villiers-le-Bel, the home village of Couture, who, although best known as the painter of the academic machine *The Romans of the Decadence* (1847, Musée d'Orsay), was the teacher of Edouard Manet as well as Hunt and many other American artists.[12] Eakins did not study with Couture, but in his letters to his father when he was in France in the late 1860s studying with Gérôme, he is full of praise for the French painter: "What a grand talent. He is the Phidias of painting & drawing. . . . In his Decadence he has far exceeded all other painters."[13] Unlike the teachers at the Ecole des Beaux-Arts, Couture granted students great freedom in terms of subject matter and technical methods. He encouraged pupils to abandon the academy's strict adherence to linear design, as practiced by Ingres and his followers, instructing them in the more painterly demands of realism and naturalism. Under his guidance Cassatt prepared a work (unidentified) for the Salon of 1869, which to her great disappointment was not accepted and is now lost.

Cassatt's spirits lifted when her mother, Katherine Kelso Cassatt, arrived in Paris in December 1869. The two women did not stay long in the city but traveled to Rome, where they spent six months. Rome, with its ancient ruins and Renaissance and Baroque masterpieces, was still a powerful attraction for art students. It may be that Cassatt, frustrated by her inability to succeed in the Salon, was prompted to seek another type of artistic environment. Here she studied briefly with the relatively obscure French watercolorist and engraver Charles-Alphonse-Paul Bellay, who was best known for his prints after Raphael.

Cassatt's decision to relocate and find a new teacher was rewarded when her painting *Young Peasant Girl* (now lost) was accepted at the 1870 Salon. Still exhibiting as Mary Stevenson, she now listed herself as the pupil of Soyer and Bellay, the two artists she would continue to cite as her masters through 1876, the last year she exhibited at the Salon.

With the outbreak of war between Germany and France, Cassatt and her mother left Europe in the summer of 1870. Once back in Philadelphia Mary expressed in letters to Emily Sartain, a potential new traveling companion, her impatience and longing to return to Europe. Justifying an extensive trip to Italy and Spain, Cassatt complained about the conditions in the United States: the lack of models, the poor quality of canvas, the paucity of great works of art to study, and her inability to sell her work. Like many other artists of the period, Manet and Eakins included, Cassatt had a fascination with Spain, referring to it in one her letters to Sartain as her "heimats land" (homeland).[14] Yet she was hampered by a lack of funds. It is not clear whether her family refused to finance the trip or whether she wanted to be financially inde-

pendent. Ultimately she accumulated enough money, partially through a commission from the bishop of Pittsburgh for two copies of well-known works by Antonio Allegri da Correggio, *Madonna of Saint Jerome* (1527–28, Galleria Nazionale) and *Coronation of the Virgin* (1522, detached fresco, Galleria Nazionale), and, I assume, through funds given to her by her father, so that she and Sartain were able to leave for Europe in December 1871.

Their time together, first in Italy and then in Spain, is chronicled primarily in letters from Emily to her father, the well-known Philadelphia artist and engraver John Sartain.[15] The two women settled initially in Parma, a city and a region of northwest Italy that remained a favorite of Cassatt's. The purpose of their stay was to study and to allow for Cassatt's copying work and her preparation of a painting for the spring Salon. Judging by Sartain's accounts, the two women were warmly received at the Parma Academy, where Cassatt was given her own studio.

Cassatt began by copying Correggio's *Madonna of Saint Jerome*, one of the artist's best known and admired works, yet for reasons unknown Cassatt abandoned the project and began her other commission, a copy of the *Coronation of the Virgin*. Since the *Coronation*, or *Virgin Crowned*, was known even at the time to be a replica of Correggio's original, Cassatt, in effect, created a pastiche from fragments of the original fresco. She sent her copy to Pittsburgh, where it was favorably received, but it was destroyed by fire in 1877.[16]

This history is less important than was Cassatt's overall experience in Parma, where she fell in love with Correggio's mural paintings. She cited the artist as "perhaps the greatest painter that ever lived," an enthusiasm that may be difficult for us to understand today.[17] Cassatt, like her impressionist contemporaries, rejected the cold, linear style of such popular academic painters as Alexandre Cabanel and Léon Bonnat, characterizing their figural work as "washy, unfleshlike, and grey."[18] Instead she sought inspiration in the work of old master colorists such as Correggio, Velásquez, Murillo, and Rubens. While these artists would have been familiar to her from the Louvre, where she would have seen Correggio's voluptuous *Venus and Cupid with a Satyr* (c. 1525), she felt it essential to see more of their work firsthand. In Cassatt's *Two Women Throwing Flowers during Carnival* (1872, private collection), which was exhibited at the 1872 Salon, the tilted heads of the two women and the warm sensuous colors confirm the lessons she learned from Correggio. The late Renaissance master was renowned for his paintings of babies and cherubs, memories of which Cassatt no doubt called upon for her own renderings of the same subjects. It was also memories of Italian mural paintings, with their rich narrative programs and concern for decorative effect, that Cassatt would draw upon in her painting *Modern Woman*.

Cassatt's efforts were admired by her fellow artists in Parma, as mentioned by Sartain, and their compliments must have been gratifying for this twenty-eight-year-old woman painter from Philadelphia. In contrast Sartain, discouraged by her own lack of progress, was restless and left in May 1872 to join her mother and brother in Paris. Originally the plan had been for the two young women to go on together to Spain. In spite of Cassatt's heartfelt entreaties Sartain remained in Paris, preferring

the familiarity of France and study with Evariste Luminais. Undaunted, Cassatt stayed on in Italy and left for Madrid in September.

She remained in Spain for seven months, living by herself and haunting the Prado, which was known at the time as the Real Museo. She wrote to Sartain of her impressions: "The men and women have a reality about them which exceeds anything I ever supposed possible, Velasquez Spinners, good heavens, why you can walk into the picture. Such freedom of touch, to be sure he left plenty of things unfinished, as for Murillo he is a baby alongside of him, still the Conception is lovely most lovely. But Antonio Mor! and then Rubens! I won't go on, oh Emily *do do*, come you will never regret it."[19]

The next month Cassatt abandoned Madrid for Seville. Writing shortly after her arrival, she noted that "one learns how to paint" in Madrid but she preferred Seville for inspiration. As she rhapsodized, "there is nothing but *pictures*, for nature and pictures and *climate*, Seville."[20] In another letter she raved about the town's beauty and "the odd types and peculiar dark coloring of the models." Some of these models appear in several of her paintings, including *Offering the Panal to the Bullfighter* (1873, Sterling and Francine Clark Art Institute, Williamstown, Mass.), which was accepted for exhibition at the 1873 Salon.[21] Wishing to attend the Salon and to join her mother in Paris, she left Seville in April 1873.

After spending the spring in France, she and her mother toured Holland and Belgium, and Cassatt took a studio in Antwerp to create copies of paintings by Rubens, whose work she had admired in Madrid.[22] When her mother left in October, Cassatt returned to Rome, where, as she had done in Parma and Seville, she worked on a painting to be submitted to the spring Salon. In a 1913 interview she described the painting, titled *Ida* (private collection), to the French critic Achille Segard as "a head of a young Roman, Rubenesque woman with hair that is almost red."[23] *Ida* exhibits both the influence of Couture in its loose brushwork and the rich coloration of Rubens. As in the Spanish pictures of the year before there is a marked loosening of Cassatt's technique, as she ascribes greater importance to color than line. More important, according to Cassatt's testimony in Segard's interview, it is this painting that was admired by Degas. When he saw it at the Salon, Degas declared: "It's true. Here is someone who feels as I do."[24] Evidently, Cassatt's work was brought to his attention by a mutual friend, Joseph Tourny, whom Cassatt and her mother had met in Antwerp the year before when they were viewing the Rubens that Tourny was copying for the statesman Adolphe Thiers.[25] It would be three more years before Cassatt and Degas would meet.

Cassatt's ongoing interest in exhibiting at the Salon was motivated partially by her desire to sell her work. Such official recognition was important for American buyers who were her primary patrons. It was difficult to manage her career long distance and she made what was, for her, an unpleasant decision to leave Italy and live in Paris. As Sartain noted in a letter to her father: "I think I told you that Miss Cassatt is in Paris. She astonished me by telling me she is looking for an atelier here, for next winter. She has always detested Paris so much that I could scarcely believe it pos-

sible that she would consent to stay here,—but she says she sees it is necessary to be here, to look after her own interests."[26]

PARIS AND IMPRESSIONISM

Cassatt returned to Paris in 1874 and took up residence at 19, rue de Laval in 1875 when she was joined by her sister Lydia. Two years later, their parents, upon her father's retirement, came to live with them in a new home at 13, avenue Trudaine, which became the locus of an extended family of brothers, sisters, nephews, and nieces, many of whom served as Cassatt's models. The year 1877 was a decisive one for Cassatt in another way. Even before her parents joined her, Edgar Degas had visited her studio, inviting her to exhibit with the impressionists.

The history of impressionism is well known. In the late 1860s, a group of artists (whose names today are legendary)—Claude Monet, Auguste Renoir, Edgar Degas, Alfred Sisley, Edouard Manet (who did not exhibit with them but was their artistic godfather), Camille Pissarro, and Paul Cézanne—met regularly at the Café Guerbois to debate, among other things, their dissatisfaction with the exhibition policies and jury system of the official Salon. Earlier, in 1863, half the works submitted to the annual salon were rejected by the faculty of the Ecole des Beaux-Arts (who controlled the exhibition policies), including Manet's *Luncheon on the Grass* (1863, Musée d'Orsay). The controversy that ensued was such that the Emperor Louis-Napoleon for political reasons found it expedient to support a subsidiary exhibition that ran concurrently. Dubbed the Salon des refusés, it included not only Manet's work but paintings by Whistler, Pissarro, and Cézanne. Some reforms ensued but made little impact on exhibition policies, and in 1873 this new generation of artists banded together and formed the Société anonyme des artistes, peintres, sculpteurs, graveurs, etc., their goal being to establish exhibition practices that would be independent of official taste and to select artists whose participation would be left to the judgment of fellow artists. It was they who arranged to rent the recently vacated studio of the photographer Nadar and organize and install the work of thirty artists for what has come to be called the first impressionist exhibition, which ran from April 15 to May 15, 1874. One of the works by Monet, *Impression, Sunrise* (1873, Musée Marmottan), was ridiculed by several critics who labeled the entire group "the impressionists," a name they themselves adopted a few years later.[27]

Today this history has been researched, rehashed, and endlessly debated, but it is important to remember that this was the beginning, artistically speaking, of modernism. Both the artists' assertion of their independence and the aesthetic innovation they championed came to define modernist practice. The impressionists succeeded in shifting artistic control from the state to the individual. This separation was critical for artists whose style and aesthetic concerns differed significantly from those espoused by the French Academy. These competing concerns included a rejection of historical narrative in favor of subject matter drawn from modern, every-

day life; the substitution of classical drawing and design with sketch-like effects and flattened pictorial space; the adoption of a new chromatic palette that eschewed local or conventional color; the abandonment of the controlled, even light of the studio for a preference for painting out of doors, en plein air. All of these innovations had a decisive impact on Cassatt's art, and her loyalty to this group of artists and their art never diminished. The group's philosophy paralleled her own, as evidenced in the independent path she had established for herself and in her rejection of academic practice.

While Degas first saw Cassatt's painting at the Salon, she discovered his work in a store window. As she wrote to her friend Louisine Havemeyer around 1915: "How well I remember nearly forty years ago seeing for the first time Degas' pastels in the window of a picture dealer in the Boulevard Haussmann. I would go there and flatten my nose against that window and absorb all I could of his art. It changed my life. I saw art then as I wanted to see it."[28]

They met when their mutual friend, Tourny, brought Degas to Cassatt's studio. It took very little time for Degas to decide to invite her to participate in what was to have been the 1878 show. That show was postponed a year, so that she first exhibited with the group in the fourth impressionist show, which took place in April 1879. She had eagerly accepted the invitation, for she was frustrated with the criteria for exhibiting at the Salon. As she later wrote to Segard: "In 1877, I once again submitted [to the Salon]. It was refused at the same time Degas was persuading me to no longer submit work to the Salon."[29] She took an active role in helping to organize the 1879 impressionist exhibition and was well aware of its objectives. In March 1878, she had been in correspondence with the American artist J. Alden Weir, who was working in New York on a parallel revolutionary venture by American artists who were organizing an alternative to the powerful National Academy of Design. Called the Society of American Artists, their group had plans for similar independent exhibitions, and Weir had invited Cassatt to participate in the society's inaugural show. She declined at the time because she had promised all her new work to the impressionist exhibition. In her letter to Weir she declares her support of the Americans' efforts and relates them to events in Paris: "Your exhibition interests me very much. I wish I could have sent something, but I am afraid it is too late now. We expect to have our annual exhibition here, and there are so few of us that we are each required to contribute all we have. You know how hard it is to inaugurate anything like independent action among French artists, and we are carrying on a despairing fight and need all our forces, as every year there are new deserters." She added that she hoped that sometime New York would become "artists ground" and believed that the efforts of the SAA would form the basis of an "American school."[30]

Meanwhile, in Paris dissension arose within the ranks of the impressionists. The disaffection was primarily in response to Degas's insistence that for the fourth exhibition, "no artist intending to exhibit with the group should send anything to the Salon."[31] The major exhibitors continued to be Caillebotte, Degas, Monet, and Pissarro but the "deserters" included Renoir, Sisley, Cézanne, and Morisot.

Cassatt was drawn into the controversy when Degas asked her to convince Berthe Morisot to remain with the impressionist group. While it is not known when Cassatt and Morisot first met, Morisot's biographer Anne Higonnet notes that "by March of 1879 Cassatt clearly knew Morisot well enough for Degas to think she was the one to conduct an important bit of diplomacy."[32] In addition, a year earlier Cassatt had acquired a painting by Morisot.[33] Nonetheless, Cassatt's efforts to persuade Morisot were unsuccessful. While Morisot refrained from exhibiting that year, it may have been because her first child, Julie, had just been born. From this time on, however, Cassatt and Morisot enjoyed a cordial and supportive relationship.

The most important development for Cassatt, though, was the startling impact impressionism had on her art. Hints of what is to come can be perceived in the small oil on panel entitled *Woman on a Striped Sofa with a Dog*, painted around 1875 (figure 5). Gone are the references to picturesque subjects with homages to Italy or Spain; instead, the painting introduces the personal, modern, domestic subjects for which Cassatt is best known. In addition, by the end of the decade her technique had been transformed. Her compositions were more complex and her palette light and vibrant, changes that can be seen in *Woman with a Necklace in a Loge* (figure 6) and *Woman Reading* (figure 7). Recognition of her contribution to what would soon be defined as an impressionist aesthetic was immediate and her participation in the fourth exhibition was glowingly noted. Among the favorable reviews was one by the Italian critic Diego Martelli: "Cassatt is a young American woman who, like Degas (perhaps she is his student), seeks movement, light, and design in the most modern sense. Her half-figure of a woman in a theater box lit by gaslight and reflections from a mirror is a very beautiful work. It is good enough to place its author among the ranks of the best artists." In an essay on the fourth impressionist exhibition, the art historian Ronald Pickvance concluded that "Cassatt enjoyed an astonishingly successful debut."[34]

The fourth impressionist exhibition marked the beginning of Cassatt's and Degas's long association. Because both artists destroyed their correspondence, what we know of the relationship between the two comes largely from the memoir of Louisine Havemeyer, whose reminiscences of Degas were informed by her conversations with Cassatt. Over the years historians and others have speculated on the two painters' romantic involvement. It is generally conceded that while they shared a passionate devotion to art, their personal relationship was probably platonic.[35]

The most intense period of their relationship dates from the late 1870s. Following the close of the fourth impressionist exhibition, Degas invited Cassatt, along with Pissarro, to join him in creating an experimental journal of etchings, *Le Jour et la nuit*.[36] This collaboration marked a turning point for Cassatt. She began to devote serious attention to printmaking and it brought her into closer contact with Pissarro, from whom she increasingly sought advice. He was always on the lookout for places where she and her family could spend the summers, and ultimately her choice of a country house in Bachivillers was near Pissarro's home in Gisors, northwest of Paris.

The journal never became an ongoing publication. Scholars are divided as to

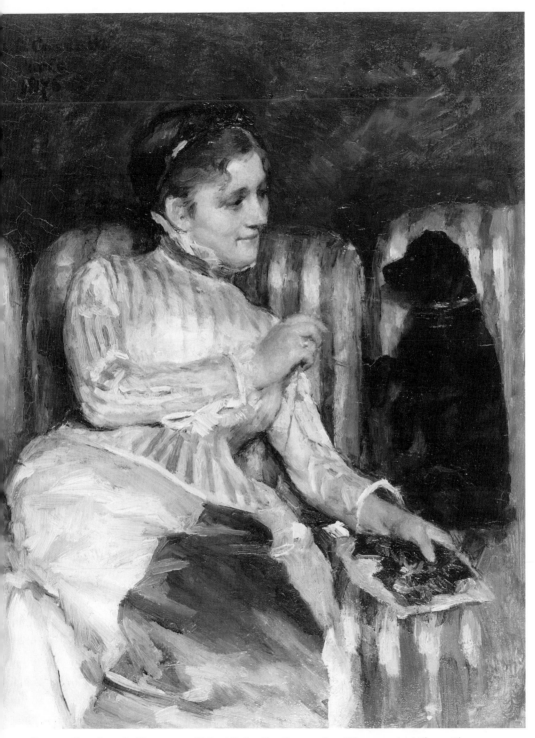

Figure 5. Mary Cassatt, *Woman on a Striped Sofa with a Dog*, c. 1875. Oil on panel, 16 ½ × 13 ⅛ in. Courtesy of the Fogg Art Museum, Harvard University Art Museums, Gift of Mr. and Mrs. Peter I. B. Lavan; photo by Photographic Services © President and Fellows of Harvard College.

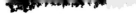

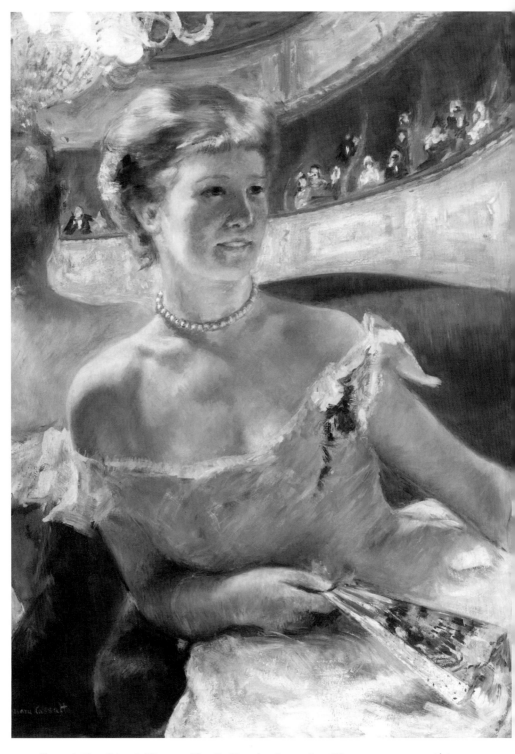

Figure 6. Mary Cassatt, *Woman with a Necklace in a Loge,* 1879. Oil on canvas, 32 × 23 ½ in. Philadelphia Museum of Art, Bequest of Charlotte Dorrance Wright.

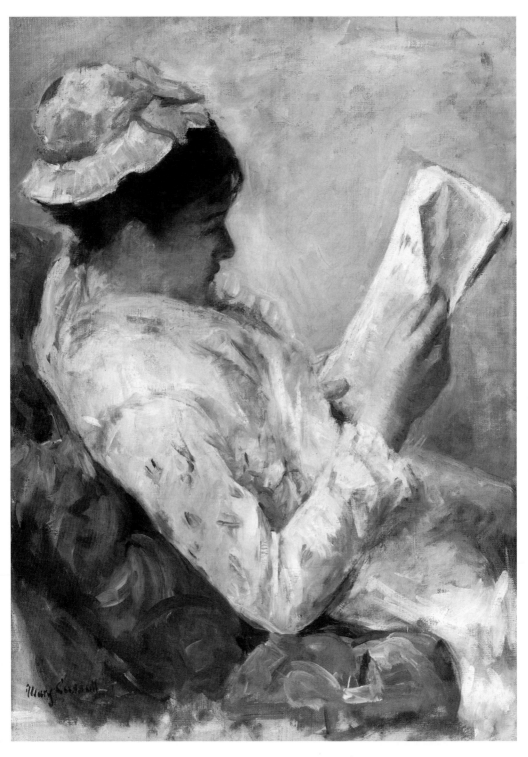

Figure 7. Mary Cassatt, *Woman Reading*, 1878–79. Oil on canvas, 32 × 23 ½ in. Joslyn Art Museum, Omaha, Nebraska.

whether single prints from *Le Jour et la nuit* were exhibited at the fifth impressionist exhibition, in 1880. Surviving examples intended for the journal document the innovative and uninhibited approach to etching undertaken by these three artists.[37] They combined so many different processes in a given print that they themselves referred to their procedures as a "cuisine" method.[38] Cassatt's prints from 1880 are extraordinary. This is not to make an outsized claim for her abilities but to acknowledge her newly acquired graphic skill and her openness to experimental techniques. The prints from this period also form an intriguing contrast, in terms of subject matter, to the paintings she exhibited in 1880. Her paintings are of women often in domestic settings but in public guises: *Young Woman in Black* (figure 8), *Tea* (1879–80, Museum of Fine Arts, Boston), and another work entitled *Tea* (1880–81, Metropolitan Museum of Art). In comparison, her prints show her family members intimately involved in their own personal pleasures, often at the end of the day: *Mr. Cassatt Reading* (c. 1882, soft-ground and aquatint); *Sewing by Lamplight* (c. 1882, soft-ground); and *Before the Fireplace* (figure 9). Etching is the ideal medium for rendering these darkened, night-time interiors.

It was also for *Le Jour et la nuit* that Degas created two etchings of Cassatt and her sister, *Mary Cassatt at the Louvre: The Paintings Gallery* (c. 1879–80) and *Mary Cassatt at the Louvre: Museum of Antiquities* (figure 10). These were preceded by several pastel studies: *Two Studies of Mary Cassatt at the Louvre* (c. 1879, private collection), *Woman in Street Clothes* (c. 1879, Collection of Walter M. Feilchenfeldt, Zurich), *Portraits in a Frieze* (1879, Collection of Dr. Herman J. Abs, Cologne), and *At the Louvre* (c. 1879, private collection).[39] In this latter work, Degas has included an additional figure in the foreground, presumably Cassatt's sister Lydia, who sits on a bench looking toward her sister and the paintings she's viewing. Both figures form a strong diagonal that nearly bisects the work. This pastel, in turn, is the source for two etchings for *Le Jour et la nuit*. In the etching *Mary Cassatt at the Louvre: The Paintings Gallery*, the figure of Lydia has been reversed and the space between the two has been compressed. Along the left-hand side is a flat, wide border, in Japanese style, that further emphasizes the sense of flattened space. For *The Museum of Antiquities*, Degas also reverses the figure of Cassatt and expands the space the women occupy to include more of the trappings of the museum, thereby making the composition more naturalistic and narrative. In the latter etching, both Mary and her sister Lydia are depicted. Lydia is seated in the foreground to the left, holding a catalog. She glances over the catalog and to her left at the Cerveteri sarcophagus, which dates from the sixth century B.C. and is one of the best known sculptures in the museum. She holds the catalog high, as if to protect herself from the full impact of this sensuous work. Cassatt, with her back to the viewer, stands upright, leaning on her umbrella and seemingly mesmerized by the power of the ancient Etruscan piece.

Cassatt noted in conversations with Louisine Havemeyer that she served as the model for two versions of Degas's *At the Milliner's*. Both were done in pastel, both date from 1882, and both are at the Metropolitan Museum of Art. Degas also produced a portrait of Cassatt around 1884, now in the National Portrait Gallery, Wash-

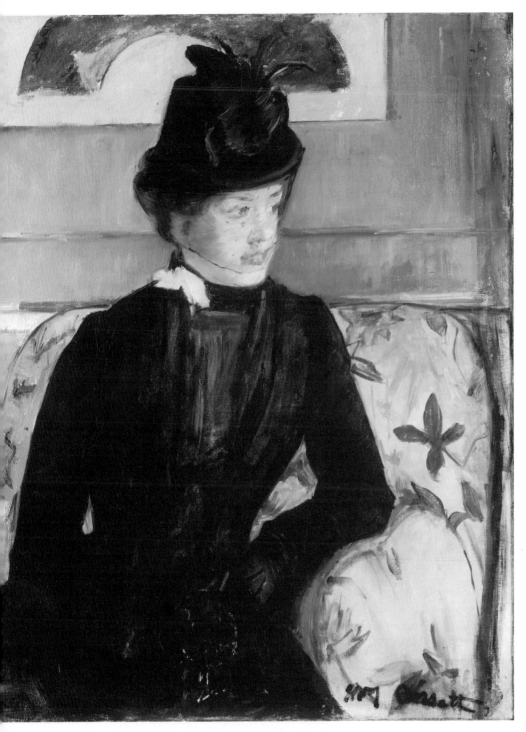

Figure 8. Mary Cassatt, *Young Woman in Black,* 1883. Oil on canvas, 31 ¾ × 25 ½ in. Courtesy of the Maryland Commission on Artistic Property of the Maryland State Archives, on loan to the Baltimore Museum of Art, MSA SC 4680-10-0010.

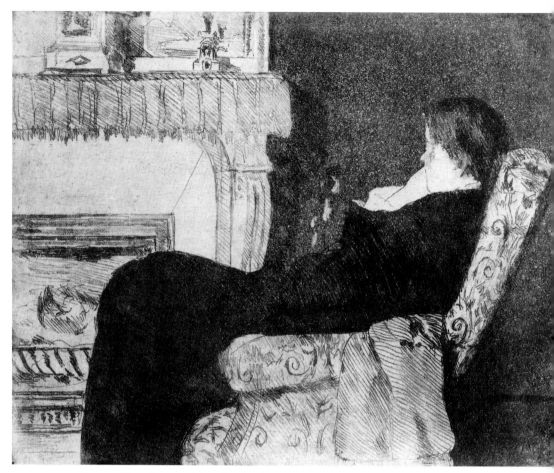

Figure 9. Mary Cassatt, *Before the Fireplace*, c. 1882. Soft-ground and aquatint, 6 7/16 × 8 1/16 in. New York Public Library, Astor, Lenox, and Tilden Foundations.

ington, D.C. Although Cassatt kept the portrait for nearly thirty years, she grew to hate it. Around 1912 when she decided to sell it, she wrote to Durand-Ruel: "I do not want to leave it with my family as being [a picture] of me. It has some qualities as art, but it is so painful and represents me as such a repugnant person, that I would not want it known that I posed for it."[40]

It was during the time of the experiments that Degas, Cassatt, and Pissarro conducted with printmaking that they hatched plans for the fifth impressionist exhibition (1880), which, like the 1879 exhibition, was marked by dissension. While Morisot rejoined the group, Monet, Renoir, Cézanne, and Sisley did not participate. Gauguin was officially represented for the first time by nine works, and Cassatt exhibited fifteen, the most she ever showed. Degas's strictures against showing at the Salon continued to be upheld for the sixth impressionist exhibition, held in 1881, and once again Monet, Renoir, and Sisley absented themselves from the impressionists' show.

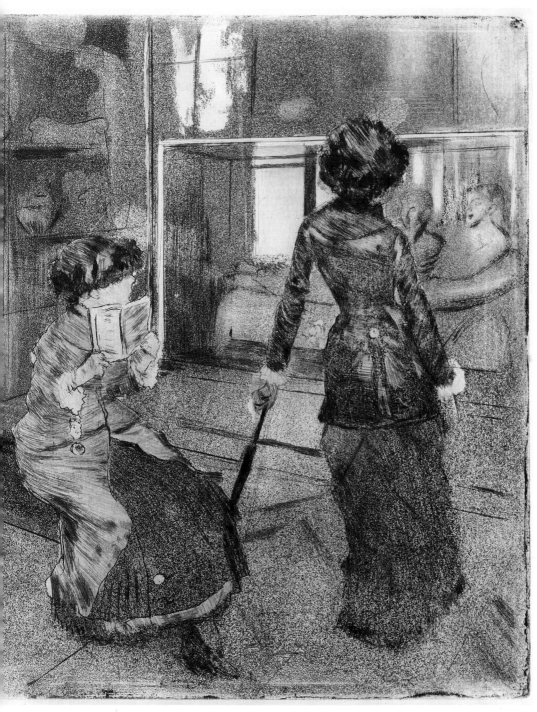

Figure 10. Edgar Degas, *Mary Cassatt at the Louvre: Museum of Antiquities,* c. 1879. Etching, aquatint, and electric crayon. Third state. Metropolitan Museum of Art, New York, Rogers Fund, 1919 (19.29.2). All Rights Reserved.

Gustave Caillebotte, another defector and a backer of Monet, wrote a letter of complaint about Degas to Pissarro in 1881. Interestingly, he cited Cassatt as one of the artists whose work should be included and did not consider her to be merely one of "the crowd he [Degas] drags along," referring, for example, to Raffaëlli.[41] With works such as *Lydia Crocheting in the Garden at Marly* (1880) and *The Cup of Tea* (1879) (both now in the Metropolitan Museum of Art), Cassatt had established in two short years an enviable reputation and was no longer dependent solely upon Degas's endorsement for acceptance into the circle of the avant-garde.

The disagreements among the impressionists did not subside and when it came time to plan for the seventh exhibition, Degas withdrew and let others organize it. His role was assumed by Paul Durand-Ruel, the dealer who represented a number of the impressionists, some of whom—Alfred Sisley, Pissarro, Monet, and Renoir—had become money makers. Seeing this as an opportunity to showcase works of theirs that he had in stock, Durand-Ruel took responsibility for the seventh impressionist exhibition. Yet the largest concern of many of the artists was that the exhibition not be diluted by second-rate work, which they ascribed to Degas's friends and followers. Typical of their concerns was Gauguin's, expressed in a letter to Pissarro: "Despite all my good will I can no longer continue to serve as buffoon for M. Raffaeli [*sic*] and Co. Please accept my resignation."[42]

Degas was not successful in discouraging Pissarro from participating in the seventh show, but he had dissuaded Cassatt. Fortunately, a year earlier, the Durand-Ruel Gallery had begun to represent Cassatt, which began a long and important relationship between artist and dealer.[43] Maybe it was just as well that Cassatt did not take part in the seventh exhibition, for in 1882 she was preoccupied with the need to look after her beloved sister Lydia, who died later that year of a lingering illness, Bright's disease.

By 1886, the year of the eighth and last impressionist show, a number of victories had been won, the Salon's prestige had declined, and dealers such as Durand-Ruel and Georges Petit had become more influential. The artists' desire to exhibit together again was due largely to the efforts of the two who remained stalwartly independent, Pissarro and Degas, and who again teamed up as organizers. True to his principles, Degas set down admission regulations: "the exhibition will be made completely independent without the intervention of dealers and with the conditions that [participants] cannot send to the Salon or to the exhibition of a dealer like Petit."[44] This condition effectively excluded Monet, Renoir, Sisley, and Caillebotte. Cassatt, however, exhibited to great critical success with works such as *Young Girl at the Window* (1883, Corcoran Gallery of Art), *Etude* or *Girl Arranging Her Hair,* and *Children on the Beach* (1884, National Gallery of Art). As noted at the time by the critic Gustave Geffroy:

> The six paintings and the pastel by Mary Cassatt are portraits of children, young girls, and women studied in the corners of windows bathed in light or in gardens aglow with sunlight. Unity is harmoniously achieved among the figures' rosy complexions, light clothing, and the young green foliage. Her drawing yields to the fabric's softness, the

hands' nervousness, the motion of supple bodies. . . . The young girl in night dress who twists her hair before her dressing table is still swollen with sleep and damp from her first ablutions.[45]

Historically the most noteworthy aspect of the exhibition was the presentation of Georges Seurat's *A Sunday on La Grand-Jatte* (1884, Art Institute of Chicago) and the introduction of the neo-impressionist, divisionist aesthetic. Cassatt was affected by these developments. Over the next ten years, 1886–96, a new decisiveness and control entered her work as she absorbed the flat patterning, intense color, and allegorical, symbolist content of postimpressionism. It was also during this next decade that she continued her important work in printmaking and undertook the most ambitious work of her career, the mural *Modern Woman* for Chicago's 1893 World's Columbian Exposition. A modern woman herself, Cassatt through her affiliation and identification with the impressionist movement became a modern artist.

Notes

1. See Huber, *The Pennsylvania Academy and Its Women, 1850–1920*, and Peet, "The Art Education of Emily Sartain."

2. See Andrew J. Walker, "Mary Cassatt's Modern Education: The United States, France, Italy, and Spain, 1860–1873," in Barter et al., *Mary Cassatt: Modern Woman*, 21–43, and, for background on the experience of American art students, Weinberg, *The Lure of Paris*. For information on Eakins's study with Gérôme see Kathleen Foster, *Thomas Eakins Rediscovered* (New Haven: Yale University Press, 1997), 32–37.

3. Chaplin was best known for his fashionable portraits and paintings of women and children. These works were highly popular during the Second Empire and influenced the careers of a number of notable French woman artists—Henriette Brown (née Sophie Desaux), Berthe Délorme, Louise Abbéma, and Madeleine Lemaire. Valerie E. Morant, "Charles Joshua Chaplin: An Anglo-French Artist, 1825–1891," *Gazette des Beaux-Arts* 114 (October 1989): 143–52.

4. Ibid., 150.

5. See Peter Bermingham, *American Art in the Barbizon Mood* (Washington, D.C.: Smithsonian Institution, 1975), and Sally Webster, *William Morris Hunt* (New York: Cambridge University Press, 1991), 27–38.

6. Mathews, *A Life*, 43.

7. Stevenson was Cassatt's middle name and the maiden name of her maternal grandmother, Mary Stevenson Johnston. Cassatt exhibited under this name in the Salons of 1868, 1870, 1872, 1873. In the Salons of 1875, 1876, 1877 she exhibited under her own name.

8. For an overview of Americans' participation, see Lois Fink, *American Art at the Nineteenth-Century Paris Salons* (New York: Cambridge University Press, 1990).

9. Other well-known American artists who exhibited at the Salon were the expatriates John Singer Sargent and James McNeill Whistler. Sargent, who was born in 1856, began to exhibit at the Salon in 1877. Whistler, who was ten years older than Cassatt, exhibited etchings in 1859 and 1863 before he had a painting, *La princesse du pays de la porcelaine* (1863–64, Freer Gallery of Art), accepted in 1859. While the controversy surrounding the rejection of his painting *The White Girl* (1862, National Gallery of Art) from the Salon of 1863 and its later placement in the Salon des refusés is always cited as testimony to his affiliation with the avant-garde, Whistler continued to participate in the Salon through 1897.

10. See Linda Nochlin, "Issues of Gender in Cassatt and Eakins," in Eisenman, *Nineteenth-Century Art*, 255–73.

11. For an early assessment of the work of these artists, see Frederick Sweet, *Sargent, Whistler, and Mary Cassatt* (Chicago: Art Institute of Chicago, 1954).

12. See Marchal E. Landgren, *American Pupils of Thomas Couture* (College Park: University of Maryland Art Gallery, 1970).

13. Quoted in Lloyd Goodrich, *Thomas Eakins* (Cambridge, Mass.: Harvard University Press, 1982), 1:46–47.

14. Cassatt to Sartain, May 22, [1871], quoted in Mathews, *Cassatt and Her Circle*, 70. In 1871, the Cassatt family moved to Hollidaysburg, in west-central Pennsylvania. While there they met the Catholic bishop of Pittsburgh, Father Michael Domenec, who offered to pay Cassatt three hundred dollars for copies of the Correggios then located in S. Giovanni Evangelista, for the new St. Paul's Cathedral in Pittsburgh.

15. Sartain's letters are located in the archives of the Pennsylvania Academy of the Fine Arts. Many of those concerning Cassatt are reproduced in Mathews, *Cassatt and Her Circle*. Also see Peet, "The Art Education of Emily Sartain," 9–15.

16. For a full discussion of these commissions see Walker, "Mary Cassatt's Modern Education," 22–30.

17. Cassatt to Sartain, October 5, 1872, Mathews, *Cassatt and Her Circle*, 103.

18. Mathews, *Cassatt and Her Circle*, 68.

19. Cassatt to Sartain, October 5, 1872, Mathews, *Cassatt and Her Circle*, 103.

20. Cassatt to Sartain, October 13, 1872, Mathews, *Cassatt and Her Circle*, 108.

21. Cassatt to Sartain, January 1, 1873, Mathews, *Cassatt and Her Circle*, 114. Three other known works from this period are *On the Balcony* (1873, Philadelphia Museum of Art); *Spanish Dancer Wearing a Lace Mantilla* (1873, Smithsonian American Art Museum); and *After the Bullfight* (1873, Art Institute of Chicago). See M. Elizabeth Boone, "Bullfights and Balconies: Flirtation and *Majismo* in Mary Cassatt's Spanish Paintings of 1872–73," *American Art* (Spring 1995): 54–71. Two years earlier, Eakins had taken an almost identical trip to Spain, living in both Madrid and Seville. His enthusiasm for the picturesque types he found in Seville was similar to Cassatt's. See Goodrich, *Thomas Eakins*, 1:54–9.

22. She would later tell the critic Achille Segard: "The Rubens in the Prado Museum filled me with such admiration that I ran from Madrid to Antwerp" ["Les Rubens du musée du Prado me transportérent d'une telle admiration que je courus de Madrid à Anwers."] Segard, *Un peintre des enfants*, 6. (Unless noted otherwise, translations in this chapter are mine.)

23. "Une tête de jeune fille aux cheveux presque roux qui avait été peinte à Rome, sous l'influence de Rubens." Ibid., 7.

24. "C'est vrai. Voilà quelqu'un qui sent comme moi." Ibid., 35.

25. Cassatt wrote to Sartain, June 25, 1874, from Antwerp: "I met here a Mr. & Mrs. Tourny, Mr. T. copies in water colours for Mr. Thiers." Mathews, *Cassatt and Her Circle*, 121.

26. Emily Sartain to John Sartain, June 17, 1874, Mathews, *Cassatt and Her Circle*, 124–26.

27. The two histories of impressionism I have relied upon are John Rewald, *The History of Impressionism* (New York: Museum of Modern Art, 1961), and Moffett et al., *The New Painting*.

28. Havemeyer, *Sixteen to Sixty*, 275. In conversations with Havemeyer, Cassatt relayed some of Degas's family history, which she retells in a gossipy, chatty tone. For instance, Cassatt knew that Degas's great-grandfather was reduced to selling pumice stone in Naples during the Reign of Terror and that the family was redeemed socially when Degas's sister "married the Marquis of Rochefort" (243). Cassatt had met Louisine Elder, later Havemeyer, through Sartain in 1874 when Louisine was visiting Paris. This marked the beginning of one of Cassatt's most important friendships. In 1877 Cassatt encouraged Louisine to purchase her first Degas painting, *Répétition de Ballet* (c. 1876, Nelson-Atkins Museum). See *Splendid Legacy*, 329–30. See also Weitzenhoffer, *The Havemeyers*.

29. "En 1877, je fis encore un envoi. On le refusa. C'est à ce moment que Degas m'engagea à ne plus envoyer au Salon." Segard, *Un peintre des enfants*, 7.

30. Cassatt to J. Alden Weir, March 10, 1878, Mathews, *Cassatt and Her Circle*, 137. Cassatt was elected an honorary member of the Society of American Artists in 1880.

31. Ronald Pickvance, "Contemporary Popularity and Posthumous Neglect," in Moffett et al., *The New Painting*, 244.

32. Higonnet, *Berthe Morisot*, 154.

33. While it is not certain which Morisot painting Cassatt purchased, Charles F. Stuckey assumes that it is *Woman at Her Toilette* (unlocated). "Berthe Morisot," in Charles F. Stuckey and William P. Scott, *Berthe Morisot, Impressionist* (New York: Hudson Hills Press, 1987), 76.

34. The Martelli quote comes from "Gli impressionisti, mostra del 1879," *Roma Artistica*, June 27 and July 5, 1879, translated into French in *Diego Martelli: Les Impressionistes et l'art moderne*, ed. Francesca Errico (Paris: Editions Vilo, 1979), 28–33, and included in Moffett et al., *The New Painting*, 276. The Pickvance remark appeared in Moffett et al., *The New Painting*, 257.

35. As noted in Jean Sutherland Boggs et al., *Degas* (New York: Metropolitan Museum of Art, 1988): "It is unfortunate for students of the Impressionist movement that in later life, when her sentiments for Degas were decidedly ambivalent, Mary Cassatt destroyed her letters from the artist, who did not save his correspondence from her, either" (320). It is not known if Cassatt and Degas were physically intimate. The most recent scholar to weigh in on the subject is George Shackelford, who concludes that "nothing we know about these two individuals" suggests that "they were romantically involved." George T. M. Shackelford, "*Pas de deux*: Mary Cassatt and Edgar Degas," in Barter et al., *Mary Cassatt: Modern Woman*, 109

36. Mathews and Shapiro, *Mary Cassatt: The Color Prints*, 58–59.

37. See Shackelford, "*Pas de deux*," 118–25.

38. As noted by Mathews and Shapiro in *Mary Cassatt: The Color Prints*: "During this period Cassatt was introduced to a series of innovative printmaking methods, primarily the possibilities of mixing and superimposing intaglio techniques: etching, drypoint, softground, and aquatint were all applied in unconventional ways and in unusual combinations to the copperplates" (58–59). The quote in the text regarding the "cuisine" method comes from page 59.

39. The identification of the various figures in these works has a complicated history, which is detailed in Boggs et al., *Degas*, 318–24.

40. Quoted in Boggs et al., *Degas*, 442. The portrait is titled *Mary Cassatt Seated, Holding Cards* (c. 1880–84, National Portrait Gallery).

41. Quoted in Fiona E. Wissman, "Realists among the Impressionists," in Moffett et al., *The New Painting*, 337.

42. Quoted in Joel Isaacson, "The Painters Called Impressionists," in Moffett et al., *The New Painting*, 376.

43. See Erica Hirshler, "Helping 'Fine Things across the Atlantic': Mary Cassatt and Art Collecting in the United States," in Barter et al., *Mary Cassatt: Modern Woman*, 177–211.

44. Quoted in Martha Ward, "The Rhetoric of Independence and Innovation," in Moffett et al., *The New Painting*, 423.

45. Quoted in Moffett et al., *The New Painting*, 450.

MODERN WOMAN AND THE WORLD'S COLUMBIAN EXPOSITION

It is difficult to overestimate the significance of the 1893 World's Columbian Exposition for Chicago and the United States. Even its critics agree that it was a watershed event in American history as the country assumed a global role in world trade and politics. Symbolic of this new stature was the adoption by exposition planners and architects of the most influential international style of architecture, that of the French Beaux-Arts. Buildings in this style were based on classical precedent and often incorporated sculpture and paintings. The fair's architecture had a profound impact on American civic buildings and city planning for the next fifty years. More important for the country's future was the recognition the exposition gave to women's new public role.

THE WORLD'S COLUMBIAN EXPOSITION

On April 28, 1890, President William Henry Harrison signed into law "An Act to Provide for the Celebration of the 400th Anniversary of the Discovery of America by Christopher Columbus by holding an International Exhibition of Arts, Industries, Manufacturers and the Products of the Soil, Mine and Sea, in the City of Chicago, in the State of Illinois." This full title explains the fair's scope and links it to other world's fairs, enterprises that began in England in 1851 with the Crystal Palace Exposition organized by Prince Albert and Henry Cole.[1] This first fair, officially called the Great Exhibition of the Works of Industries of All Nations, was primarily dedicated to promoting British manufacturing and trade. Joseph Paxton's innovative cast-iron and glass building contained grand displays of all manner of machinery and decorative arts, which were augmented in later international fairs by agricultural products and the fine arts of painting and sculpture. Over time these exhibits expanded in size and scope, necessitating more buildings and greater acreage. The host country's leading architects and landscape designers often were invited to showcase their talents in designing exposition facilities.

The 1889 Universal Exposition in Paris, in particular, became a competitive model

for the Columbian Exposition. As noted by one historian at the turn of the twenti-eth century, competition between France and the United States led to "spectacular excesses . . . perpetuated in the name of art, science and education," which began with the Universal Expositions of 1878 and 1889.[2] In Paris the United States competed with France and other nations on equal footing in terms of its industrial, agricultural, and manufacturing products. However, in the area of the fine arts, many prominent Americans felt their country's efforts were inferior and provincial.[3] Thus the site and design of Chicago's World's Fair were of foremost concern, and the leading archi-tects and designers of the period were called upon to lend their expertise.

The heart of the exposition was the Court of Honor, on the fairground's south-ern end. Here gleaming white, classically inspired buildings by Richard Morris Hunt, George B. Post, and the firm of McKim, Mead, and White surrounded a large reflecting pool and gave the impression that ancient Rome had been resurrected in America's heartland (figure 11). Yet the buildings' academic style was condemned for most of the twentieth century as antithetical to the progressive spirit of modern ar-chitecture. More recently, the fair itself has been criticized as representing all that is wrong with American enterprise, including its hegemonic Indian removal program and exclusionary racial policies. With the writings of Louis Sullivan, Lewis Mumford, and, in our own time, Robert Rydell, it has gotten bad press since the 1920s.[4]

What is missing from these assessments is a broader understanding of the fair's cultural significance and the national importance of its midwestern locale. Chicago had become the heart of the nation, and the wealth, influence, and industry of its local business leaders won the franchise to locate the fair in that city. These were the same people who spearheaded the formation of the Chicago Symphony, the University of Chicago, and the Art Institute, to name just a few of the now internationally regarded institutions that were founded in the years during which the fair was being organized. As noted by Helen Lefkowitz Horowitz:

> These men were members of a new generation of civic leaders who had emerged in the years after the 1871 fire with a new energy, significant wealth, and a vision of the city and its needs. The founders and early trustees of the Art Institute had worked together in the Art Department of the Interstate Industrial Exposition, the annual trade fair originally held to celebrate Chicago's recovery from the fire. Some were also ac-tive in the Chicago Biennial Musical Festival Association and the Chicago Grand Opera Festival and the promotion of the Auditorium and ultimately the Chicago Sym-phony Orchestra. It was to this group of men that the Baptist founders of the Univer-sity of Chicago would turn as they stretched their denominational institution into a secular university. The World's Columbian Exposition in 1893 would give to the out-side the first real glimpse of the effects of this ferment.[5]

Like the fair itself, these institutions became models, both in purpose and in archi-tecture, for many other American cities—St. Paul, Milwaukee, St. Louis, Kansas City, Denver, Pittsburgh, Cleveland—seeking to develop civic pride through the estab-lishment of similar cultural, educational, and civic organizations. These efforts later came together under the rubric of the City Beautiful, which, although largely asso-

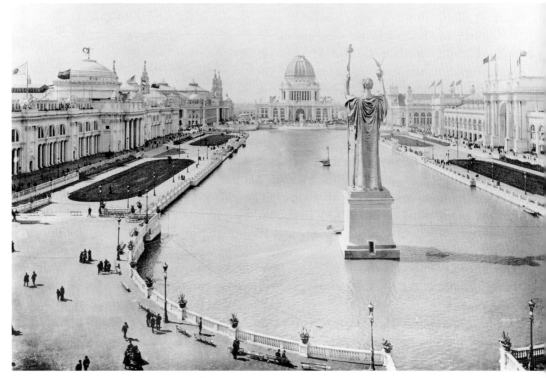

Figure 11. Grand Basin and Court of Honor. From Hubert H. Bancroft, *The Book of the Fair* (Chicago, 1893), 370. Photo courtesy of General Research Division, New York Public Library, Astor, Lenox, and Tilden Foundations.

ciated with urban planning, also encompassed the ambitions and ideals of a broad range of community organizations. As William Wilson, author of *The City Beautiful Movement*, flatly states, the World's Columbian Exposition with its "great visual power" was "the inspiration for the City Beautiful movement and the beginning of comprehensive city planning in the United States."[6]

In communities across the country, members of garden clubs worked with newly formed park commissions, judges advised artists on murals for new courthouses, university trustees consulted with architects on the siting of new campuses, while politicians dithered about the construction of new statehouses. These were newly incorporated cities, many of them less than twenty-five years old in 1893. But grain, timber, livestock, oil, and iron had brought unprecedented wealth to the Midwest, and burgeoning cities in the region assisted in transforming these raw materials into flour, lumber, meat, kerosene, and steel, which was then shipped east by boat through the Great Lakes and the Erie Canal or by rail east and west across the country.

Earlier, Philadelphia's Centennial Exposition had celebrated the reunion of North and South; in 1893 the World's Columbian Exposition extolled a nation that extended

from the Atlantic to the Pacific, from Mexico to Canada, with Chicago as its center. The balance of power in all senses—economic, geographic, political—had shifted from the East Coast to the country's midsection. The Midwest was prepared to go toe-to-toe with the East, and Chicago would challenge New York's hegemony.

Construction of the fair got started late and the city's ambitious plans could not be realized in time to mark the true quadricentennial of Columbus's voyage. The exposition officially opened May 1, 1893, and closed on October 31. Two different groups were charged with the responsibility for organizing and running it—one local, the other national. The local organization was called, variously, the Chicago Corporation, the Chicago Directory, or the Chicago Company and was comprised of prominent businessmen, many of whom were members of the prestigious Chicago Club. They had worked hard to secure the fair for Chicago over the competing interests of New York, St. Louis, and Washington, D.C., and had succeeded in convincing the United States government that by holding the fair in the Midwest the fair would be "American, not foreign, National not Provincial."[7]

Consisting of forty-five members, the Chicago Corporation was responsible for selecting the site, designing the exposition's layout, hiring architects, and apportioning space and buildings for the various exhibits. In April 1890, following passage of the federal enabling legislation, Lyman Gage, vice president of the First National Bank of Chicago, was named president of the Chicago Corporation, and Potter Palmer (whose wife, Bertha Honoré Palmer, would be elected president of the Board of Lady Managers) became second vice president as a member of the Committee on Grounds and Buildings and the Committee on Fine Arts.

A second committee, the World's Columbian or National Commission, was initially set up as an oversight committee since Chicago had not yet established itself in the nation's eyes as being sophisticated and cosmopolitan enough to ensure that the fair would "give a positive expression of the progress and unity of the American people."[8] As it turned out, the 108-member commission was too large to be effective and its responsibilities devolved to negotiating with foreign nations and awarding prizes. Authority thus became more closely invested in the Chicago Corporation and its board of directors.[9]

Their first task was to find a site for the fair, a responsibility that fell to the Committee on Grounds and Buildings. Its chairman, E. T. Jeffery, president of the Illinois Central Railroad, appointed Daniel H. Burnham as chief of construction, to whom "all advisors and officials . . . would . . . report directly."[10] Burnham along with his partner, John Wellborn Root, had already been responsible for $40 million worth of construction in Chicago following the historic fire of 1871, which destroyed a great deal of the downtown.[11] While Burnham would go on to design many other buildings, including New York's Flatiron Building, at the time of the fair the firm's best-known buildings were the Rookery (1888) and the Monadnock (1891), both excellent examples of what came to be called the Chicago School. Ironically, the iron or steel girder system, the essential interior skeleton that made the high-rise office building possible, was also used in the construction of the Columbian Exposition

architecture. The difference between the two building types—the stripped-down, practical office building and the Beaux-Arts–inspired exposition architecture—lay in the cladding of the exteriors.

Burnham appointed as his earliest advisers for the exposition project John Wellborn Root and the East Coast landscape architect Frederick Law Olmsted and his partner, Henry C. Codman. Years earlier Olmsted had served as a designer, along with Calvert Vaux, of Chicago's South Park. Olmsted and Vaux's 1871 design included plans for Jackson Park, but these improvements were never realized. When Olmsted was called back to the city in 1890, he reminded the committee of these earlier schemes and pointed out that undeveloped Jackson Park was an ideal location for the fair.[12]

Central to the concerns of all involved in the exposition planning was a desire to surpass the 1889 exposition held in Paris. Dominated by the Eiffel Tower, the fair was highly regarded both for its design and the beauty of its buildings (figure 12). Jackson Park, far from downtown Chicago and essentially swamp land, had not been anyone's first choice for the Columbian Exposition. Yet the designers—primarily Olmsted, who designed the fair's layout with its elaborate interconnecting waterways—worked to exploit its proximity to Lake Michigan. As noted by Root, the lake

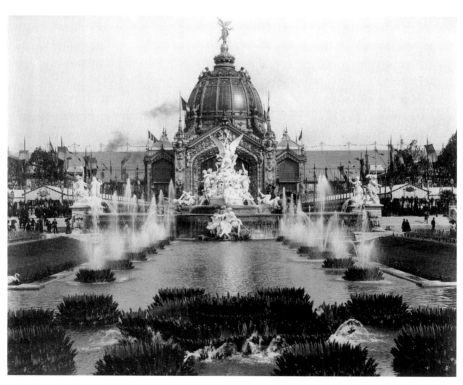

Figure 12. Exposition Universelle de Paris, 1889. Dôme Central, Palais des Industries Diverses, shown behind Jules-Félix Coutan's *The City of Paris, on Her Barge Surrounded by Science, Industry, Agriculture, and Art, Enlightening the World with Her Flame*. Photo, Library of Congress, lot 6634.

would "associate the fair with the grandeur and beauty of the one distinguishing natural, historical and poetic feature of this part of the American continent—its great inland seas."[13]

Burnham's next challenge was to select an appropriate architectural style and architects. Unity was deemed necessary to counteract the enormous diversity of the exhibits to be contained inside the buildings. Knowing his own limits, and those of his Chicago colleagues, Burnham made a fateful decision and turned for advice to architects with more experience and larger national reputations. These included three New York firms—Richard Morris Hunt (who ultimately designed the Administration Building); McKim, Mead, and White (Agricultural Building, among others); and George B. Post (Manufactures and Liberal Arts Building)—one from Boston, Peabody and Stearns (Machinery Hall); and one from Kansas City, Van Brunt and Howe (Electricity Building). Burnham's Chicago colleagues were not happy and he subsequently invited five Chicago firms to join the deliberations: Burling and Whitehouse (who created the Venetian Village); Jenney and Mundie (Horticulture); Henry Ives Cobb (Fisheries); S. S. Beman (Mines and Mining); and Adler and Sullivan (Transportation Building). To avoid jealousies and conflicts, the firm of Burnham and Root abstained from competing for any of the architectural commissions.

Collectively the ten firms formed an advisory board and elected a chairman, Richard Morris Hunt. Hunt was the first American architect to be trained at the Ecole des Beaux-Arts and by the 1890s the acknowledged dean of American architects. Louis Sullivan was elected treasurer.

At their first joint meeting, the architects agreed that the classical style would be adopted for the Court of Honor. Tragically, Root, who was the design partner of the Burnham firm, died on January 15, 1891, just a few days after the joint meeting.[14] His appointment as designer-in-chief of the fair was filled by Charles Atwood, who would go on to design sixty of the fair's smaller buildings, the Peristyle in the Basin, and the Palace of Fine Arts, the only structure that remains in Jackson Park and is now the Museum of Science and Industry.[15]

The site covered 633 acres and consisted of 200 buildings (figure 13). The Court of Honor was bordered by Hunt's Administration Building at the western end and by Charles Atwood's 150-foot-high, 830-foot-long peristyle on the eastern end (figure 14). Decorated with roof sculptures by Theodore Baur and Bela Pratt and a quadriga designed by Daniel Chester French and Edward Clark Potter, the peristyle formed a gateway to the shores of Lake Michigan (figure 15). The buildings on the Court of Honor surrounded a basin that was 350 feet long and 100 feet wide. Within the basin were two monumental sculptures, Frederick MacMonnies's *Columbian Fountain* (figure 16) on the western end and, toward the east, French's 67-foot-high gilded plaster statue called *The Republic*. The buildings themselves were decorated with exterior sculpture and all contained mural paintings, the most extensive of which could be found in the eight entrance pavilions of Post's Manufactures and Liberal Arts Building (figures 17 and 18).

Most of the other buildings were located to the north near the Lagoon. Here were

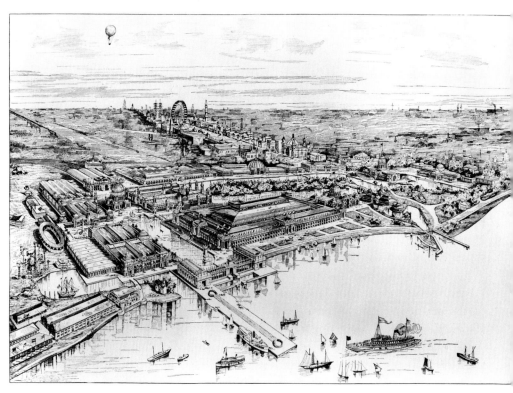

Figure 13. Charles Graham, *Bird's Eye View of the World's Columbian Exposition*. Engraving after watercolor. From Hubert H. Bancroft, *The Book of the Fair* (Chicago, 1893), 71.

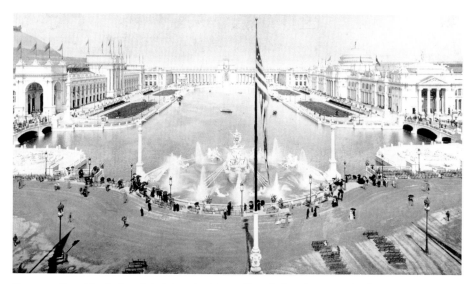

Figure 14. Grand Basin from Administration Tower. From Hubert H. Bancroft, *The Book of the Fair* (Chicago, 1893), 236. Photo courtesy of General Research Division, New York Public Library, Astor, Lenox, and Tilden Foundations.

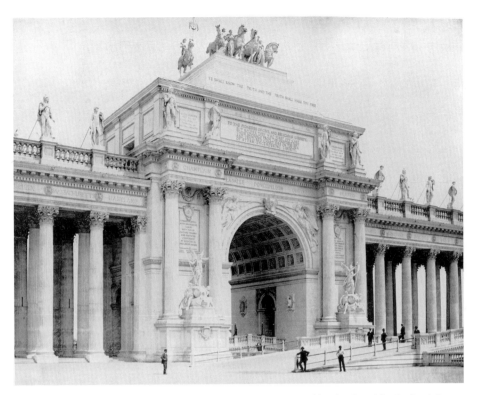

Figure 15. Charles Atwood, Columbus Arch, Peristyle, surmounted by the *Quadriga* by Daniel Chester French and Edward Clark Potter. From Hubert H. Bancroft, *The Book of the Fair* (Chicago, 1893), 374. Photo courtesy of General Research Division, New York Public Library, Astor, Lenox, and Tilden Foundations.

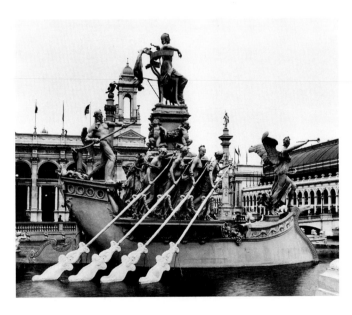

Figure 16. Frederick MacMonnies, *Columbian Fountain,* Basin, Court of Honor, World's Columbian Exposition, Chicago, 1893. Photo by C. D. Arnold. Chicago Historical Society, ICHi-02502.

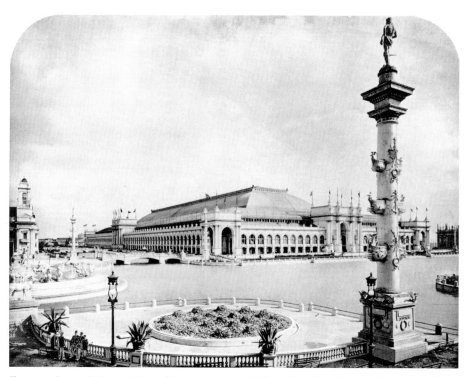

Figure 17. George B. Post, Palace of Manufactures and Liberal Arts. From Hubert H. Bancroft, *The Book of the Fair* (Chicago, 1893), 242. Photo courtesy of General Research Division, New York Public Library, Astor, Lenox, and Tilden Foundations.

Figure 18. Edwin H. Blashfield, *The Arts of Metal Working,* 1893, north dome of west portal, Manufactures and Liberal Arts Building. From Royal Cortissoz, "Color in the Court of Honor," *Century Magazine,* July 1893, 327. Photo courtesy of General Research Division, New York Public Library, Astor, Lenox, and Tilden Foundations.

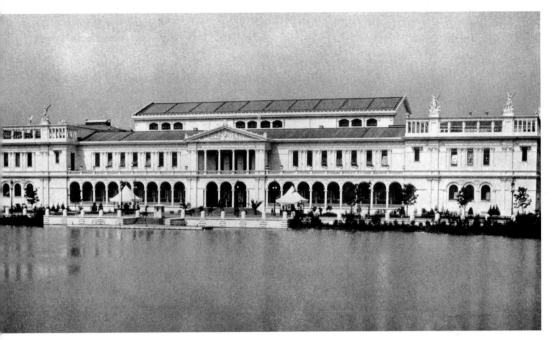

Figure 19. Sophia Hayden, Woman's Building, World's Columbian Exposition, Chicago, 1893. Photo, collection of the author.

found structures sponsored by states and foreign governments, Louis Sullivan's Transportation Building, and, further along the western shore of the Lagoon, the Woman's Building, created by the Board of Lady Managers (figure 19).

The major fair buildings were constructed to be temporary. Their supporting skeletons were iron and wood with exteriors modeled from plaster or staff—a mixture of plaster, cement, and jute fibers. The buildings were highly flammable and after the fair closed at the end of October 1893, most were destroyed through neglect, vandalism, or fire. The one building to survive, as noted earlier, was Atwood's Fine Arts Building. A few of the murals (including Cassatt's) and sculptures had been removed when the fair closed, and some can be found in various locations throughout the country.

The Woman's Building

More has been written about the Woman's Building than any other building at the fair. Even Sullivan's Transportation Building has not garnered a 600-page book, the length of Jeanne Madeleine Weimann's highly detailed and valuable work *The Fair Women*, published in 1981.[16] The enthusiasm that women historians feel for this project reflects the dedication the Woman's Building's organizers—and they were legion—brought to the original enterprise. While Sophia Hayden's design was noteworthy, it was the enterprise itself, the assembling of women's work—handicrafts, inventions, books, paintings, sculpture, and statistics on women's employment—that

galvanized women nationally and internationally. The entire project mirrored a passionate desire by women from all walks of life to document the contribution women had made to the world's culture and economy.

The last half of the nineteenth century was witness to an historic, revolutionary change in women's lives that occurred primarily in the United States and Western Europe.[17] In the late twentieth century this history was largely subsumed within the history of woman suffrage. It should be the other way around. As important as suffrage was, the opening up of professional fields and educational opportunities was profound and provided the substructure, particularly among women themselves, for the final passage of the suffrage amendment in 1920. The history of the 1893 Woman's Building must be studied within this larger context of the combined struggles for emancipation, autonomy, and suffrage.

These often competing agendas were played out when the various factions lobbied on behalf of women's participation in the fair's organization and their representation at the fair itself. The leaders of the suffrage movement saw the World's Columbian Exposition as an important opportunity to help promote the vote for women. Social reformers and women professionals who were mainly Chicago-based wished to further the cause of women's welfare at home and in the work force. For them, suffrage was of secondary concern, and they believed it should not detract from the larger issues governing women's economic well-being. It was this latter group's philosophy that ruled the day in Chicago. The history of these competing interests, which were often separated only by a matter of degree, is an important backdrop to the history of the Woman's Building.

These antagonisms were not new. The original split among supporters of woman suffrage occurred in 1869, following the Civil War, when controversy erupted over support of the Fifteenth Amendment and the extension of the franchise only to black males. The interfactional warring of the woman suffrage movement split it in two, with one group based in New York (the National Woman Suffrage Association) led by Elizabeth Cady Stanton and Susan B. Anthony, and the other in Boston (the American Woman Suffrage Association) led by Julia Ward Howe and Lucy Stone.[18] The Stanton-Anthony axis urged defeat of the Fifteenth Amendment, while the Howe-Stone followers advocated passage. Stanton in particular was outraged that illiterate black males would be granted full citizenship while highly educated white abolitionist women were to be denied the vote. Howe and Stone were closely allied with the Boston abolitionists William Lloyd Garrison and Wendell Philips, both of whom supported the amendment. There were other difficulties as well. As described by Elisabeth Griffith in her biography of Stanton: "Stanton's refusal to admit men to membership in the National Woman Suffrage Association, the racist tone of her opposition to the Fifteenth Amendment, and her association with working women, union organizers, unwed mothers, murderers, and advocates of free love, shocked the Boston branch of the reform community."[19]

By the 1890s, suffrage still had not been secured. It was acknowledged that old grievances had to be put aside to attain a shared goal, and the two groups merged to

form the National American Woman Suffrage Association (NAWSA). This new union energized the woman's rights movement and brought into focus the extent of women's accomplishments over the forty-two years since the first Seneca Falls convention. While women still had not secured the vote, they had made enormous inroads into various professions and had become leaders, particularly in the fields of education and social reform. There were also a number of important books that documented women's history, including the first four volumes of *History of Woman Suffrage*, edited by Elizabeth Cady Stanton, Susan B. Anthony, and Mathilda J. Gage; Phebe Hanaford's *Daughters of America; or, Women of the Century* (1882); and James Parton's *Daughters of Genius* (1888).[20] Hanaford's volume included biographical sketches of women prominent in many fields, including philanthropy, science, reform, medicine, business, religion, journalism, and the fine arts. For the latter she often cited Elizabeth Ellet in her vignettes of the sculptors Harriet Hosmer, Emma Stebbins, and Margaret Foley, and the painters Eliza Greatorex, Lily Martin Spencer, May Alcott, and Emily Sartain (but not Cassatt), along with many others.[21] Volumes such as these are invaluable since they validate and give substance to the ambitions and philosophy of the Woman's Building.

Efforts had been made at two previous expositions to include the contributions of women to American life and culture, first in Philadelphia at the time of the nation's centennial and later, in the mid-1880s, at the World's Industrial and Cotton Centennial Exposition held in New Orleans.[22] These precedents were acknowledged by Bertha Palmer, president of Chicago's Board of Lady Managers, in an address she gave to the Fortnightly Club in April 1891: "The valuable work done by these two organizations of women had prepared the public mind so thoroughly for the cooperation of women in exposition work, that when the matter was under discussion by the World's Fair Committee of Congress, Mr. Springer of Illinois inserted the clause authorizing the creation of the board of women, and championed it in the committee and before the House, where it met with no serious opposition."[23] Palmer's remarks put a good face on what were grave areas of conflict. Women had not been invited to join the official boards of either the National Commission or the Chicago Corporation, and many women felt that a separate Board of Lady Managers was belittling.

Women still remembered that they had not been invited to serve on the Philadelphia Centennial Board. It was only when their participation as fund raisers was needed that a separate Women's Centennial Committee was created. Elizabeth Duane Gillespie, great-granddaughter of Benjamin Franklin, agreed to serve as chairwoman only on the condition that a display of women's work was included in the Main Exhibition Hall. Even though the women raised nearly $100,000, their seemingly modest request was denied. They were informed by both the director general and the chairman of grounds, plans, and buildings that were was no room for their display and that if they wished to have one they could raise even more money and construct their own pavilion. Anger mobilized them and they succeeded in securing enough money to build the Woman's Pavilion, a 40,000-square-foot structure that housed a library, art hall, kindergarten annex, and the offices of a woman's newspa-

per, *New Century for Women*. It was also filled with nearly six hundred exhibits of laces and books, bric-a-brac and butter sculpture, the latter receiving the most notoriety.

At the time, Stanton was incensed at the Centennial Commission's high-handed treatment of women: "The Woman's Pavilion upon the centennial grounds was an afterthought, as theologians claim woman herself to have been. . . . But to have made the Woman's Pavilion grandly historic, upon its walls should . . . have been exhibited framed copies of all the laws bearing unjustly upon women."[24]

Women in Chicago were familiar with the difficulties their counterparts in Philadelphia had experienced and they began organizing early to ensure their own participation, ideally on equal footing with men. In 1889, just as the Chicago fair committee was being organized, two competing groups of Chicago women active in philanthropy, education, and reform work—the Women's Department, or Auxiliary, and the Isabellas—approached the executive committee of the World's Columbian Exposition for representation on the board itself.

There was a history in Chicago of women's voluntary involvement that began during the Civil War with the organization of the Great Northwestern Sanitary Fair.[25] Initiated to raise money for first aid and other supplies for the Union Army, these efforts were spearheaded by Mary Livermore, who would later become cofounder of the Home for Aged Women and the Hospital for Women and Children. In 1868 she organized the first Chicago suffrage convention, and she went on to become president of the Illinois Woman Suffrage Association. Colleagues of Livermore— Myra Bradwell and Emma Wallace—were the first to approach the fair committee for official recognition of a women's auxiliary. Members of the auxiliary supported suffrage, but the organization's first commitment was to the advancement of charitable and philanthropic work on behalf of women.[26] As the women in Philadelphia had done, the Chicago women worked with men to secure the fair for their city and helped them raise money. In exchange they too requested a Woman's Pavilion that would contain space for the "exhibition of women's industries" and for an auditorium where international conventions could be held.[27] Most of these women would later be appointed to the Board of Lady Managers.

They were not the only women in Chicago interested in securing representation at the fair. There was another, more militant group dedicated to suffrage and equal rights for women. They called themselves the Isabellas, after Queen Isabella, who "had enabled Columbus to make his voyage" and therefore should be consider as the co-discoverer of America.[28] In contrast to the Women's Auxiliary, the Isabellas were committed to having women compete equally with men throughout the fair and to ensuring that women's work be included in all the fair's displays. Although they too petitioned for a Woman's Pavilion, the Isabellas intended that it be used not as a separate exhibition space for women but as a venue for international conferences.[29] Another important difference between the two was that the Isabellas were a national body, not a local organization, and worked first to obtain female representation on the National Commission. This effort was led by Susan B. Anthony, who operated from the sidelines, while Isabella Beecher Hooker served as the public spokesperson for the NAWSA

in Chicago. Congress responded, almost after the fact, to these various appeals by approving the so-called Springer amendment, which called for the formation of a Board of Lady Managers. Not even the more conservative Women's Auxiliary was happy with this title for to some it implied that members would be "idle women of fashion."[30]

Once the authorizing legislation was in place, however, the Women's Auxiliary and the Isabellas began to compete for membership on the Board of Lady Managers. They had opposing goals. The Isabellas not only wanted women to be represented in exhibitions and events throughout the fair; they also sought to have the fair serve as an arena to advance woman suffrage. For their part, members of the auxiliary promoted their organizational competence and a commitment to a separate exhibition facility for women, as there had been in Philadelphia.

Having no precedent, the National Commission made the Board of Lady Managers a mirror of itself, with one hundred eight national representatives. This appeased the Isabellas temporarily but the commission then went on to appoint nine additional members from Chicago. Five of the nine belonged to the auxiliary, while only one, Dr. Frances Dickinson, belonged to the Isabellas. Bertha Honoré Palmer, while not a member of the Women's Auxiliary, was appointed one of the Chicago delegates. When the Board of Lady Managers first met in November 1890, Palmer, who had played little role in lobbying for women's participation in the exposition, was unanimously elected president as a compromise candidate. Clearly her sympathies lay with the auxiliary, yet she acknowledged the frictions between the two groups shortly after her election in an address to the Fortnightly Club:

> This was a burning question, for upon this subject every one had strong opinions, and there was a great feeling on both sides, those who favored a separate exhibit believing that the extent and variety of the valuable work done by women would not be appreciated or comprehended unless shown in a building separate from the work of men. On the other hand, the most advanced and radical thinkers felt that the exhibit should not be one of *sex*, but of *merit*, and that women had reached a point where they could afford to compete side by side with men with a fair chance of success, and that they would not *value* prizes given upon the sentimental basis of sex.[31]

This did not prevent Palmer from defining her personal goals regarding women's participation in the fair. While she was not a suffragist, she did believe in women's rights to equal pay and believed that the fair offered an ideal opportunity to bring to the public's attention the status of women's employment outside the home. As she explained to the members of the Fortnightly Club: "The desire of the Board of Lady Managers is to present a complete picture of the condition of women in every country of the world at this moment, and more particularly of those women who are bread-winners."[32]

BERTHA HONORÉ PALMER

The ultimate success of the Woman's Building was due principally to the unflagging efforts of Mrs. Potter Palmer. Bertha Honoré was born in Louisville, Kentucky, in

1849, but her father, Henry Honoré, moved his family to Chicago in the 1850s, where he invested in real estate. Her southern connections were a factor in her being elected president of the Board of Lady Managers and in her success in gaining women's national participation.

During her childhood her parents were members of Chicago's elite, and their social circle included Cyrus McCormick, George Pullman, Marshall Field, George Armour, and Potter Palmer. Palmer had made his fortune as a dry goods merchant during the Civil War. He was thirty-six and Bertha was thirteen when they first met in 1862. They were married eight years later, when she had reached the respectable age of twenty-one. Construction on her husband's hotel, the Palmer House, was all but finished when it, along with a large part of downtown Chicago, was destroyed by fire in October 1871. The city's recovery from the fire became a milestone in its history. Although Palmer had lost most of his fortune, he borrowed enough money to rebuild the hotel, into which he and Bertha moved in 1874, the year before it officially opened.[33]

As Chicago business people worked industriously to rebuild the city after the fire, so too did women take a public role on behalf of women's education and social reform. The two most prestigious women's clubs were the Fortnightly Club, which promoted women's literary efforts, and the more reform-minded Chicago Woman's Club, one of the principal backers of Jane Addams's Hull-House, which opened in 1889. Another important and influential women's organization, the Woman's Christian Temperance Union (WCTU) was founded in 1874 in nearby Evanston. With local chapters in towns and villages throughout the United States and the United Kingdom, its membership eventually far exceeded that of the combined organizations that promoted woman suffrage. Its influence was such that the Eighteenth Amendment, the prohibition amendment, was passed in 1919, a year before suffrage was granted to women by the Nineteenth Amendment. Frances Willard, who had been dean of the women's division at Northwestern University and who became president of the WCTU, saw the fair as a golden opportunity to promote the organization's cause, which extended far beyond the prohibition of alcohol. The WCTU's larger calling was the home life of women and to this end the group supported "kindergartens, schools, medical dispensaries, low-cost restaurants, and homes for the homeless. They supported prison reform, sex education in the schools, minimum wage laws, and—finally—woman suffrage."[34]

Palmer supported the work of the WCTU, so it is not surprising that many of its aims and programs were reflected in the philosophy of the Woman's Building.[35] Furthermore, Palmer, as a member of these organizations, gained excellent administrative experience. Not just an elegant socialite (figure 20), she was a tactful and firm administrator and unstinting in her efforts to secure help on behalf of the Woman's Building. She never backed away from dealing with the thousands of problems that cropped up among the women themselves and with the various other boards involved in running the fair: the central Board in Chicago, the state boards, the male-only corporation that ran the fair, and the United States Congress. Her addresses and

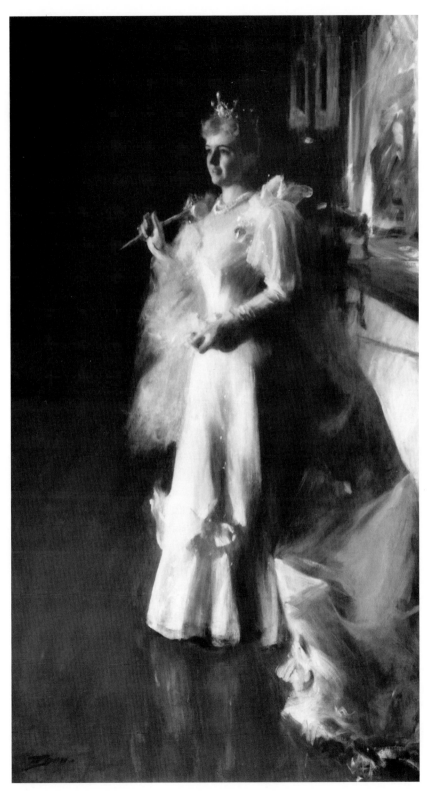

Figure 20. Anders Zorn, *Mrs. Potter Palmer,* 1893. Oil on canvas, 105 × 55 in. Art Institute of Chicago, Mr. and Mrs. Potter Palmer Collection, 1922.450. All Rights Reserved.

reports, which were later published, reveal her as a literate, passionate woman who had a clear sense of herself and her mission. Well aware of the fight that other women were engaged in to secure the vote, she was more concerned with women's economic status and their rights to free employment. In response to concerns that women's work should be shown on a equal footing with men's, she suggested that exhibitors tell in their displays just what percentage of the labor in a particular field—for example, in agriculture—was performed by women. While her suggestion was accepted, its implementation proved impractical. In her address to the Fortnightly Club, Palmer spoke of the problem of documenting women's work at both the Centennial and the New Orleans fairs. She noted: "From the farm, dairy products went into the general exhibit, presumably men's work. The interesting and unusually attractive showing of the bee and silk-worm industries, although made entirely by women, went also into the general classification; and so with the thousand and one articles made in the factories of the world by men and women working conjointly; for women's distinctive part could not be separated without destroying the finished article."[36]

Yet by raising the issue of women's general employment, many involved in the fair at all levels were made aware that women were much more involved in the work force than anyone had imagined.[37] In fact, Palmer ordered the first international assemblage of statistics on women's work. In the French Record Room, for instance, data were displayed that detailed the occupations of French women. According to these statistics, 49 percent of the French innkeepers and apartment managers were women, 30 percent of the shop owners and retail workers were women, and women occupied 20 percent of the agricultural force.[38]

Palmer began her tenure with characteristic energy. During the first four months of her presidency she made several trips to Washington and sent out 1,334 letters, all of which were copied in her letter books, now in the archives of the Board of Lady Managers at the Chicago Historical Society. She also asked women representatives from all the states to scour the countryside for women's work. For instance, the Iowa Board of Lady Managers solicited things such as "fine specimens of every industry carried on by women in the state," including books written and illustrated by women, scientific collections, inventions, colonial relics, statistics on employment, education and charitable work, and women's history.[39]

Over the course of her presidency she also made several trips to Europe, first to England, then to France and Austria, to solicit women's work from these countries. She first approached Helena, Princess Christian, the third daughter of Queen Victoria. As Palmer reported to the Board of Lady Managers, the princess "was most conservative in her views regarding higher education of women and their entrance into the professions, deprecating every influence that would draw them from their homes."[40] But the princess was also head of the Royal School of Art Needlework, organized for the benefit of distressed gentlewomen, and she understood that participation in the Woman's Building would offer an opportunity to exhibit the work done by her favorite charity; she agreed to lend her name to the cause. Other noblewomen responded in turn, including Lady Ishbel Aberdeen, head of the Irish Indus-

trial Association, which sent Irish lace and homespun to the fair, and Baroness Burdett-Coutts, who sent work done by students in technical training schools.

In Austria, she met with Princess Metternich, Princess Windisgratz, and Empress Marie Therese, all of whom supported the Austrian Women's Commission, which contributed peasant crafts by women.

In France, Theodore Stanton introduced Mrs. Palmer to Emiley de Morsier, head of the First International Congresses on Women's Rights and Feminine Institutions for the 1889 Paris Exposition. Historians today regard the 1889 Paris Exposition as the moment the French feminist movement came of age.[41] De Morsier, who in 1891 was the president of the Work for Women Liberated from the Prison of St. Lazare, organized a conference attended by French and Americans to discuss French women's participation at the World's Columbian Exposition. As noted by Palmer in her later report to the board, some of the same issues that challenged the members of the Board of Lady Managers had also confronted their French colleagues: "Many difficult questions were asked, which had already come up in connection with our work at home. . . . The difficulties seemed so great that at the first conference, the women were decidedly of the opinion that they would better confine themselves to a showing of the benevolent and charitable work, instead of undertaking anything more complicated, and leave the industrial exhibit to manufacturers, artists, and those interested."[42]

In other words, what kind and type of work should be shown was a vexing issue. For displays of industrial or agricultural products it was impossible to determine what aspects were done by women. Often the fine artist, such as Harriet Hosmer, did not want at first to exhibit exclusively with women. By default, the crafts of all nations became the dominant type of object depicted in the Woman's Building.

In addition to her efforts to secure national and international participation in the Woman's Building, Bertha Palmer also worked to secure a site and building to house exhibits and to serve as the official headquarters for the Board of Lady Managers.[43] Her plans did not include the auditorium that the Isabellas had recommended as a place in which congresses on women's issues could be held. The organization of these congresses, or conventions, was administered by the all-male World's Congress Auxiliary. Paralleling the second-class status of the Board of Lady Managers, there was a "separate but equal" Woman's Branch charged with organizing the Congress of Representative Women. Again disputes arose between those who supported suffrage and the more conservative club women. Palmer, who had also been appointed president of the Woman's Branch, intervened and urged that congresses be as truly representative as possible, accommodating the needs of both the recently forged National Council of Women (suffrage) and the equally new General Federation of Women's Clubs. It was Palmer's intention that the congress sessions sponsored by the Woman's Branch be held in Chicago proper at the Crystal Palace, or Art Palace, on Michigan Avenue, along with those sponsored by the World's Congress Auxiliary.[44] She also argued that the exhibitions in the Woman's Building and the congresses complement each other so that "a more comprehensive and complete portrayal of women's achievements in all departments of civilized life" be made manifest.[45] Over

the course of the fair, only the Parliament of Religion drew larger crowds than the Congress of Representative Women.

To secure the construction of the Woman's Building, Palmer began by making an application to the Grounds and Buildings Committee and drew a pencil sketch of a plan showing the interior arrangement of a building 200 by 500 feet.[46] This she presented to Daniel Burnham, the chief of construction, and after two meetings he ceded a site and appropriated $200,000 for construction.[47] Burnham and the Grounds and Buildings Committee agreed that the Lady Managers could sponsor an architectural competition and award "three prizes, for the three best designs."[48] While it was first thought that either a man or a woman would be eligible to submit a design, the Board of Lady Managers was persuaded that there were enough competent American women in the field of architecture to restrict the competition to women. The board published a brochure that included design requirements and stated a very short, six-week submission deadline. Thirteen women applied, and in March 1892, Sophia Hayden, one of the few professionally trained woman architects in the country, won first prize for her Renaissance-inspired design, whose overall plan followed Palmer's sketch most precisely.

Bertha Palmer detailed the purpose of the Woman's Building in an address to the Fortnightly Club. Among the issues she planned to document at the fair were women's wages and working conditions; women's access to education; women's achievements in literature, the arts, medicine, and architecture; and a compilation of statistics on child labor. When finally built, the Woman's Building provided space for women's exhibits of fine and applied arts; it served as a locus for special exhibits; and it became a repository for statistics on women's employment.

The building was not on the prestigious Court of Honor but along the western side of the Lagoon, north of Louis Sullivan's now famous Transportation Building. Walking south from the Woman's Building one would encounter the Children's Building, the Puck Building, the White Star building (the latter two by McKim, Mead, and White), and William Le Baron Jenney's Horticultural Hall, next door to Sullivan's Transportation Building.

The plan of Hayden's building was symmetrical, with an interior Hall of Honor, or rotunda (as it is referred to in the plans), bordered on east and west by rooms for displays (figure 21). For the building's exterior the Board of Lady Managers, through an open competition, commissioned Enid Yandell from Bertha Palmer's hometown of Louisville, Kentucky, to create a series of caryatids for the open roof garden. The nineteen-year-old Alice Rideout of San Francisco was hired to carve a series of free-standing cornice figures.[49]

One entered the building through the north wing into a large vestibule where an array of international decorative arts, including pottery, stained glass, and textiles, was displayed. Here and in the southern vestibule were cases containing handicrafts from Spain, India, Siam (figure 22), Germany, Austria, Belgium, Sweden, Mexico, Italy, and France. One then crossed a narrow corridor and entered the Hall of Honor, which rose over two stories. It measured 70 feet high, 67½ feet wide, and 200 feet

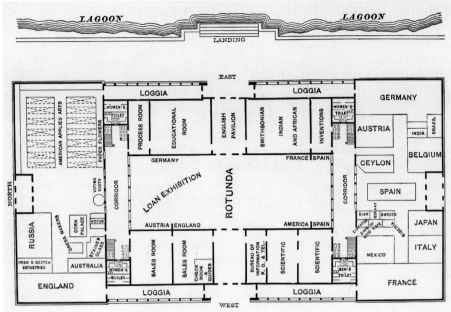

GROUND PLAN WOMAN'S BUILDING.

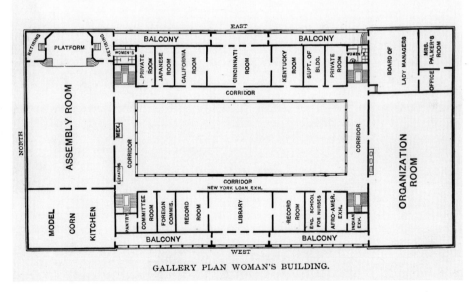

GALLERY PLAN WOMAN'S BUILDING.

Figure 21. Sophia Hayden, plans for ground floor and gallery of the Woman's Building, World's Columbian Exposition, Chicago, 1893. From Elliott, *Art and Handicraft in the Woman's Building,* frontispiece.

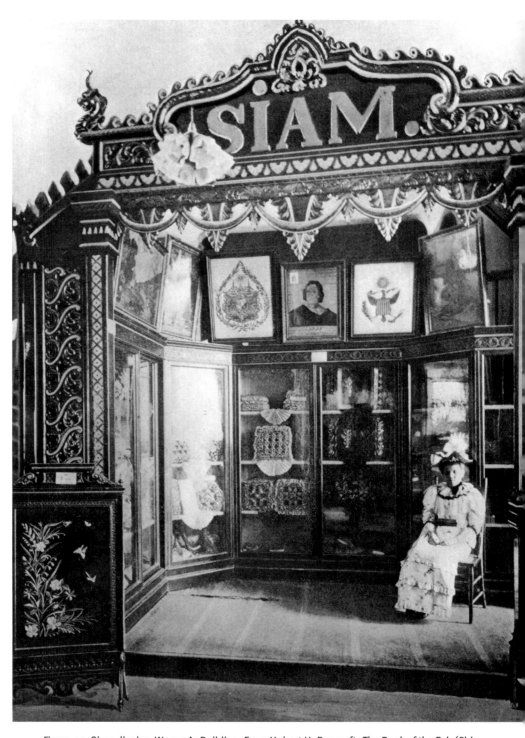

Figure 22. Siam display, Woman's Building. From Hubert H. Bancroft, *The Book of the Fair* (Chicago, 1893), 296.

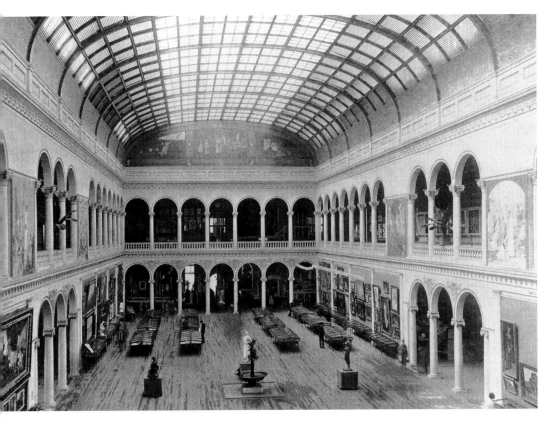

Figure 23. Sophia Hayden, Hall of Honor, Woman's Building, with Mary Cassatt's *Modern Woman* on the south tympanum. From Hubert H. Bancroft, *The Book of the Fair* (Chicago, 1893), 269. Photo courtesy of General Research Division, New York Public Library, Astor, Lenox, and Tilden Foundations.

long and was illuminated by a large skylight (figure 23). It was here that the most select of women's artistic work was installed. Above the second-floor gallery on the north entrance to the hall was the mural *Primitive Woman*, by Mary MacMonnies, which faced Cassatt's *Modern Woman* on the south wall. In addition to the murals by MacMonnies and Cassatt, the Hall of Honor was filled with easel paintings, four other smaller murals, statuary, and handicrafts, including laces lent by the queen of Italy.

Flanking the Hall of Honor on the east and west were first-floor rooms containing science exhibits and ethnographic displays that reflected the organizers' dedication to creating a comprehensive history of women's contribution to the human race, from prehistoric times to the present. As early as 1891, the Board of Lady Managers had included this statement in its "Preliminary Prospectus": "It will be shown that women, among all the primitive peoples, were the originators of most of the industrial arts, and that it was not until these became lucrative that they were appropriated by men, and women pushed aside."[50] Pottery and other handicrafts by indigenous women were also included in exhibits organized by other nations. Several of

these were located beyond Cassatt's mural, in the southern wing. In all, forty-one countries were represented throughout the building.

Upstairs, an arcaded gallery screened a number of rooms around the perimeter of the Hall of Honor, the most important room of which was the Assembly Room. It was located above the north entrance and decorated with stained-glass windows done by women artists of Massachusetts and Pennsylvania. The area above the north entrance also contained a separate room that was a corn kitchen, sponsored by the women's board of Illinois. It served both as a model kitchen and as a way to promote corn as a food for humans. Palmer had made a conscientious effort to include in the Woman's Building representative work—including textiles, books, engravings, and music—done by African American women, and there was a small display room on the second floor designated for display of their handicrafts. In addition, statistics on African American women were collected by Imogen Howard, an African American schoolteacher from New York City, and were bound in book form and displayed in the building's library, which was also on the second floor. [51]

Most of the work by professional women artists was placed in the Hall of Honor on the ground floor. An elaborate fountain by Anne Whitney, who earlier had been opposed to exhibiting separately from men, stood in the center of the hall. It was surrounded by four portrait busts—of Susan B. Anthony, Elizabeth Cady Stanton, Lucretia Mott, and Dr. Caroline Winslow—carved by Adelaide Johnson, and by three sculptures by Vinnie Ream Hoxie, including her allegorical figure *The West* (figure 24). By most accounts, the Woman's Building was among the most popular at the fair.

The building's success could not be attributed entirely to the architect. The story is complicated. Hayden had little experience with building construction and a great deal of work needed to be done in a hurry. Hayden also suffered from depression and was hospitalized during the summer of 1892. In her 1894 report she noted that she had had "an especially aggravating experience with the Lady Managers. . . . the Lady President had been of all others especially trying."[52] It is clear from Hayden's report that she was aware that classical design, as promoted by the Ecole des Beaux-Arts, called for the integration of decorative elements into the building's initial plans. Hayden did not like most of the work contributed by various craftswomen and "felt, as a result of her 'careful training in Classical design,' that it should all have been integrated into the Building when it was first planned and not stuck in here and there to get rid of it."[53] Hayden distanced herself from the project, making few trips to Chicago to supervise the construction, and was not on hand to oversee the building's interior decoration.

Most of the other exposition buildings had elaborate facades that enclosed large open spaces with exposed girders, not unlike decorated train sheds. In contrast, the Woman's Building was ornamented within and without; Palmer herself hired and supervised this additional work. In her enthusiasm she had asked the Board of Lady Managers that women in their home states donate "marble columns, carved balustrades and porcelain tiles."[54] The board was then overwhelmed with contributions, and it was feared that the building's interior would take on the appearance of a patch-

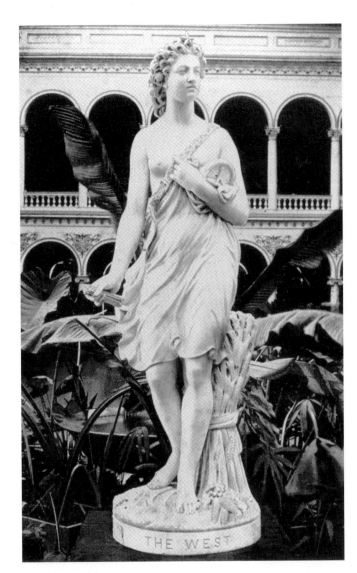

Figure 24. Vinnie Ream
Hoxie, *The West,* Hall of
Honor, Woman's Build-
ing, World's Columbian
Exposition, Chicago,
1893. From Hubert H.
Bancroft, *The Book of
the Fair* (Chicago, 1893),
260. Photo courtesy of
General Research Divi-
sion, New York Public
Library, Astor, Lenox,
and Tilden Foundations.

work quilt. To Hayden's credit she objected to these decorative fragments' being incorporated into her design. As she stated in her architect's report: "I also wished at this time to undertake the interior decoration but as it was determined to have the decorations a part of the exhibit, I gave the idea up as it was practically impossible to separate the two."[55]

Given Hayden's inability to be more forceful, let alone present, Palmer still needed advice on the coordination of the decorative elements of the interior—the color of the walls and trim, the addition of the murals, and the selection and placement of other decorative elements solicited from craftswomen. She turned for help to Candace Wheeler.[56] Wheeler was an appropriate choice, having founded in 1877 the Society of Decorative Art, an organization based on London's Kensington School, for the

training of "economically deprived gentlewomen" in the decorative arts. Wheeler employed such prominent artists as Louis Comfort Tiffany, Lockwood de Forest, Samuel Colman, and John La Farge to teach classes in design. Two years later she, Tiffany, Forest, and Colman formed a decorating firm, Associated Artists, a partnership that lasted four years. When it was dissolved, Candace Wheeler kept the name Associated Artists and created her own decorating firm, whose primary focus was the design of textiles and wallpapers.[57] By the 1890s, she was the leading woman decorator in America and had already been invited by the separate New York Board of Lady Managers to assemble and exhibit "women's work" and to oversee the decoration of the Woman's Building library. In the summer of 1892, after Palmer had hired Cassatt and MacMonnies to create murals for the building, she asked Wheeler to serve as color decorator, or coordinator, for the whole building.

While Wheeler was able to offer advice on the interior color scheme, she was not available to organize the display of various arts and crafts sent by the states and foreign governments. This task fell to Amey Starkweather from Rhode Island. In desperation six weeks before the fair opened, Palmer had appointed Starkweather as chief of installation.[58]

The final decorative effect of the Hall of Honor was described by Virginia C. Meredith, vice president of the Board of Lady Managers: "The Hall is in ivory white with ornamental plaster work picked out in gold. A decorative band in Italian design upon a gold background connects the two great pictures in either end of the Hall; under this band runs a series of panels, each bearing in gold letters the names of some women distinguished in history beginning on one side with the heroines of Bible history and on the other with queens famous for a career beneficial to mankind."[59]

As for the addition of the murals, Palmer was influenced and inspired by the decorations commissioned for the other fair buildings, principally those surrounding the Court of Honor.[60] In a report to the Board of Lady Managers in September 1891, Palmer first mentioned plans to include mural paintings in the building: "There are two beautiful surfaces for mural paintings at the ends of our main Hall. These we hope to have decorated by women who have had sufficient experience to warrant their being intrusted with so important a commission."[61] In February of the following year, Palmer wrote a letter to one of the fair's agents, Sara Hallowell, who was organizing the loan exhibition of nineteenth-century European art from private American collections for the Palace of Fine Arts, asking for her help in finding women of sufficient stature and training for such an undertaking. Over the next six months Palmer and Hallowell corresponded at length regarding possible candidates. Following Palmer's trip to France that spring she finally settled on Mary MacMonnies and Mary Cassatt as the most capable.

The Commission

When Mary Cassatt received the commission to paint the mural *Modern Woman* (figure 25) she was at the height of her career. Although French impressionism had been introduced in the United States in 1886 principally through an exhibition at

Figure 25. Mary Cassatt, *Modern Woman*, in situ, south tympanum. From Hubert H. Bancroft, *The Book of the Fair* (Chicago, 1893), 263. Photo courtesy of General Research Division, New York Public Library, Astor, Lenox, and Tilden Foundations.

the National Academy of Design organized by Durand-Ruel, Cassatt's work was little known in America.[62] She had come to Palmer's attention through the efforts of Sara Hallowell in Hallowell's capacity as assistant to Halsey C. Ives, the chief of the Department of Fine Arts for the exposition.[63]

Hallowell was originally from Philadelphia but at age twenty moved to Chicago with her mother. There she established a reputation as an energetic and discriminating organizer of contemporary art exhibitions, beginning in 1878 with an exhibition for the Inter-State Industrial Exposition of Chicago. The interstate expositions were important models for the World's Columbian Exposition's fine arts section and also introduced the latest in American and European painting to a Chicago audience.[64] Over the years Hallowell included works by the American artists James McNeill Whistler, John Singer Sargent, William Merritt Chase, and Eastman Johnson, along with paintings by the Barbizon artists and their American followers. Like Cassatt, these Americans had been trained in Europe and were indebted to the lessons they learned at the leading capitals of modern European art—Paris and Munich. At the last interstate exposition, held in 1890, Hallowell, with the cooperation of the Durand-Ruel Gallery, presented the work of Monet, Pissarro, and Degas, effectively introducing French impressionism to Chicago.[65] Fittingly, these expositions were held in a "Crystal Palace" on the site of what came to be the Art Institute of Chicago in 1893. Guided by Hallowell's advice, members of the interstate exposition's art committee became influential collectors, supporters of impressionism, and promoters of the Art Institute.[66]

For the World's Columbian Exposition, Hallowell's primary responsibility was the securing of loans of nineteenth-century European art from private American collections for the Palace of Fine Arts.[67] She did most of this work from Paris where Palmer contacted her regarding candidates for the two large murals for the Hall of Honor in the Woman's Building. Writing in February 1892, Palmer mentioned that

she had consulted with the Chicago-born artist Walter McEwen, whose carefully articulated paintings of Dutch peasants had won wide acclaim in the 1889 Paris Exposition. Although considered an expatriate because he lived most of the time in Holland, McEwen made frequent trips to Chicago to vote, and he was one of ten artists hired to create painted decorations for the entrance pavilions of George B. Post's Manufactures and Liberal Arts Building. Here McEwen did two tympana for the south corner entrances, *The Arts of Peace* and *Music*. Palmer also consulted another Chicago-born artist, Gari Melchers, who, like McEwen, was hired to create murals for the Manufactures and Liberal Arts Building.[68] She sought additional advice from the Swedish artist Anders Zorn at the time he painted her portrait commissioned by the Board of Lady Managers (see figure 20).

Mural painting was a new endeavor for American painters, and the World's Columbian Exposition is generally credited with inaugurating the mural renaissance in the United States.[69] Many of the painters who worked in Chicago would later join the National Society of Mural Painters, organized in 1895, and would participate together in the decoration of the Library of Congress in 1898.[70] Over the next twenty years a large number of artists were drawn to this new endeavor and created murals for state houses, courthouses, universities, and libraries throughout the country.[71]

In her February 1892 letter to Hallowell, Palmer mentioned that the two artists chosen for the large Hall of Honor murals would each be paid three thousand dollars, and she estimated that each mural should be twelve by fifty-eight feet. She then went on to articulate her concept, which to a large degree was carried out by both painters. These ideas reflected the philosophy of the Woman's Building itself. Palmer wrote, "Of course we should want something symbolic showing the advancement of women. My idea was that perhaps we might show woman in her primitive condition as a bearer of burdens and doing drudgery, either as an Indian scene or a classic one in the manner of Puvis [de Chavannes], and as a contrast, woman in the position she occupies today."[72]

Palmer also expressed uncertainty as to whether one artist should be employed to do both murals. In any case she urged Hallowell to contact their first choice, Elizabeth Gardner, the student, and later, wife, of the popular French academic painter Adolphe William Bouguereau. Palmer believed this association gave Gardner an edge since she would have "the advantage of a very expert master."[73] Other artists were mentioned as well: a Miss Robbins, a student of Carolus-Duran, who Palmer thought would not be appropriate because she had heard that "her character was not above reproach"; Madame Demont-Breton, a French painter who might be invited to participate if no American women was "willing to undertake the work"; and Mary Fairchild MacMonnies, who was "faintly suggested" by McEwen.[74]

A month later, in March, Palmer wrote to Mrs. William Reed, a member of the Board of Lady Managers from Baltimore, that the two leading contenders in her mind were Gardner and MacMonnies. She included the names of two younger artists, Rosina Emmet and Dora Wheeler: "I have thought of Rosina Emmet and Dora Wheeler, but they have not had the drill that is necessary for this work."[75] What

Palmer meant by this is unclear since Emmet and Wheeler were students of William Merritt Chase. Perhaps she did not think them schooled enough in the demands of large-scale mural painting. It may have been the influence of Candace Wheeler that secured for Dora Wheeler Keith, her daughter, a commission from the New York State Women's Committee in March 1893 to create a ceiling decoration for the Woman's Building library, on the second floor. There was no mention of Cassatt at this point.

Hallowell, who was in Paris, began by contacting Gardner, who quickly refused for, as Hallowell wrote, Gardner thought that she "should not be equal to the physical fatigue necessary in painting on a high ladder."[76] Further contacts were delayed until Palmer herself arrived in Paris in May.

The first artist Palmer and Hallowell met was Mary MacMonnies, who had painted Hallowell's portrait, which she exhibited in the Salon of 1889 (figure 26).[77] Just as there were interconnections among the Chicagoans, both male and female, who organized the fair, so too were there contacts among the artists and the fair's advisers. MacMonnies had not only painted Hallowell's portrait, but she was also the protégée of Hallowell's boss, Halsey Ives.

MacMonnies was born Mary Fairchild in New Haven in 1858. She studied first in the early 1880s at the newly opened School of the Fine Arts in Saint Louis, whose director was Ives. So impressed was he by her talent that he helped secure for MacMonnies a three-year scholarship (1885–88) to study in Paris at the Academie Julian. Here she studied with Carolus-Duran, the teacher of Sargent. In her third year in Paris she met and married the sculptor Frederick MacMonnies, who was then studying with the French academic sculptor Falguière at the Ecole des Beaux-Arts.[78]

By the 1890s both husband and wife were well launched upon their careers. Frederick's work was promoted in the United States by Augustus Saint-Gaudens and the architects Charles McKim and Stanford White, while Mary continued her success at the Paris Salon. She also became acquainted with France's leading muralist, Puvis de Chavannes, whose work greatly influenced her design for her mural *Primitive Woman*. She also copied the "recently discovered Botticelli frescoes from the Florentine villa of Dr. Lemmi," which were on view at the Louvre.[79] Since her copies had been admired by Falguière, Carolus-Duran, and the director of the Louvre, Hallowell thought it important that Bertha Palmer see them. So impressed was Palmer with these copies and her other work that she offered MacMonnies both spaces. It was later, after Palmer met Cassatt, that she asked MacMonnies to paint only one and the artist chose to paint the theme "primitive woman."

Hallowell suggested Cassatt as another possible muralist for the Woman's Building, but the reason is unknown. They may have had friends in common in Philadelphia but it is more likely that Hallowell, who followed contemporary art in the United States and Paris, was well aware of Cassatt's reputation. Although not well known to the American public, Cassatt was respected by fellow artists in the United States. As noted earlier she had been invited in 1878 by J. Alden Weir to become a member, along with Whistler, Sargent, Eakins, and others, of the Society of American Artists.[80] More

Figure 26. Mary MacMonnies, *Portrait of Sara Hallowell,* 1886. Oil on canvas, 44 × 38 ¼ in. Photo courtesy the Warden and Fellows, Robinson College, University of Cambridge, England.

to the point, the society supported those American artists who were influenced by modern European art and its break from strict allegiance to academic painting.

Cassatt and Bertha Palmer had already met when the Palmers were in Paris in 1889. It was then, evidently, that Cassatt suggested they buy Degas's *On the Stage.*[81] The date of Cassatt's meeting with Hallowell and Palmer has not been recorded but it was probably in late May 1892, for Palmer left France in mid-June and by early summer Cassatt was writing her friend Louisine Havemeyer about the commission:

> I am going to do a decoration for the Chicago Exhibition. When the Committee offered it to me to do, at first I was horrified, but gradually I began to think it would be great fun to do something I had never done before and as the bare idea of such a thing put Degas in a rage and he did not spare every criticism he could think of, I got my

spirit up and said I would not give up the idea for anything. Now, one has only to mention Chicago to set him off, Bartholemy, his best friend is on the Jury for sculpture and took the nomination just to tease him.[82]

Like many of the details relating to the fair, the choice of muralists for the Woman's Building, as well as the glamorous Bertha Palmer's comings and goings, was discussed in the American press. The highly regarded New York critic Mariana Griswold Van Rensselaer reported on Palmer's trip and the commission in late July in the *New York World*. According to Van Rensselaer "all the world" knew that Palmer's trip to Paris was "for the purpose of getting women artists to adorn the Woman's Building." She further noted that Palmer was "fortunate" in being able to secure two Americans, although she cautioned: "What either of them may be able to do in the way of monumental decoration, Chicago and the nations of the world must wait to discover." Van Rensselaer then perceptively evaluated Cassatt's reputation at the time:

> Miss Cassatt is not a painter whom the average American tourist is likely to hear much about in Paris or whose works are likely to delight him much if he happens to stumble upon them. But every Parisian must know about her, and every person who has a real sympathy with really modern art must adore her work. She is a beloved artist of the Impressionists, a clever and individual painter in oils, a still more remarkable painter in pastels and a singularly artistic etcher, with a well marked mood and style of her own. She is distinctively an artist's artist, and this is about the best praise that could be given her.[83]

She had little to say about MacMonnies except to note that she was "the wife of the young sculptor whose big fountain will form the chief decorative feature of the Fair."[84]

After Palmer returned she had Frank Millet, who advised Burnham on matters pertaining to mural painting for the fair, send both women their contracts. When the contracts finally arrived in late July 1892, Cassatt and MacMonnies found the terms unacceptable. Cassatt's indignation was such that she immediately wired Palmer threatening to resign: "Contract received. Conditions impossible. If maintained I must resign."[85] She also wrote Hallowell a blistering letter explaining in detail her objections. Cassatt had second thoughts and went to see Hallowell in person to explain her disagreements. Meanwhile, Palmer had cabled Hallowell for help. Hallowell promptly cabled back spelling out Cassatt's objections: "October completion. Submitting sketch. Terms of payment. Expenses of delivery."[86] As noted by Weimann, MacMonnies had similar objections and also "refused to sign because of the October deadline (it was already July), because she was not to be paid anything until her work was finished, and she was to bear all charges for freight and installation of the mural."[87] Two of the objections were answered. February 15, instead of October, became the completion date, and Cassatt would not be required to submit a sketch; Hallowell was charged with the responsibility of approving her work. The fee of three thousand dollars (which was the same as the fee for the highest paid male painters) remained the same and the expenses of delivery and installation continued to be the responsibility of the artists.[88] The women's quick acceptance of their revised contracts attests to their seeing this professional opportunity as a great plum.

Cassatt's enthusiasm for the project was strong, and she began work even before receiving her contract from Chicago. She wrote Pissarro on June 17: "We (my mother & I) are settled at Bachivillers for some months to come. I have begun a great decoration for one of the buildings in Chicago."[89] Although inexperienced as a mural painter, she set about her task with authority and confidence. She built an addition to her studio, "an immense glass-roofed building at her summer home, where, rather than work on a ladder, she arranged to have the canvas lowered into an excavation in the ground when she wished to work on the upper part of its surface."[90] She continued to express her enthusiasm to Bertha Palmer: "I have enjoyed these new experiences in art immensely and am infinitely obliged to you for the opportunity you have given me."[91] By October she had completed enough of her design so that she could send a description of it to Palmer to share with the Board of Lady Managers, and in December she wrote to Palmer: "I have one of the sides well under way & hope to have the whole finished in time for you to have it up & out of the way by the end of February." As it turned out, Cassatt was overly optimistic. Her mural did not arrive in Chicago until early April. Her work may have been delayed by the pressure and isolation she felt. In her December letter she wrote:

> The fact is I am beginning to feel the strain a little & am apt to get a little blue & despondent. Your cable came just at the right moment to act as a stimulant. I have been shut up here so long [at Bachivillers] with one idea, that I am no longer capable of judging what I have done. I have been half a dozen times on the point of asking Degas and come and see my work, but if he happens to be in the mood he would demolish me so completely that I could never pick myself up in time to finish for the exposition. Still he is the only man I know whose judgment would be a help to me.[92]

When her mural was completed, she sent it rolled up to be later installed on stretchers and hoisted up for placement at the southern end of the Hall of Honor. Cassatt loathed sea travel and did not attend the World's Columbian Exposition, so it fell to Mary MacMonnies to travel to the United States and supervise the installation of Cassatt's mural.[93] MacMonnies wrote to Palmer in January regarding the method of applying the canvases to the wall. As Weimann noted: "[MacMonnies] had used a 'fine and strong quality' of canvas so that if it were fastened to the wall by white lead or rye paste, it could easily be removed after the Fair. If it were to be mounted on wooden stretchers she needed to know immediately so that she could have them made to measure in Paris. . . . [MacMonnies wrote,] 'I shall send the packages containing the decoration, third-size sketch, and all studies, in bond to Mr. Millet, and unless delays occur everything will leave Paris between the 10th and 15th of February.'"[94]

MacMonnies had her hands full when she arrived in Chicago. She was charged not only with overseeing the installation of her own mural and Cassatt's, but with the assembling of her husband's grandiose fountain, *Columbia*, for the Grand Basin.

As one art historian has described it, "On her arrival in Chicago, neither the crated murals nor most of the 27 huge fountain pieces could be found. . . . She worked for a month supervising the construction of stretchers for the murals and finally managed to locate and release the murals and fountain parts, first from the New York Customs House, and then from freight quarantine outside Chicago. By April 15 both murals had been raised into place."[95]

It is fortunate that the Chicago-based art critic Lucy Monroe was at the Woman's Building the day the Cassatt mural was installed, because she was able to see it before it was placed sixty feet above the hall floor. Monroe's is one of very few written descriptions of the mural's color, which makes it invaluable since only one color print of a portion of the central panel exists. That there is no color reproduction of the full mural is made doubly tragic given the mural's evident beauty.[96]

Although lost today, Cassatt's mural represents the aspirations and fulfillment of youth. In the central panel, *Young Women Plucking the Fruits of Knowledge or Science*, the harvesting of the fruits of knowledge and science is enjoyed by young women who had been shown as girls in the left-hand panel, *Young Girls Pursuing Fame*, and who are ambitious enough to pursue their dreams; in the right-hand panel, *Art, Music, Dancing*, these dreams are symbolized by women's active participation in humanity's most exalted precinct—that of the arts. Ultimately, the program of *Modern Woman* is best understood when these three panels are also seen as representing the cycle of a woman's life—childhood, youth, and maturity—and as a reflection of Cassatt's own accomplishments after thirty years as a painter. For the United States and the World's Columbian Exposition, the painting also represented women's new status and achievements, which Bertha Palmer forcefully articulated in her addresses and that were evidenced throughout the Woman's Building and in women's history of the preceding fifty years.

Notes

1. For a detailed discussion of the fair, see Jeffrey A. Auerbach, *The Great Exposition of 1851: A Nation on Display* (New Haven: Yale University Press, 1999).

2. Paul Greenhalgh, *Ephemeral Vistas: The Expositions Universelles, Great Exhibitions, and World's Fairs, 1851–1939* (Manchester, Eng.: University Press, 1988), 15.

3. See Carol Troyen, "Innocents Abroad: American Painters at the 1867 Exposition Universelle, Paris," *American Art Journal* 16 (Autumn 1984): 2–29; Annette Blaugrund, *Paris 1889: American Artists at the Universal Exposition* (Philadelphia: Pennsylvania Academy of the Fine Arts, 1989).

4. See the negative assessments in Louis H. Sullivan, *The Autobiography of an Idea* (Washington, D.C.: American Institute of Architects, 1924; reprint, New York: Dover, 1956); Lewis Mumford, *The Brown Decades: A Study of the Arts in America, 1865–1895* (New York: Harcourt, Brace, 1931; reprint, New York: Dover, 1971); and Robert W. Rydell, *All the World's a Fair: Visions of Empire at American International Expositions, 1876–1916* (Chicago: University of Chicago Press, 1984). Similar assessments color more recent publications; see Neil Harris et al., *Grand Illusions: Chicago's World's Fair of 1893* (Chicago: Chicago Historical Society, 1993); and Sund, "Columbus and Columbia in Chicago."

5. Helen Lefkowitz Horowitz, "The Art Institute of Chicago: The First Forty Years," *Chi-

cago History 7 (Spring 1979): 5; and idem, *Culture and the City: Cultural Philanthropy in Chicago from the 1880s to 1917* (Lexington: University Press of Kentucky, 1976).

6. Wilson, *The City Beautiful Movement*, 53.

7. From the *Chicago Tribune*, quoted in Weimann, *Fair Women*, 32.

8. Badger, *Great American Fair*, 52.

9. Ibid., 53–61.

10. Ibid., 63.

11. Cassatt had traveled to Chicago to sell two paintings and was there at the time of the fire. These unidentified paintings were on display in a jewelry store when they were destroyed. These were paintings that she had consigned to Goupil's New York branch the previous fall.

12. Badger, *Great American Fair*, 58–59.

13. Quoted in ibid., 64.

14. Root was a highly respected designer of high-rise office buildings and an articulate spokesman for new American architecture. Critics of the fair's architecture and its deleterious effect on American building often cite Root's death as the reason the East Coast academic architects were free to impose the classical style on the Court of Honor. A corrective to this view is Dimitri Tselos, "The Chicago Fair and the Myth of the 'Lost Cause,'" *Journal of the Society of Architectural Historians* 26 (December 1967): 259–68.

15. Badger, *Great American Fair*, 68–69.

16. For a history that is counter to Weimann's see Frances K. Pohl, "Historical Reality or Utopian Ideal? The Woman's Building at the World's Columbian Exposition, Chicago, 1893," *International Journal of Women's Studies* 5, no. 4 (1982): 289–311. For other studies of the Woman's Building see Corn, "Women Building History," and Garfinkle, "Women at Work."

17. For a good summary of this historic revolution in the United States see George Cotkin, "Woman as Intellectual and Artist," in *Reluctant Modernism: American Thought and Culture, 1880–1900* (New York: Twayne, 1992), 74–100. For the situation in Europe see T. Stanton, *The Women Question in Europe*.

18. The literature on woman suffrage and women's history is vast. Surprisingly, there is no comprehensive modern history of the woman's movement, from the Seneca Falls meeting in 1848 to the passage of the Nineteenth Amendment in 1920. This period brackets the creation of the Woman's Building and Cassatt's mural. The sources I have relied upon include Griffith, *In Her Own Right*; Aileen S. Kraditor, *The Ideas of the Woman's Suffrage Movement, 1890–1920* (New York: Columbia University Press, 1964; reprint, New York: Norton, 1981); Stanton, Anthony, and Gage, eds., *History of Woman Suffrage*, vols. 1–3; Anthony and Harper, *History of Woman Suffrage*, vol. 4; and Harper, *History of Woman Suffrage*, vols. 5–6.

19. Griffith, *In Her Own Right*, 138.

20. For Stanton et al. see above, note 18. See also Phebe A. Hanaford, *Daughters of America; or, Women of the Century* (Augusta, Me.: True, 1882), and James A. Parton, *Daughters of Genius* (Philadelphia: Hubbard, 1888).

21. See Elizabeth F. Ellet, *Women in All Ages and Countries* (New York: Harper, 1859).

22. See Samuel C. Shepherd Jr., "A Glimmer of Hope: The World's Industrial and Cotton Centennial Exposition: New Orleans, 1884–1885," *Louisiana History* 26, no. 3 (1985): 271–90, and Judith Paine, "The Women's Pavilion of 1876," *Feminist Art Journal* 4 (Winter 1975/76): 5–12. There are several dissertations on women and world's fairs in the late nineteenth century, including Virginia Darney, "Women and World's Fairs: American International Expositions, 1876–1904" (Ph.D. diss., Emory University, 1982), and Mary Frances Cordato, "Representing the Expansion of Woman's Sphere: Women's Work and Culture at the World's Fairs of 1876, 1893, and 1904" (Ph.D. diss., New York University, 1989). Also see "Chart 1: Woman's Buildings at American Fairs—1876–1915" and "Appendix A: 'A Peculiar People': Women's Buildings and Participation at American Fairs—1876–1915," both in Garfinkle, "Women at Work," 430–34 and 479–93, respectively.

23. Palmer, *Addresses*, 42. The Fortnightly Club was one of a number of women's study clubs

that were organized during the second half of the nineteenth century. The Fortnightly was formed in 1873 and, according to Theodora Penny Martin, its "members 'gained a reputation for brains.'" Martin, *The Sound of Our Own Voices: Women's Study Clubs, 1860–1910* (Boston: Beacon, 1987), 43.

24. E. Stanton, *Eighty Years*, 314, 316.

25. See Beverly Gordon, *Bazaars and Fair Ladies: The History of the American Fundraising Fair* (Knoxville: University of Tennessee Press, 1998), 59–93.

26. Myra Bradwell was secretary of the Illinois Woman Suffrage Association and the first woman admitted to the Illinois Bar; Emma Wallace was active with the Illinois Industrial School for Girls, the Woman's Relief Corps, the Woman's Exchange, and the Home for the Friendless. Rena Michaels was also active. She was dean of the Women's College of Northwestern, president of the YWCA, the founder and editor of the woman's magazine *Home*, a commissioner of the United States Pension Office, and the president of the Woman's Relief Corps. Weimann, *Fair Women*, 25–27.

27. Ibid., 28. Also see Garfinkle, "Women at Work," 29–34.

28. Weimann, *Fair Women*, 28.

29. The Isabellas also commissioned a statue of the queen from Harriet Hosmer. Because of delays, not even the plaster version was completed in time for the fair. See Dolly Sherwood, *Harriet Hosmer: American Sculptor, 1830–1908* (Columbia: University of Missouri Press, 1991).

30. Weimann, *Fair Women*, 36.

31. Palmer, *Addresses*, 42–43.

32. Ibid., 44.

33. That same year, 1874, Bertha's sister Ida married Frederick Dent Grant, the oldest son of President Ulysses S. Grant, in Chicago. See Ross, *Silhouette in Diamonds*, 34.

34. Scott, *Natural Allies*, 96.

35. Ross, *Silhouette in Diamonds*, 45, and Scott, *Natural Allies*, 128–29.

36. Palmer, *Addresses*, 43.

37. See Gullett, "'Our Great Opportunity.'"

38. Weimann, *Fair Women*, 377.

39. Ibid., 129.

40. "Report to the Board of Lady Managers, Second Session, September 2, 1891," in Palmer, *Addresses*, 81.

41. See Silverman, *Art Nouveau*, 65.

42. Palmer, *Addresses*, 77.

43. Bertha Palmer in a letter to the Hon. Lyman J. Gage, president of the World's Columbian Exposition, December 8, 1890, noted that she and others recommended "the erection of a suitable building on the Exposition grounds, to be placed under the control of the Board of Lady Managers . . . in which shall be placed special exhibits of women's work . . . said building also to be used as the official headquarters of the Board of Lady Managers." Reprinted in Palmer, *Addresses*, 31.

44. This would later become the site of the Art Institute of Chicago.

45. Weimann, *Fair Women*, 530.

46. For a complete discussion of the competition and a critical analysis of the building, see Garfinkle, "Women at Work," 35–84.

47. "Report to the Executive Committee of the Board of Lady Managers, April 8, 1891," in Palmer, *Addresses*, 14–15.

48. Ibid., 16.

49. For a detailed discussion of these artists and their Woman's Building commissions see Garfinkle, "Women at Work," 85–113.

50. Quoted in Wiemann, *Fair Women*, 393.

51. Since the 1980s several scholars have written on the racial politics of the World's Columbian Exposition. For the most part these are polemical accounts that fail to acknowl-

edge the nuances of the historical record. There are two earlier accounts that are more even-handed and provide the substance for most later analyses: Elliott M. Rudwick and August Meier, "Black Man in the 'White City': Negroes and the Columbian Exposition, 1893," *Phylon* 26 (1965): 354–61, and Ann Massa, "Black Women in the 'White City,'" *Journal of American Studies* [Great Britain] 8 (December 1974): 319–37. These authors refer to contemporary newspapers and archival records to document the exclusion of African Americans from the planning stages of the fair. At the same time they illuminate the ideological splits within the black community. This factionalization was paralleled among women for representation at the fair and for control of the Woman's Building. Whereas some modern scholars claim that Palmer's efforts were too little, too late, and patronizing, the record shows that the infighting among the groups who could work to create greater visibility for the contribution of African American women resulted in the appointment of Imogen Howard as a default representative, much in the same way that Palmer herself became a compromise president.

52. Quoted in Weimann, *Fair Women*, 180.

53. Ibid., 175.

54. Ibid.

55. Ibid.

56. For a discussion of Wheeler as well as her career and its context, see Peck and Irish, *Candace Wheeler.*

57. For more on this group, see Wilson H. Faude, "Associated Artists and the American Renaissance in the Decorative Arts," *Winterthur Portfolio* 10 (1975): 101–30.

58. Wiemann, *Fair Women*, 235.

59. Meredith, "Woman's Part at the World's Fair," 419.

60. For information on the other fair murals see F. D. Millet, "The Decoration of the Exposition," *Scribner's Magazine* 12 (December 1892): 692–709, and Royal Cortissoz, "Color in the Court of Honor at the Fair," *Century Magazine* 46 (July 1893): 323–33. Millet was a muralist and supervisor of the mural decoration for the entire fair. Cortissoz was one of the leading critics of the era and a staunch supporter of civic art. Both articles contain excellent and important illustrations of works that are, for the most part, lost today.

61. Palmer, *Addresses*, 66.

62. As noted by Palmer: "Miss Cassatt has lived in Paris ever since she went abroad many years ago to study her art. She had the good fortune to select Degas, one of the most eminent of modern French artists, as her master. She unfortunately imbibed his prejudice against exhibitions, so that she has never been an exhibitor in Paris or in America, and her name is consequently unknown among us." Palmer, *Addresses*, 102. Also see Kevin Sharp, "How Mary Cassatt Became an American Artist," in Barter et al., *Mary Cassatt: Modern Woman*, 145–75. For a history of impressionism in the United States see Gerdts, *American Impressionism.*

63. In addition to the sumptuous architectural and sculptural displays throughout the fair, international exhibitions of painting and sculpture were held in Charles Atwood's Palace of Fine Arts. Supported by Palmer, Hallowell had campaigned to be appointed chief of fine arts but lost out to Ives, who was then director of the St. Louis Art Museum.

64. According to Carolyn Carr, "Many paintings shown at the 1893 World's Columbian Exposition were first shown in Chicago at an Inter-State art exhibition." Carr, "Prejudice and Pride," 114 n. 8.

65. See Gerdts, *American Impressionism*, 246.

66. The early Chicago collectors of French impressionism included, in addition to the Potter Palmers, Edward Ryerson and Martin Yerkes. Throughout her career, Hallowell continued to promote the most avant-garde work from Europe and the United States. After the Columbian Exposition, Hallowell established a home in Paris, acting as an agent for American collectors and museums. Living in Paris also allowed her a continuing friendship with Cassatt. See Carr, "Prejudice and Pride," and Kysela, "Sara Hallowell."

67. The other assistant chief to Ives, Charles Kurtz, was responsible for the exhibition of

American art since 1876 and a retrospective exhibit of eighteenth- and early nineteenth-century American painting, both of which would also be shown in the Palace of Fine Arts. Art from many foreign countries was included as well. See Charles Kurtz, *The Art Hall Illustrated: World's Columbian Exposition* (Philadelphia: George Barrie, 1893).

68. Murals for the Manufactures and Liberal Arts Building were located on the ceilings of four entrances and on the walls of four corner pavilions. There were two murals in each pavilion, and all eight were saved and later sent to four educational institutions within a hundred-mile radius of Chicago. Only those sent to the University of Michigan, Ann Arbor, are on display today: Gari Melcher's *Arts of Peace* and *Arts of War*. McEwen's *The Arts of Peace* (also called "Textiles" and "Life") was sent to Knox College, Galesburg, Illinois, where it remains, in poor condition and in storage; his *Music* was sent to Beloit College in Wisconsin and has been lost. Information courtesy of Richard Murray, Smithsonian American Art Museum.

69. An important contemporary discussion of mural painting's importance is King, *American Mural Painting*. The period from the Centennial to World War I is known in American art as the American Renaissance. See Richard Guy Wilson, "The Great Civilization," *The American Renaissance* (Brooklyn: Brooklyn Museum of Art, 1979), 10–71.

70. For instance, McEwen did a series entitled "The Greek Heroes" for the south corridor of the Library of Congress. See Herbert Small, *The Library of Congress: Its Architecture and Decoration* (Boston: Curtis and Cameron, 1901; reprint, New York: Norton, 1982).

71. In addition to a rich contemporary literature on turn-of-the-century mural painting, there is also a recent comprehensive modern history. See Bailey Van Hook, *The Virgin and the Dynamo: Public Murals in American Architecture, 1893–1917* (Athens, Ohio: Ohio University Press, 2003). There are also several excellent studies on various programs and artists. See Richard V. West, *The Walker Art Building Murals* (Brunswick, Me.: Bowdoin College Museum of Art, 1972); H. Barbara Weinberg, *The Decorative Work of John La Farge* (New York: Garland, 1977); Cynthia H. Sanford, *Heroes in the Fight for Beauty* (Jersey City, N.J.: Jersey City Museum, 1985); Sally Promey, *Painting Religion in Public: John Singer Sargent's "Triumph of Religion" at the Boston Public Library* (Princeton: Princeton University Press, 1999); and an invaluable unpublished checklist of American Renaissance murals prepared and held by Richard Murray, Smithsonian American Art Museum.

72. Quoted in Weimann, *Fair Women*, 191.

73. Ibid., 190. See Madeleine Fidell-Beaufort, "Elizabeth Jane Gardner Bouguereau: A Parisian Artist from New Hampshire," *Archives of American Art Journal* 24 (1984): 2–9.

74. All three quotes appear in Weimann, *Fair Women*, 190–91. Mme Virginie Demont-Breton was the controversial president of the Union des femmes peintres et sculpteurs, the first women-only exhibiting society in France. See Garb, *Sisters of the Brush*.

75. Quoted in Weimann, *Fair Women*, 193.

76. Ibid., 192.

77. According to Mary Smart, Hallowell's portrait is her earliest known painting. Smart, "Sunshine and Shade," 21. Also see Joyce Henri Robinson and Derrick R. Cartwright, *An Interlude in Giverny* (University Park, Pa.: Palmer Museum of Art, 2000).

78. They had two daughters but were divorced in 1909. Shortly afterwards Mary married the painter Will Hickok Low. She adopted his name and was known thereafter as Mary Fairchild Low. See Cartwright, "Beyond the Nursery."

79. Smart, "Sunshine and Shade," 22.

80. Mathews, *Cassatt and Her Circle*, 137. According to Jennifer Bienenstock in her dissertation on the Society of American Artists, Cassatt exhibited only twice with the SAA, in 1879 and 1892. Jennifer A. Martin Bienenstock, "The Formation and Early Years of the Society of American Artists" (Ph.D. diss., City University of New York, 1983, 114 n. 81.

81. Erica E. Hirshler, "Helping 'Fine Things across the Atlantic': Mary Cassatt and Art Collecting in the United States," in Barter et al., *Mary Cassatt: Modern Woman*, 200. The Palmers also purchased a set of prints and a pastel, *Young Mother* (1888, Art Institute of Chicago), by Cassatt in 1892.

82. Reprinted in Mathews, *Cassatt and Her Circle*, p. 229 n. 2.

83. Mariana Griswold Van Rensselaer, "Current Questions of Art," *New York World*, July 31, 1892, 27.

84. Ibid.

85. The content of this cable was included in a letter from Cassatt to Hallowell. Mathews, *Cassatt and Her Circle*, p. 231.

86. The contents of this cable were restated in a letter sent by Hallowell to Palmer, in which is also enclosed Cassatt's letter asking Palmer to destroy it. Ibid., 230–31.

87. Weimann, *Fair Women*, 195.

88. In an 1892 letter to Hallowell, Palmer wrote, "Miss Cassatt and Mrs. McMonnies [*sic*] case is on the terms as Mr. [Gari] Melchers and Mr. [Walter] McEwen and so are among the best paid." Quoted in Mathews, *Cassatt and Her Circle*, 233.

89. Cassatt to Pissarro, Mathews, *Cassatt and Her Circle*, 229.

90. Palmer, *Addresses*, 125. Cassatt rented the Château de Bachivillers in 1891 and spent three summers there, including the summer she worked on *Modern Woman*. The building is now owned and maintained by the children's organization Le Moulin Vert. In 1893 Cassatt bought the Château de Beaufresne in Mesnil-Theribus. She lived here and in Paris for the rest of her life. The château is now privately owned by M. and Mme. Jean Baillou of Paris.

91. Cassatt to Palmer, September 10 [1892], Mathews, *Cassatt and Her Circle*, 235.

92. Cassatt to Palmer, December 1, [1892], ibid., 241.

93. Smart, "Sunshine and Shade," 23.

94. Weimann, *Fair Women*, 211–12.

95. Smart, "Sunshine and Shade," 23.

96. Monroe, "Chicago Letter," April 15, 1893, 241. Lucy Monroe was the sister of Harriet Monroe, author of the "Columbian Ode" recited at the opening of the World's Columbian Exposition. Today Harriet is best known as the influential editor of *Poetry: A Magazine of Verse* (1912–36). A third Monroe sister, Louise, married the architect John Wellborn Root.

A TRANSATLANTIC VISION

Cassatt's mural was created for an American audience yet its design and pictorial sources were European. As Cassatt herself acknowledged, her mural was done to celebrate "a great national fête."[1] Through her reading of American newspapers and magazines, correspondence with Philadelphia relatives, and visits from friends, Cassatt kept current with events and trends in the States. At the same time she was keenly aware of contemporary developments in French painting: the advanced color theories of postimpressionism, the debates surrounding mural painting and decoration, the rediscovery in the 1870s of Sandro Botticelli, and the adoption of less naturalistic, more symbolic subject matter. The new European-inspired painterly tools were the ones she deployed in her large-scale mural *Modern Woman* for Chicago's World's Columbian Exposition.

YOUNG WOMEN PLUCKING THE FRUITS OF KNOWLEDGE OR SCIENCE

The heart of Cassatt's allegorical *Modern Woman* is its central panel, *Young Women Plucking the Fruits of Knowledge or Science* (figure 27). Here, in a deep orchard, women and girls harvest fruit, accompanied by two turkeys and a dog. The prevailing color of the entire mural, as described by the Chicago-based art critic Lucy Monroe, was "bright grass green," with the complementary colors of yellow and violet appearing in the right-hand panel, *Art, Music, Dancing.*[2] Today it takes a great leap of the imagination to superimpose these colors on contemporary gray, grainy reproductions. However, the single color print of the center section of *Young Women Plucking the Fruits of Knowledge or Science* (shown in black and white, figure 28), with its intense blue/green tonalities, confirms Monroe's color description.

The women are placed largely in the foreground, loosely organized into several clusters, three in front and two in the back. The central group, in which a young woman hands down an apple to a girl, announces the panel's theme: the transference of knowledge from one generation to the next. Their actions are amplified by a third

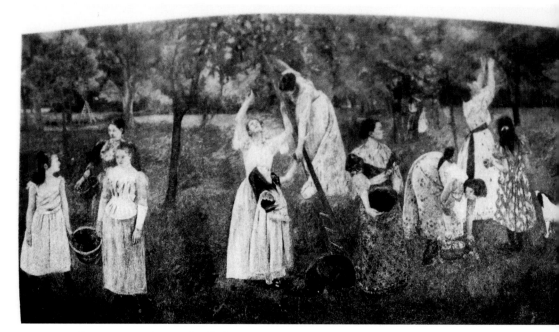

Figure 27. Mary Cassatt, detail of *Young Women Plucking the Fruits of Knowledge or Science,* center panel of *Modern Woman,* 1893. From *Harper's New Monthly Magazine,* May 1893, 837.

female who supports the ladder while plucking fruit from low branches. On the ground below, two turkeys fill the space between this group and a fourth figure slightly to right. An older woman, she holds a basket and pensively looks off to her left, creating a visual bridge between the central group and another immediately to our right. In this cluster two women and a girl, accompanied by a dog, pick fruit and mirror the poses of the central group. This activity is repeated by other, smaller groups of women and girls further back on the left and right. In the left foreground three figures are shown leaving the orchard. Two girls hold a basket of fruit between them, and an older woman carries a fruit-filled container on her hip. This industrious activity, which on one level signifies the domestic realm, is the pictorialization of the age-old association between apple picking, specifically by women, and the biblical Temptation story, as indicated in part by Cassatt's title *Young Women Plucking the Fruits of Knowledge or Science.* Cassatt has transformed the orchard behind her house into a modern Garden of Eden. Without Adam and the serpent, however, hers is not the traditional rendering but shows a domesticated Eden in which Eve and her female companions pluck the fruits of knowledge and science for their own benefit and advancement. This reconfiguration of the Temptation story is the most radical aspect of Cassatt's narrative since it advances a reinterpretation of Eve's transgressions as a precursor to women's emancipation.

In the nineteenth century, Eve was regarded as a complex figure, the symbol of women's emancipation and of decadence.[3] John A. Phillips in his book *Eve: The His-*

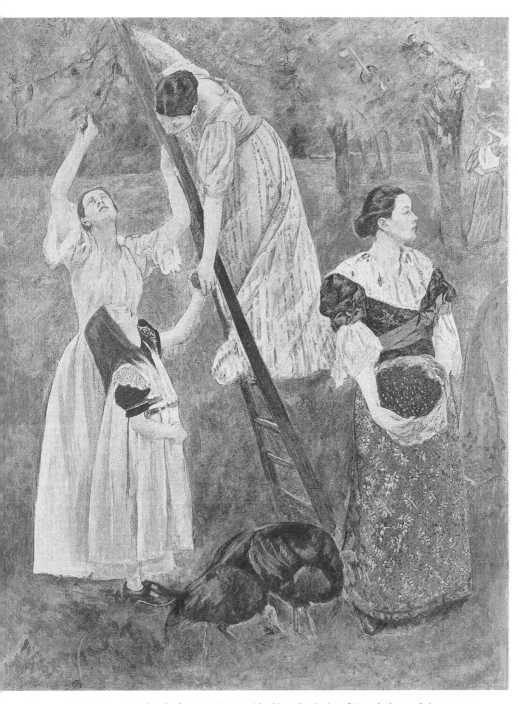

Figure 28. Mary Cassatt, detail of *Young Women Plucking the Fruits of Knowledge or Science,* center panel of *Modern Woman,* 1893. From William Walton, *World's Columbian Exposition Art and Architecture,* 3 vols. (Philadelphia: George Barrie, 1893), vol. on architecture, opposite xxxvi. Photo courtesy Smithsonian Institution.

tory of an Idea documents how pervasive and longstanding this rigid association of women and Eve's sinfulness was.[4] During the Protestant Reformation, Martin Luther and John Calvin attempted to have Adam and Eve share equally in the guilt of original sin, yet they still regarded Eve as Adam's handmaiden, a view John Milton expressed in his seventeenth-century epic poem *Paradise Lost*. Milton's is the most detailed modern interpretation of the Genesis story and in it he presents a nuanced and substantive portrait of the first woman. Nonetheless he joins Luther and Calvin in his representation of Eve—hence, woman—as subordinate and thus to be forever regarded as inferior to men:

> Not equal, as their sex not equal seemed;
> For contemplation hee and valour formed,
> For softness shee and sweet attractive Grace,
> Hee for God only, shee for God in him.[5]

This Protestant conviction of women's inferiority continued to be countenanced in the United States and elsewhere, and survived well into the nineteenth century.

Phillips liberally illustrates his book with familiar images of the Fall by the great masters of the past—Dürer, Michelangelo, Jacopo della Quercia, Masaccio, Hans Baldung Grien, Lucas Cranach, Hubert and Jan van Eyck, and, in the modern period, William Blake, Paul Gauguin, and Emil Nolde. Yet only Cassatt puts a positive spin on Eve's transgression, making Cassatt's apostasy even more remarkable.

While pictorially this new and heretical reading of Eve's temptation was unique to Cassatt, this reinterpretation of the Genesis story was undertaken earlier in the century by American women writers and theologians who challenged and subverted the biblical text that condoned the second-class status of women. As noted by Donna Behnke: "[Women's] chief enemy was tradition; centuries of biblical scholarship had labored, intentionally and unintentionally, to delineate woman's place in the created order of things—a place which was always envisioned far below that of the male and equally far removed from public life and the arenas of authority."[6]

Much of the justification of this position centered on the notion that Eve (woman) was created from Adam's rib. To combat this entrenched idea and to assert that women were mentally, emotionally, and spiritually the equal of men, it was necessary to confront the Genesis story head on. Chief among the commentators was the suffragist Elizabeth Cady Stanton. Although Cassatt was a latecomer to the suffrage movement, in 1909, when in her sixties, she wrote to Louisine Havemeyer, "Go in for the suffrage, that means great things for the future."[7] She also advised Havemeyer on the suffrage benefit exhibition at Knoedler's gallery in New York that was held in 1915.[8] Yet throughout her life, as evidenced by her correspondence, she maintained a profound regard for women's independence.

Given her talent and aspirations, Cassatt was lucky to come of age during the 1860s and 1870s, which became, following the famous Seneca Falls convention, the "high point in the history of the feminist movement."[9] Yet following the Civil War there were profound divisions within the American suffrage movement. Elizabeth

Cady Stanton and Susan B. Anthony, the movement's most radical supporters, were unable to gain abolitionists' support for the franchise for women. This led to a serious rift within the American Woman Suffrage Association, and Stanton and Anthony left to form their own group, the National Woman Suffrage Association.

The disaffection between the two factions prompted Stanton, in particular, to reflect on the reasons why women's equality was disputed not only by men, but now by members of her own sex. She believed that the root cause lay in the dictates of organized religion. To help disseminate her nonconformist beliefs and to further the wider and more progressive agenda she and Anthony advocated, the two women published a short-lived newspaper called *The Revolution*. It is here that Stanton first formulated her feminist theology, which was later expanded in *The Woman's Bible* (1895). Instead of advocating self-denial and self-sacrifice, as demanded by abolitionists such as Wendell Philips, who accused suffragists of being selfish, Stanton urged self-assertion in order to overcome what she termed "women's degradation and subordination." For her this negative attitude toward women existed because "the whole foundation of the Christian religion rests on her temptation and man's fall."[10] Stanton believed this biblical injunction was at the heart of women's enslavement. She had been outraged when no women were appointed to the groups of scholars convened by the Church of England in 1870 to revise the seventeenth-century King James version of the Bible. In rebuttal, Stanton published a series of commentaries by her and other women. Typical of her rereading is the following analysis, which takes as its focus a critically important Old Testament passage in which the serpent tempts Eve to eat from the Tree of Knowledge. Stanton may have also relied on Milton's commentary in Book 9, which deals in much greater detail than does Genesis with the meeting between Eve and the serpent.

> In this prolonged interview [between Eve and the serpent], the unprejudiced reader must be impressed with the courage, the dignity, and the lofty ambition of the woman. The tempter [the serpent] evidently had a profound human nature, and saw at a glance the high character of the person he met by chance in his walks in the garden. He did not try to tempt her from the path of duty by brilliant jewels, rich dresses, worldly luxuries or pleasures, but with the promise of knowledge, with the wisdom of Gods. Like Socrates or Plato, his powers of conversation and asking puzzling questions, were no doubt marvelous, and he roused in the woman that intense thirst for knowledge, that the simple pleasures of picking flowers and talking with Adam did not satisfy. Compared with Adam she appears to great advantage through the entire drama.[11]

In most respects, absent the serpent, Cassatt's mural illustrates this commentary. Like Stanton, Cassatt does not cast Eve as the evil temptress who caused Adam to eat the apple from the Tree of Knowledge in defiance of God's law, but has her and her daughters picking the fruits of knowledge to enhance their understanding of the larger world and as an escape from the drudgeries of domestic life. In this way Cassatt acknowledges that women are entitled to knowledge and that women are neither guilty of nor responsible for original sin.

Nor is Cassatt's inclusion of the word "Science" in the panel's title arbitrary, since

science was the most controversial and preeminent area of new knowledge in the nineteenth century. As noted by William Leach: "feminists [relied] on science and organization as the basis for a humanitarian ideology."[12] The embrace of science as a liberating force was articulated earlier by the influential French social thinker Auguste Comte, who claimed scientific progress as the cornerstone of his theory of positivism. It was Comte's belief that science would triumph over the delusions of theology and organized religion. Comte's theories were embraced by Stanton and she published excerpts from his writings in *The Revolution*, enlisting his prestige and condemnation of religion in her own cause.[13]

Comte's writing led Stanton to rethink, in particular, the Genesis story of the Temptation. For millennia it was used to justify an ambivalent attitude toward women and the pursuit of knowledge. In the nineteenth century, scientific knowledge (such as Darwin's newly formulated theory of evolution) was viewed as a challenge to the dictates of conservative theologians. Stanton carefully articulated her case, drawing an important parallel between Eve's disobedience and the history of scientific investigation by exhorting her readers to consider what would have happened, particularly in the field of science, if Eve had ignored God's injunction:

> That act [Eve's plucking the apple from the Tree of Knowledge] was the unlocking to the human family of all the realms of knowledge and thought; but for that, Moses and Aaron, Samson and Solomon, Columbus, Newton, Fulton and Cyrus Field, would have been to this hour listlessly sunning themselves on the grassy slopes of Paradise. . . . Yes, when Eve took her destiny in her own hand and set minds spinning down through all the spheres of time, she declared humanity omnipresent, and today thinking people are wrapt in wonder and admiration at the inventions and discoveries of science.[14]

In Stanton's view, without Eve's insubordination humankind would remain forever indifferent to the power of the intellect. While there is no indication of Cassatt's views on Comte and positivism, certainly his ideas that science could liberate modern man—and for Stanton and Cassatt, modern woman—can be considered one of the larger social constructs that would have appealed to Cassatt and helps account for its reference in Cassatt's mural. Modern women, who heeded Eve's example, must follow in her footsteps and not repress their thirst for knowledge and education.

Education for women, unlike suffrage, united women across the political spectrum. Yet it was almost as controversial as suffrage; education too could lead to the undermining of women's first obligations to her home and family. In the beginning of the nineteenth century, according to Barbara Miller Solomon, advocates of women's education had "attempted to balance their aspirations for students with society's claims of the traditional female sphere. None questioned the accepted Christian ideal of true womanhood summed up in the precepts of piety, purity, obedience, and domesticity" and it was thought that the "well-being of the republic demanded educated mothers."[15] Enrollment at academies such as Catharine Beecher's Hartford Seminary, Emma Willard's Troy Seminary, and Mary Lyon's Mount Holyoke Seminary far exceeded the founders' expectations and after the Civil War led to demands

for women's collegiate education. Public education for men and women also grew through the First Morrill Land Grant Act, in 1862, an effort spearheaded in Congress, ironically, by the same "male abolitionists [who] having deserted the cause of woman's suffrage . . . ardently backed the collegiate education of women."[16]

Resistance to these efforts was based on a wrong-headed reading of Darwin that held that "women were too far behind men in human evolution to ever catch up."[17] Furthermore, some doctors believed that higher education would be harmful physically to women. Most egregious were the claims of Dr. Edward H. Clarke, who, as a retired professor of the Harvard Medical School, brought the gloss of the university's prestige to his 1873 book *Sex in Education*. In it he asserted that "if women used up their 'limited energy' on studying, they would endanger their 'female apparatus.'" Yet Clark's warnings were refuted by a number of subsequent studies including a 1885 study of collegiate women's health which "emphasized the positive effects of coeducation."[18]

In addition to the advancement of coeducation in newly founded state universities, six of the Seven Sisters colleges (the preeminent four-year women's colleges)—Vassar, Wellesley, Smith, Bryn Mawr, Barnard, and Radcliffe—were founded after the Civil War. (The seventh, Mount Holyoke, became a four-year college in 1861.) The floodgates were open and demand was such that by the 1890s private universities begin to admit female students. Foremost was the University of Chicago, which was founded as a coeducational institution at the same time the Columbian Exposition opened.

Cassatt's painting was not the only one in the Woman's Building that celebrated women's new access to knowledge. Pictorial tributes to women's higher education were also found in the two large easel paintings by the sisters Rosina Emmet Sherwood and Lydia Field Emmet that appeared on the east wall of the Woman's Building Hall of Honor. That Sherwood's *The Republic's Welcome to her Daughters* (figure 29) and Emmet's *Art, Science, and Literature* (figure 30) are devoted to the subject of women's education further underscores the relevance of Cassatt's allegory.

On the facing west wall were two other paintings, Amanda Brewster Sewell's *Arcadia* and Lucia Fairchild Fuller's *Puritan Settlers*, or *Women of Plymouth*. Each of the four paintings measured 12 × 11 feet and all were referred to as mural paintings.[19] After Palmer had hired Cassatt and MacMonnies, she needed to find other women artists who could create large-scale paintings. It was then that she sought the advice of Candace Wheeler, newly appointed as coordinator of decoration for the entire building, who in turn consulted with her daughter, Dora Wheeler Keith. Besides her study with William Merritt Chase (1879–81), her training at the Society of Decorative Art, and her later affiliation with her mother's design firm, Associated Artists, Dora also studied in Paris at the Academie Julian (1883–84). Her training was paradigmatic of that of a younger generation of women artists who were no longer confined to careers in the decorative arts but who now had access to education in the higher arts of painting, sculpture, and architecture. It was Dora who recommended the Emmet sisters, who had also been students of Chase. All three young

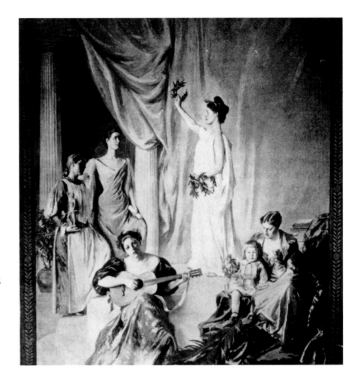

Figure 29. Rosina Emmet Sherwood, *The Republic's Welcome to Her Daughters,* 1893. Hall of Honor, Woman's Building, World's Columbian Exposition. From Elliott, *Art and Handicraft in the Woman's Building,* 29.

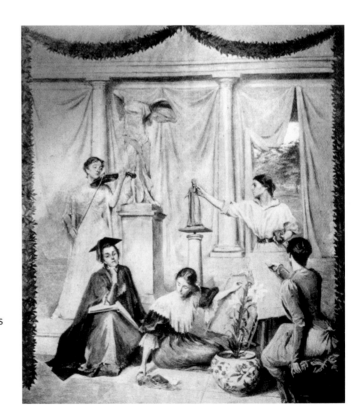

Figure 30. Lydia Field Emmet, *Art, Science, and Literature,* 1893. Hall of Honor, Woman's Building, World's Columbian Exposition. From Elliott, *Art and Handicraft in the Woman's Building,* 31.

women, along with Amanda Sewell, had later studied together at the Academie Julian. (Fairchild was brought in late to the project and was probably recommended by Lydia Emmet, who had been a student with her at the Art Students League.) Originally Dora and Rosina were invited to contribute the two paintings for the east wall but Dora declined because she was already at work on her ceiling mural for the library. Lydia was then invited to participate instead, along with Sherwood and Fuller.[20]

The paintings by the Emmet sisters show women wearing mortarboards and contain allusions to women in the arts as performers and creators. A woman playing a guitar who appears in Sherwood's *The Republic's Welcome to Her Daughters* echoes the banjo player in Cassatt's right-hand panel. Yet the sisters' works are very staid and traditional, almost like costume dramas or *tableaux vivants* that glorify the educational achievements of women in a clichéd way. By equating modern woman's aspiration for higher education with Eve plucking the apple in the Garden of Eden, Cassatt goes right to the heart of the nineteenth-century controversies concerning women's status and education.

Another issue that Cassatt investigates, one that was as hotly debated as theology and women's education, is dress reform.[21] The women in all three sections of Cassatt's mural are not dressed like Pissarro's peasants in his paintings of orchards, nor are they arrayed in the generic classical garb of the women in MacMonnies's painting. Rather they appear in comfortable day dresses worn by middle-class French women, attire that was similar, although not identical, to that worn by the young women in Morisot's *The Cherry Tree*.

Cassatt wrote in some detail to Mrs. Palmer about the women's costumes: "Mr. Avery sent me an article from one of the New York papers this summer [1892], in which the writer [Mariana Van Rensselaer], referring to the order given to me, said my subject was to be the 'Modern Woman as glorified by Worth'! That would hardly describe my idea, of course I have tried to express the modern woman in the fashions of our day and have tried to represent those fashions as accurately & as much in detail as possible."[22]

In this statement, Cassatt rejects the assertion that the women in her mural were to be dressed in couturier fashion, for Worth was the best-known fashion designer of the day and one favored by rich American women. The question then arises, What did she mean by saying that her models were dressed "in the fashions of our day"? As best as can be determined, her models are attired in day dresses made of soft fabrics, loosely structured, with lace or contrasting fabric at the neckline and for the sleeves. While often fitted at the waist, these are uncorseted dresses and as such reflect the health concerns of the dress reform movement.[23]

The movement has a long history, and it is generally acknowledged to have begun in the 1850s in the United States with Amelia Bloomer's "turkish-style" dress. Bloomer's innovation consisted of a long tunic that stopped at midcalf and was worn over a pair of long pants, or "bloomers" (figure 31).[24] Bloomer's dress was adopted by Elizabeth Cady Stanton and Susan B. Anthony in the 1860s, but both suffered derision when they wore it. Not wishing to divert attention from their more impor-

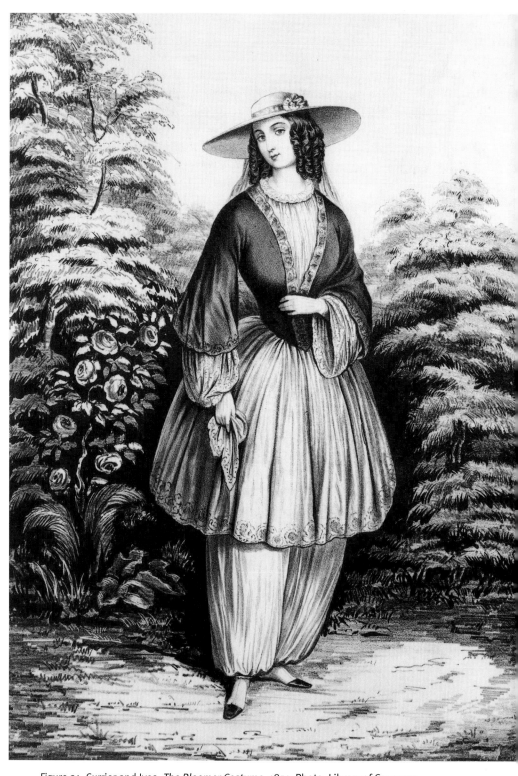

Figure 31. Currier and Ives, *The Bloomer Costume*, 1851. Photo, Library of Congress.

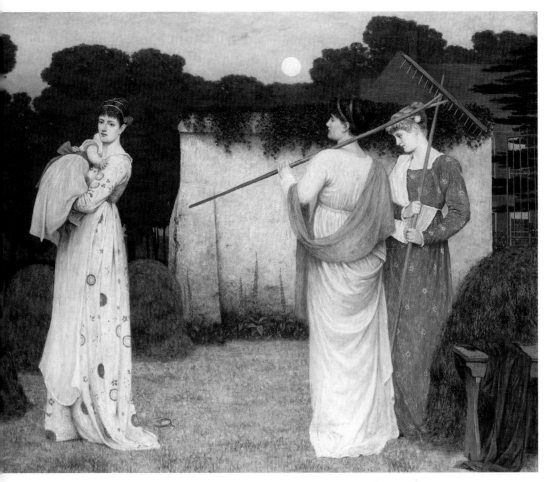

Figure 32. Thomas Armstrong, *Haytime,* 1869. Oil on canvas. Victoria and Albert Museum, London. Photo V&A Picture Library, © Board of Trustees of the Victoria and Albert Museum.

tant suffrage work, they abandoned what they found to be both sensible and comfortable attire and returned to wearing more formal Victorian clothing.

The next wave of dress reform came in Great Britain among women involved with the Pre-Raphaelites and the arts and crafts movement. Led by Jane Morris, the wife of William Morris, the primary exponent of the arts and crafts movement, the female colleagues of these artists adopted a loose-fitting medieval-style garment for everyday wear, often fashioned from luxurious fabrics (figure 32).[25] In the 1880s, other women along with their physicians called for "rational dress" reform for health reasons and advocated the adoption of the uncorseted dress.[26] Women wore what today would be culottes, a long skirt divided to form two loosely fitting pant legs. Yet these dresses were ugly and the fabrics heavy and ungraceful, certainly nothing that would appeal to Cassatt personally nor was evidenced in the dresses worn by her models.

Another source that may have more bearing on Cassatt's choice of costume and might provide a compromise solution between the utilitarian nature of the bloomer or culotte and the impracticality of Pre-Raphaelite dress is the new style of dress introduced by a Briton, Arthur Lasenby Liberty. First shown in France at the 1889 Universal Exposition in Paris, Liberty's designs and the Indian silk fabrics he used were so popular that he opened a branch of his business in Paris at 38, Avenue de l'Opéra in 1891.

In addition to being a phenomenally successful entrepreneur and a connoisseur of beautiful fabrics, Liberty was a literate, highly regarded associate of many British painters and craftsmen. In an advertising brochure for the firm, Liberty outlined his views on dress reform: "The immediate aim was to re-establish the craft of dress-making upon some hygienic, intelligible and progressive basis; to initiate a renaissance that should command itself artistically to leaders of art and fashion, and to challenge on its merits the heretofore fiat of Paris for 'change' and 'novelty' so far as it was oblivious of grace or fitness."[27] His commitment was such that he opened a dress department in 1884 under the direction of the architect E. W. Godwin, who was closely associated with members of the aesthetic movement, such as James McNeill Whistler, Dante Gabriel Rossetti, and Oscar Wilde.[28]

The costumes worn by the women in Cassatt's mural suggest that she shared Liberty's concern that women's clothing be both beautiful and comfortable. Cassatt arrayed her women in flattering, dignified styles that allowed them freedom of movement to emblematically carry out the tasks of independent womanhood. The central panel, *Young Women Plucking the Fruits of Knowledge or Science*, with references to theology, education, and dress reform, is the cornerstone of Cassatt's project. In the mural's adjoining sections, she introduced several other themes—ambition, physical education, and women's participation in the arts—that complement and expand upon this program.

YOUNG GIRLS PURSUING FAME

In the left-hand panel Cassatt animates her message by celebrating the ambitious energy of young girls. The setting for *Young Girls Pursuing Fame* (figure 33) is outdoors, probably a meadow, as best as can be determined from contemporary photo-engravings. In the foreground three girls, pursued by a flock of geese or ducks, run from left to right toward a figure that flies in the air silhouetted against a light-colored sky. This figure is a personification of fame, shown as a youthful nude female figure without wings but with a long shank of dark hair flowing behind her; in poor reproductions she looks like a kite the girls are flying. Lacking a trumpet, a palm branch, or crown, the figure is unlike any traditional image of fame and would be impossible to identify if it were not for Cassatt's own designation.

In the nineteenth century, fame meant renown, not celebrity. As a personification, it was often represented as a figure with a trumpet broadcasting those deeds that made

Figure 33. Mary Cassatt, *Young Girls Pursuing Fame,* left-hand panel of *Modern Woman,* 1893. From Hubert H. Bancroft, *The Book of the Fair* (Chicago, 1893), 263. Photo courtesy of General Research Division, New York Public Library, Astor, Lenox, and Tilden Foundations.

a person immortal. The idea that women had the potential to accomplish feats that would make them immortal is still a breathtaking idea. That Cassatt believed young women should aspire to immortality gives this panel extraordinary appeal. Cassatt herself sought fame and shortly before she accepted the mural commission believed it was in the United States that her success would be attained. As her mother wrote to her brother Aleck: "Mary is at work again, intent on fame and money she says, and count on her fellow countrymen now that she has made reputation here [Paris]."[29]

Just as she had inverted the traditional representation of Eve's temptation, Cassatt reconfigured the historic representation of fame. Instead of bestowing renown, fame is an ideal to be pursued, an aspiration for young women, making the scene the most playful and provocative of the three panels. Moreover, it is a frank attack on the nineteenth-century image of young middle-class women as demure and self-effacing, a challenge to the powerful and seductive Victorian "cult of true womanhood," which sought to define women's role as subservient and to confine her to the domestic, maternal, and religious spheres of life.[30]

In contrast to this conventional view, Cassatt's young girls are not dainty or ethereal. They race exuberantly through the landscape in pursuit of their aspirations. By showing these young girls in very unladylike fashion, Cassatt continues to address the issues that progressive nineteenth-century women deemed important for their and their daughters' welfare. Along with religion, education, and dress reform, physical

health was of concern. However, just as with the promotion of education for women, exercise by women threatened the social order. Mary Terhune in a treatise on young women's development written in the 1880s, called *Eve's Daughters*, noted sarcastically: "It is esteemed hoydenish to *run*, not to speak of the danger of making the feet large. . . . Jumping, racing, and climbing, if not prohibited, are never encouraged, by those who are bent upon the civilization of a 'graceful carriage' in their young daughters."[31]

It was also feared that if a young girl "looks strong and moves with a will, she will be mistaken for a worker, for a servant. If she looks delicate and moves languidly it will be seen at once that she does not belong to the working class."[32]

Yet as early as the 1830s, exercise for young women was advocated by educators, including the influential but conservative Catharine Beecher, who was one of the early popularizers of what was then called "purposive exercise," or calisthenics. She introduced these ideas to her students at the Hartford Female Seminary and later, in 1856, wrote a textbook on the subject, *Physiology and Calisthenics for Schools and Families* (figure 34). Although an opponent of woman's suffrage, Beecher was still concerned

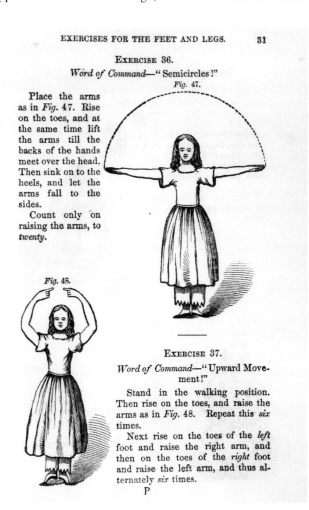

EXERCISES FOR THE FEET AND LEGS. 31

EXERCISE 36.
Word of Command—"Semicircles!"
Fig. 47.

Place the arms as in *Fig.* 47. Rise on the toes, and at the same time lift the arms till the backs of the hands meet over the head. Then sink on to the heels, and let the arms fall to the sides.

Count only on raising the arms, to *twenty*.

Fig. 48.

EXERCISE 37.
Word of Command—"Upward Movement!"

Stand in the walking position. Then rise on the toes, and raise the arms as in *Fig.* 48. Repeat this *six* times.

Next rise on the toes of the *left* foot and raise the right arm, and then on the toes of the *right* foot and raise the left arm, and thus alternately *six* times.
P

Figure 34. Exercise instructions, from Catharine Beecher, *Physiology and Calisthenics for Schools and Families*, 1856, 31.

about the poor health of American women, a state that inhibited women's ability to fulfill their duties to their families.

Beecher's initiatives were furthered by one of the most dedicated proponents of physical education, Dr. Dio Lewis, an important teacher, writer, and lecturer on the subject, who was associated with a school of physical culture in Boston. Lewis continued Beecher's lobbying efforts and in 1860 published his influential book *New Gymnastics for Ladies, Gentlemen and Children*, in which he illustrated "mutual help exercises" (figure 35). These illustrations contain images of women who, as Jan Todd describes in her book on the history of physical culture for women in the nineteenth century, "are not wasp-waisted ingenues but women in their prime who have a look of sturdiness and competence about them."[33] A similar description could be made of the women in Cassatt's mural.

Nor was the irrepressible Elizabeth Cady Stanton silent on the issue of exercise. In the 1870s she took to the lyceum circuit and lectured on the physical, as well as the intellectual, advancement of women. Her lecture called "Our Young Girls," which she gave in the 1870s throughout the United States, remained one of her most popular.

She began it by recounting the unjust discrimination experienced by young girls, particularly in comparison to their brothers, exhorting families to give their "daughters . . . the richest [?] of all fortunes, the full development of their own powers concentrated on some life work."[34] She then stressed that the most important element "necessary to realize the grand result" was that "she is to be healthy."[35] Throughout her speech she reiterated this theme: "One of the first needs for every girl to be trained for some life work, some trade in [the] professions, is good health. As a sound body is the first step toward a sound mind."[36]

She also linked good health with dress reform, noting that "for exercise to be

Figure 7.

No. 7. Raise the right hand bell from the side of
7
Figure 8.
73

Figure 35. Dio Lewis, "Ladies Gymnastic Dress," illustrated in Lewis's *The New Gymnastics for Men, Women, and Children*, 1864, 73.

pleasant and profitable [it] must be regular and to make it so one must have a convenient, comfortable dress."[37] Cassatt's clothing of young girls in loose, free-flowing dresses is seemingly in response to Stanton's exhortations.

A related development was the founding of the Young Women's Christian Association "to promote the spiritual, mental and physical interests of women." From the first, gymnastic classes were held in many of its branches, most notably Boston, Kansas City, and Minneapolis. The YWCA's fiftieth anniversary report ascribed large benefits, including the spiritual, to its gym classes: "More than in any other department democracy was felt here. A gymnasium suit and team play obliterated social and educational partitions. With the recognition of the body as the temple of the Holy Spirit old members got a new vision of a complete life and new members began to 'believe in the Young Women's Christian Association.'"[38]

This is not to claim Cassatt's direct awareness of Beecher's, Lewis's, or Stanton's writings, or even of the founding principles of the YWCA, but this American background provides a compelling historical context for the reading of this exceptional panel. These interests in children's and women's health, in calisthenics, and in healthful dress were also ones that concerned the women in Chicago. There were displays and congresses devoted to these issues and next door to the Woman's Building was a separate Children's Building with a daycare center and large play area and gymnasium for children (figure 36).

There is also an important artistic source that furthered Cassatt's pictorial program, one that illustrated the uninhibited and imaginative world of children. Cassatt's panel, with its emphasis on children's activities and the presence of barnyard animals, shares an affinity with children's stories or nursery rhymes illustrated by Cassatt's contemporary, the phenomenally popular British painter and writer Kate Greenaway, whose children's books and watercolors were exhibited in the library of the Woman's Building. Greenaway's illustrations also had a tremendous impact on the design of children's clothing.

Greenaway, along with her colleagues Walter Crane and Randolph Caldecott, came to prominence internationally through the publication in the 1870s of "toy books" by the printer Edmund Evans. Evans began his collaboration first with Crane in the mid-1860s and later with Caldecott and Greenaway in 1878, publishing her first best-seller, *Under the Window*, which sold twenty thousand copies the first year.[39] It was immediately translated into French and in all probability Cassatt over the years bought Greenaway's books and almanacs for her nephews and nieces.

By the early 1880s these books, with their illustrations using clear, pure colors, simplified drawing, and flattened picture plane, were enthusiastically reviewed by the critic and novelist J.-K. Huysmans.[40] He considered the illustrations high art and compared them favorably to the Japanese prints of Hokusai and Hokkei. After discussing several of Crane's works in his characteristic florid style, he moved on to a surprising analysis of Greenaway's *Under the Window*, or *la Lanterne magique*. (The "pictures and rhymes for children" contained in her book are not the familiar Mother Goose rhymes but poems that whimsically evoke the childhood world of fantasy.)

Figure 36. Gymnasium in Children's Building, 1893. From Hubert H. Bancroft, *The Book of the Fair* (Chicago, 1893), 295. Photo courtesy of General Research Division, New York Public Library, Astor, Lenox, and Tilden Foundations.

Interestingly Huysmans characterized Greenaway's illustrations and design as being distinctly "feminine," noting that "upon [Greenaway's] cleverly beaten mixture [of Alma-Tadema and Hokusai] floats a distinctive tenderness, a smiling delicacy, a precious spirituality which stamps her work with a feminine touch, all tender love and grace."[41] This was in no way meant to be pejorative; on the contrary Huysmans believed that only women could so expressively convey the physicality of costume and the nuance of pose and gesture. "Only women can paint childhood. . . . the tender love, a maternal ardor I find in Miss Greenaway, is missing in [Crane's] watercolors."[42] More specifically he speaks of Greenaway's ability to represent meaningfully the appearance of the hands of young girls "drowning" in their muffs ("les mains noyées dans leur manchons"), their bodies buried in green fur-lined coats ("le corps enfoui dans leurs pelisses vertes") (figure 37).[43] Male artists, in contrast, are at a disadvantage since they don't dress children or brush their hair. In Huysmans's view, women artists like Greenaway possessed unique instincts that enabled them to

Figure 37. Kate Greenaway, "Five little sisters walking in a row," from *Under the Window: Pictures and Rhymes for Children* (London: Frederick Warne, n.d.), 24.

recreate the sensuous appeal and decorative potential of even the most insignificant domestic detail: "The painter arranges teacups as actors on stage and shuttlecocks as florets above the printed verse while joyous children brandish their racquets at the bottom of the page."[44]

Huysmans had expressed similar sentiments about Cassatt's work when it was exhibited the same year, 1881, as part of the fifth impressionist exhibition: "But of course a woman is equipped to paint childhood. There is a special feeling men would be unable to render unless they are particularly sensitive and nervous. Their fingers are too big not to leave some rough awkward mark."[45]

Huysmans's reception of the work of Greenaway and other British illustrators as high art further rationalizes Cassatt's borrowing, if not the specific images, the spirit of Greenaway and the tacit acknowledgment that the substance of children's lives is on a par with a queen's. Nor were Cassatt, Greenaway, and Huysmans alone in their validation of a child's life and dreams. Huysmans, with the publication of his novel of exotic decadence, *A Rebours* (1884), was one of the leading figures of the symbolist movement. That Cassatt was aware of the shift in literature and the visual arts from naturalism to symbolism is confirmed by a change in the content and mood of her prints and related paintings, which, in the early 1890s, become more inwardly directed and reflective.[46] The strongest evidence of this conversion is found in her mural. Furthermore, Cassatt's decision to adopt the imaginative tools of allegory parallels the efforts of her male colleagues—writers and painters—to give expression to the world of the imagination, a world believed easily accessible to children. Children remain expressive and uninhibited in their passions and have not learned to repress their desires. While it was Huysmans's contention that women had unique access to children's interior life, it would be a later generation of artists and psychologists, especially Freud, who would connect childhood exuberance with creativity. So too does Cassatt signal this relationship by having the young girls become the personifications of art, music, and dance in the third panel.

ART, MUSIC, DANCING

In the right-hand panel, *Art, Music, Dancing* (figure 38), three women are situated in a barren landscape similar to that of the left panel. If contemporary reproductions can be trusted, there is a small tree in a boxed planter to the right and a flowering spray of what look to be irises in the lower left-hand corner. There is also the indication of a few shrubs and trees at the horizon. As noted earlier, the prevailing colors of the right-hand panel of *Art, Music, Dancing*, according to Lucy Monroe, were the complementary "corn-color and violet against green."[47] In the middle and toward the foreground, women in modern dress are represented as the personifications of dance, music, and art, if read from left to right. They are also the women who the three girls in the left-hand panel may aspire to be.

The figure representing dancing, on the left, faces to our right holding her skirt

Figure 38. Mary Cassatt, *Art, Music, Dancing,* right-hand panel of *Modern Woman,* 1893. From Hubert H. Bancroft, *The Book of the Fair* (Chicago, 1893), 263. Photo courtesy of General Research Division, New York Public Library, Astor, Lenox, and Tilden Foundations.

with the tips of her fingers as if performing a modern skirt dance. She is accompanied by a woman, the personification of music, seated in the middle playing a banjo, a musical instrument which, like the skirt dance, signified modernity in the early 1890s. (In fact, Cassatt portrayed a woman playing the instrument in another work, *The Banjo Lesson,* a pastel from 1894 [figure 39].) At the right sits Art, who holds none of the traditional attributes of this personification but is represented as an observer.

Of the three figures, the woman representing dance is the most surprising since the skirt dance was a form made popular in British music halls (figure 40). By the late 1880s it had also become the vogue in the United States. After the painting was installed, an early critic of Cassatt's mural confirmed that "on the right is the representation of the modern 'skirt-dance.'"[48]

The most popular exponent of the skirt dance was the American Loïe Fuller (figure 41), who introduced it to Paris at the 1889 Universal Exposition. She returned to Paris in 1893 when she introduced her sensational fire dance, a performance of translucent swirling skirts and moving lights, at the exact time that Cassatt was completing her mural.

Ruth St. Denis and Isadora Duncan are usually credited as the pioneers of modern dance, with Fuller relegated to the world of popular entertainment. Only recently has Fuller been given credit for creating an alternative to classical ballet and establishing a bridge to the highly personal work of St. Denis and Duncan two decades later. In her own time Fuller was acclaimed as the creator of "a new dance art" that

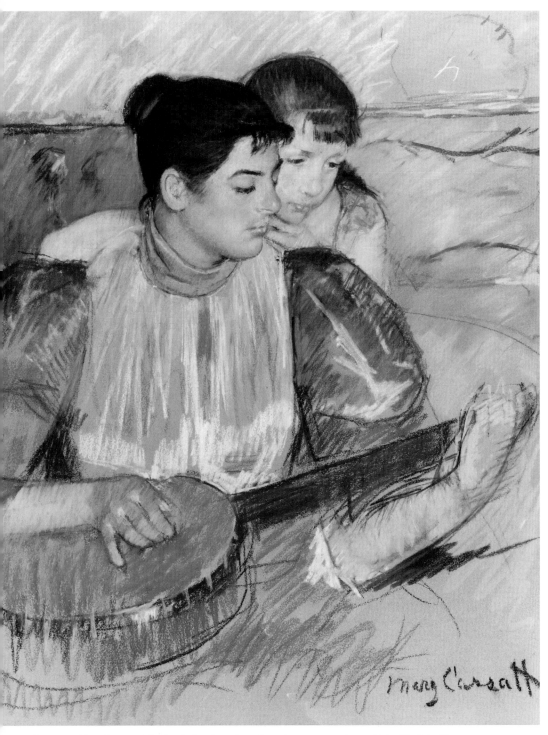

Figure 39. Mary Cassatt, *The Banjo Lesson,* 1894. Pastel on paper, 28 × 22 ½ in. Virginia Museum of Fine Arts, Richmond, Adolph D. and Wilkins C. Williams Fund. Photo by Katherine Wetzel © Virginia Museum of Fine Arts.

Figure 40. "Letty Lind performing in a skirt dance." From J. E. Crawford Fitch, *Modern Dancing and Dancers* (Philadelphia: Lippincott, 1912), facing p. 78. Photo courtesy Columbia University Libraries.

Figure 41. Sarony, Loïe Fuller, cabinet photograph, ca. 1890–1910. Jerome Robbins Dance Division, New York Public Library for the Performing Arts, Astor, Lenox, and Tilden Foundations.

challenged the hegemony of classical ballet, which by the 1890s had become a declining art. Her renowned serpentine dance (1891) and fire dance (1895) greatly inspired French writers and artists, including Stephan Mallarmé, Henri Toulouse-Lautrec, Eugène Carrière, and Auguste Rodin.

> Fuller's arrival coincided with the blooming of Art Nouveau, the development of symbolist performance theories, and the conversion of theaters from gas to electric illumination. With the first fluctuations of her silks, Fuller took Art Nouveau on stage, where the symbolist found in her dreamlike images a perfect reciprocity between idea and symbol. Fuller's enigmatic and entranced presence . . . allowed for the supremacy of image, which freed dance from the restrictions of character and narrative and forged the path toward modern dance abstraction.[49]

Cassatt's interpretation of the skirt dance depends less upon Fuller's sensuous showmanship than upon the more decorous presentations in England and the United States. In London, Letty Lind (see figure 40) performed the dance in a manner surprisingly reminiscent of the pose of Cassatt's dancing figure. The skirt dance's popularity in the United States was such that it was satirized in the *New York World* (figure 42). This illustration dating from 1892 shows not only young society matrons performing the dance on stage but, toward the right-hand side, another young woman accompanying them on a banjo. The skirt dance and the banjo in Cassatt's painting are evidence that the artist was very conscious of her American audience.

By the 1890s this type of social dancing, in contrast to ballet, was seen as a healthful exercise and a "means of teaching grace, manners, and a sense of form."[50] Called the Delsarte system, this regime of graceful exercises lifted the onus from physical exercise as an unladylike pursuit and, as a form of aesthetic calisthenics, such exercise became acceptable to genteel society.

It is hard to overestimate the impact of the Delsarte system on American dance and physical culture.[51] As a young woman St. Denis was directly influenced by its precepts, having seen a performance and demonstration (1892) by Genevieve Stebbins, author of several books that introduced the system to a broad American public.[52] As noted in the *International Encyclopedia of Dance*: "Delsartism paved the way for two middle-class women, Ruth St. Denis and Isadora Duncan, not only to become professional dancers but to initiate and lead a far-reaching renaissance of the art of dance."[53] It was Cassatt's skirt dancer, not Degas's ballerina, who presaged the modern era for women.

Extending the meaning of Cassatt's contemporary image of dance is her personification of music as a woman playing a banjo.[54] As Cassatt wrote to Bertha Palmer in one of her few references to the mural, her image of Music would contain "nothing of St. Cecilia."[55] In other words, Cassatt rejected the virtuous piety of Cecilia, the patron saint of music, whose traditional attribute is the hand organ.[56] Instead Cassatt's modern Music plays the banjo.

Both Music and Dance are observed by Art, who has no attributes. She sits sideways, looking to her right, observing the informal performances of her two companions, and may be Cassatt herself. Without sketchbook or palette she represents the

Figure 42. "At a Society Skirt Dance," *The World,* May 1, 1892, 1. Photo courtesy of New York Public Library, Astor, Lenox, and Tilden Foundations.

moment of inspiration before creation. She slips the bounds of allegory and is a link between the mural and the viewer.

There is an intriguing but obscure source for the right-hand panel that would have been known to Cassatt: Marie Bracquemond's *Les Muses des Arts* (figure 43), a decorative panel made of faïence tiles and conceived as the central narrative of a multipanel design. It was shown at the International Exposition of 1878. The following year, Bracquemond showed several studies (cartoons) for this work at the fourth impressionist exhibition. This was also the first time Cassatt exhibited with the group.

Among the female figures in Bracquemond's work are three personifications: Dance (figure 44), which was not included in the central panel; Painting, seated at the left, clutching brushes; and Music, playing a cello.[57] Bracquemond titled a drawing for Music "Sainte Cécile" when it was published in 1879 in *La Vie moderne*, which furthers the connection to Cassatt.[58] Equally significant is Bracquemond's painting *The Three Graces de 1880* (Mairie de Chemille). By including the date in her title she expresses her intention to create a modern-day version of this timeless trio, representations of which dated back to antiquity. It is not much of a leap to liken Cassatt's three personifications of music, art, and dance to the three graces, but here as symbols of women's creativity. This idea is consistent with her modernizing of the Garden of Eden as a place of women's emancipation.

Cassatt's mural was seen by a large and active group of progressive American

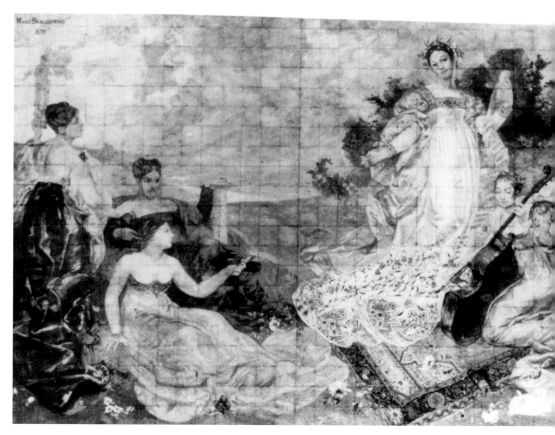

Figure 43. Marie Bracquemond, *Les Muses des Arts* (detail), 1878. Faïence tile panels, Maison Haviland. Reproduced in Joel Isaacson, *The Crisis of Impressionism* (Ann Arbor: University of Michigan Museum of Art, 1980), 59, fig. 12. Used here by permission of Jean-Paul Bouillon, Paris.

women who attended the World's Columbian Exposition. These women sought inspiration and confirmation in the fair's many women's congresses and in the Woman's Building itself, and, as evidenced by contemporary commentaries, they well understood Cassatt's program. Nonetheless, her mural was criticized for being disharmonious with the Hall of Honor's overall white and yellow color scheme, and for the lack of compositional unity among the three panels. While these may have been legitimate complaints, it is important to understand the origins of Cassatt's design since it was a product of an extraordinary knowledge of the key issues of modern mural painting and the decorative aesthetic. In the late 1870s, Cassatt acquired a sophisticated understanding of the aims of impressionism, an understanding and acceptance that led to a dramatic change in her work. Given her deep involvement with and commitment to the most avant-garde aesthetic ideas of her time, it is not surprising that her mural commission prompted her to break with the conventions of impressionist easel painting and instead seek out the newest ideas surrounding mural and decorative art.

Figure 44. Marie Bracquemond, *La Danse*, 1878. Crayon with white heightening, 13 × 9 ⁷/₈ in. Reproduced in Joel Isaacson, *The Crisis of Impressionism* (Ann Arbor: University of Michigan Museum of Art, 1980), 59, fig. 13. Used here by permission of Jean-Paul Bouillon, Paris.

THE MURAL'S DESIGN

Overall the mural is approximately fifteen feet high by sixty-four feet wide, including a deep border that varies from two to three feet in width. After considering the enormous space her mural was to occupy, Cassatt decided to reduce the size of the pictorial field by bounding her mural with a deep border. In a letter to MacMonnies, Cassatt noted that the base was one meter (3.3 feet) wide, the narrower, upper border was seventy-five centimeters (2.5 feet), and the two upright dividers were each eighty centimeters wide (2.7 feet).[59]

Yet she made changes in the border, as evidenced by a comparison of a photograph in Maud Howe Elliott's *Art and Handicraft in the Woman's Building* (see figure 3), probably taken in Paris, and another (see figure 25), taken after the mural was installed in Chicago, which appeared in Bancroft's *The Book of the Fair*. The original painted framework was richly decorated in a Renaissance style with a running garland, which in turn, was complemented by dark blue bands striped with gold. As a

notice in the Chicago edition of *The Graphic* indicates, by the time Cassatt's mural arrived in Chicago, these decorations had been replaced by "conventionalized leaves."[60] It can also be noted that Cassatt eliminated the sunflowers that had appeared on the two vertical struts framing the central panel. In addition, she changed the images in the rondels along the bottom edge of the mural. In Elliott's illustration, all five rondels show the same nude infant. In the mural as installed, babies remain in the three central rondels (figure 45) but the two outer rondels contain fruit.

Cassatt's mural had been photographed in Paris, probably in late 1892, for an article in *Harper's*. Cassatt mentioned this event in a letter dated January 6, 1893, to her dealer, Paul Durand-Ruel: "I have already (and to my great regret and only to please those ladies) provided photographs for an article that should appear in Harpers in March."[61] Two of these photographs appeared in Candace Wheeler's "A Dream City" (May 1893), which was the only article on Cassatt's mural that appeared that spring in *Harper's [New Monthly Magazine]*. The two parts of the mural that were reproduced there are a rondel from the border, on page 836, and the central section (without the border), on page 837. Presumably, Elliott's book was illustrated with another of these Paris photographs, as was a book entitled *Three Girls in a Flat*, published in 1892, which carried an illustration of the central panel, with the original border. The latter book's date helps confirm that the photographs were taken that year. One of the authors was Laura Hayes, who was Palmer's personal secretary. I assume that Hayes obtained this early photograph directly from Palmer.[62]

Cassatt did retain cameo-like images of two women in the top corners of the central image and bust-length images of women in diamond-shaped frames to the immediate right and left of the central image. These latter two images suggest Renaissance patron portraits.

Cassatt may have changed her border in response to a complaint from Mary MacMonnies, who had used nearly the full space of the north tympanum for her design. MacMonnies's border was a narrow single frame composed of naturalistic and geometric elements. MacMonnies believed that the two murals would not be complementary, and she expressed her concerns to Bertha Palmer and Sara Hallowell. Cassatt, in her own defense, wrote to MacMonnies, reminding her that she had told Palmer that she intended to add a border. She ended her letter by suggesting that if Palmer thought about how high the two works would be placed, "she would see that there could be no necessity for unity."[63]

Cassatt was fatalistic about the fact that their works would barely been seen at the height at which they were to be installed. To Palmer she wrote that "better painters than I have been put out of sight," adding that even Paul Baudry's fine decorations at the Grand Opera were "buried in the ceiling." Yet she was proud of her work and annoyed that the viewer's appreciation would be compromised by its high placement. As she wrote to her patron: "I think, my dear Mrs. Palmer, that if you were here & I could take you out to my studio & show you what I have done that you would be pleased indeed without too much vanity I may say I am almost sure you would." But as she also wrote, "When the work reaches Chicago, when it is dragged up 48

Figure 45. Mary Cassatt, cupid from border of *Modern Woman*. *Harper's New Monthly Magazine*, May 1893, 836.

feet & you will have to stretch your neck to get sight of it all, whether you will like it then, is another question."[64]

At that height, as far as Cassatt was concerned, the difference in size between the borders was immaterial. Even so she was mindful of the decorative purpose of her mural's border, which may also account for the changes she made in its design. To a large extent, Cassatt's painted frame reflects Renaissance convention. Elaborate floriated borders were hallmarks of Correggio's decorations for the interior dome of the Parma Cathedral. Cassatt alluded to another decorative source in her letter to MacMonnies. She wrote, "You will perceive that I went to the East for the foundation of the idea,"[65] meaning that the decorative function of the border and the design of the mural itself could be traced to Asian, presumably Japanese, sources. Internally, the three panels are loosely connected by a horizon line placed high within each field. In the left and right panels the landscape appears almost barren and the ground reads as a flat plane, as in a Japanese print.

Cassatt's remark implies a sophisticated knowledge of Japanese aesthetics, a decorative aesthetic well understood by connoisseurs in the late nineteenth century. This acute appreciation of Asian design was promoted by artists, writers, and dealers such as Samuel Bing, who in 1888, in the first issue of the publication *Le Japon artistique*, declared presciently that Japanese art was an "'art nouveau' that would have a lasting impact and seductive influence on European creativity."[66]

As is well known, Cassatt's enthusiasm for Japanese woodcuts greatly influenced

her printmaking. At the time she was working on her mural, the most important new stimulus for her work was the Japanese print, a passion she shared with her friends Degas, Pissarro, and Morisot. All of them had been greatly impressed by the immense display of over a thousand prints, albums, screens, and illustrated books organized by Bing at the Ecole des Beaux-Arts in the spring of 1890.[67] The impact of this exhibition was immediately apparent in the suite of prints that Cassatt exhibited the following year.

Both Judith Barter and Elliott Davis have identified certain Japanese prints that influenced Cassatt's prints of the early 1890s. As both writers make clear, Cassatt's interest in these prints lay primarily in their technique and composition and, with their focus on the everyday life of women, in their content as well.[68] These domestic, feminine themes pervade Cassatt's mural. It is also the Japanese aesthetic—the use of broad areas of intense color, flattened space, and linear construction—that informed Cassatt's border and the mural itself, particularly its two flanking panels. Confirming this idea is the observation by the critic Lucy Monroe that the mural was "painted flat without shadows."[69] The central panel, however, includes other elements: the lingering influence of impressionism, the mural aesthetic of Puvis de Chavannes, and a new interest in Renaissance art.

The overall mood of the central panel is gay and unaffected. The domestic animals and young girls give the work a playful, realistic note, and the orchard setting connects it to the realm of the everyday and to the paintings by her impressionist colleagues Berthe Morisot and Camille Pissarro. Yet there is a solemnity amidst all this activity that is communicated through the seriousness of the women's expressions and their stately poses. Significantly the proud demeanor of the women aligns this work with the ideals of monumental painting as found in the work of Cassatt's contemporary Puvis de Chavannes and the early Renaissance master Botticelli.

Cassatt's allegiance to naturalism was long-lived and remained characteristic of her style. Yet in the late 1880s, she, Pissarro, and Morisot explored the theme of the orchard as the catalyst for large-scale paintings that signal an important shift in their work. For Pissarro the orchard was a motif that propelled his exploration of neo-impressionism. For Morisot it served as the scaffold for an incursion into decorative painting. For Cassatt it became the genesis of a monumental allegory.

In the 1880s, Pissarro began to use the orchard as a site for the representation of the sturdy peasant that characterizes much of his work. In *Apple Picking at Eragny-sur-Epte* (figure 46), Pissarro attempted "to sum up his work in a single oeuvre," according to Martha Ward. Ward further states that this painting "best shows Pissarro's ambitions for something other than impressionism. . . . This was his largest picture from the early part of the decade and the one where he clearly attempted. . . to create a definitive piece, a grand oeuvre: multifigural, highly worked, intricately complex."[70] The orchard theme, as evidenced in the mural's central panel, also enabled Cassatt to make the transition from naturalism to allegory.

Morisot's two versions of *The Cherry Tree* (both were begun in 1891) (figure 47) are vertical paintings done in a very free, brushy style and are greatly influenced by the contemporary work of Renoir. Her palette is hot and the figures are lost in a rich

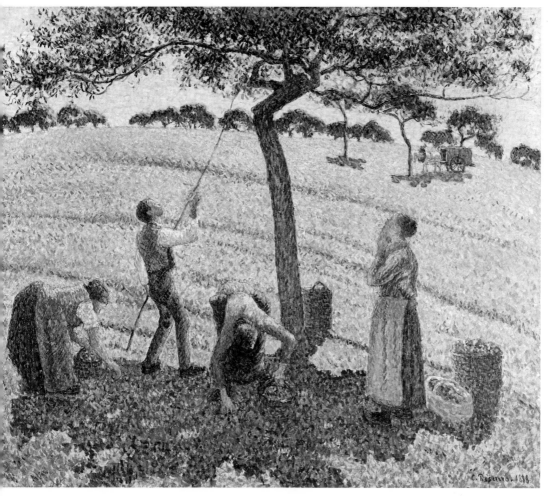

Figure 46. Camille Pissarro, *Apple Picking at Eragny-sur-Epte*, 1888. Oil on canvas, 23 × 28 ½ in.
Dallas Museum of Art, Munger Fund, 1955.17.M.

tapestry of green leaves and patches of blue sky. Green and blue are the paintings'
major keys, with grace notes of red, yellow, and white. In front and within the trees
is a triangular ladder upon which a young woman stands plucking cherries. These
she places in a basket held by her companion standing below. It has been speculated
that both of these large-scale paintings, which are universally admired for their paint-
erly treatment and decorative effect, were conceived as part of the decorative scheme
for Morisot's new home in Mézy, a project abandoned upon the death of her hus-
band.[71] The fact that they may have been intended as decorations provides a pro-
vocative link to Cassatt's later project, for it was during this time that Morisot and
Cassatt were the most intimate. Yet Morisot had not begun work on *The Cherry Tree*
during the summer of 1890 when Cassatt rented a house in nearby Septeuil. But
Morisot did bring the paintings to Paris, where Cassatt might have seen them in her

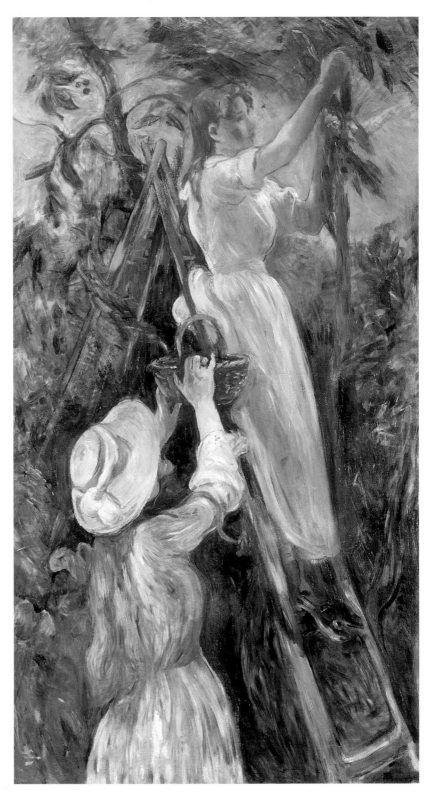

Figure 47. Berthe
Morisot, *The Cherry
Tree*, 1891. Oil on
canvas, 60 5/8 × 33
7/16 in. Musée
Marmottan, Paris.
Photo courtesy
Giraudon /
Bridgeman Art
Library.

studio.[72] Yet Morisot's studies and paintings are different from Cassatt's. Morisot's focus is on the tree and the figures, not the larger ambience of the orchard. Her paintings are more decorative, in the sense that works by Boucher (whom she admired and copied) and Renoir are thought to be pretty and colorful, not in the flat, planar way of Puvis de Chavannes or the Japanese print. Yet both Morisot and Cassatt render women as active agents of the harvest. While it can be fairly claimed that Cassatt "borrowed" motifs from Morisot, it was she, the slightly younger artist less directly burdened by domestic strain and illness (Morisot died in 1894), who was able to convert this theme of the orchard into a modern mural painting.

There was also a new generation of painters, the Nabis, specifically Pierre Bonnard and Maurice Denis, who at the time Cassatt began her mural were exploring the garden and orchard theme for large-scale painted decorations. These include Bonnard's studies for a four-panel screen (panneaux décoratifs) titled *Women in a Garden* (1890–91, Kunsthaus, Zurich) and Denis's four horizontal paintings (maybe overdoor panels) titled *Suite of Paintings on the Seasons* (1891–92, three museums and a private collection). In the latter suite, both *April* and *July* contain motifs in common with Cassatt's *Modern Woman*. In both, young women are pictured out of doors; in *April* they pick flowers in a large open field, and in the other painting they harvest apples. The work by Denis that is most closely related to Cassatt's mural is another of his decorative paintings, *Ladder in Foliage*, or as it is subtitled, *Poetic Arabesques for the Decoration of a Ceiling* (1892, Musée Départemental Maurice Denis "Le Prieuré," St.-Germain-en-Laye), which was exhibited publicly in 1892.[73] Four women in soft, flowing gowns are on a ladder that floats in a flat, tapestry-like expanse created by the foliage and patches of sky. These are not the industrious or even symbolic women of Cassatt's mural yet this large-scale decorative project was indicative of the Nabis' desire to modernize allegorical art. As Nicholas Watkins notes in the exhibition catalogue *Beyond the Easel*, "mythological painting was in a sense domesticated. . . . the subjects of interior and still life [and I would add the orchard and garden] were elevated to the scale and status of history painting."[74]

Degas was contemptuous of mural or decorative painting, which was one of the reasons Cassatt did not seek his advice. In a letter to Pissarro at the time she began work on her painting, she wrote: "You ought to hear Degas on the subject of a woman's undertaking to do such a thing, he has handed me over to destruction."[75] Cassatt should have not been so trusting that Pissarro shared her enthusiasm for mural painting. That fall he had a conversation with Degas about Cassatt's project. They did not object to the fact that Cassatt as a woman was undertaking such a project; rather they questioned the value of "decoration." Pissarro's opinion, which he shared in a letter with his son Lucien, reflected current debates about the use of painting within architecture. "Speaking about Miss Cassatt's decoration, I wish you could have heard the conversation I had with Degas on what is known as 'decoration.' I am wholly of his opinion; for him it is an ornament that should be made with a view to its place in an ensemble, it requires the collaboration of architect and painter. The decorative picture is an absurdity, a picture complete in itself is not a decoration."[76]

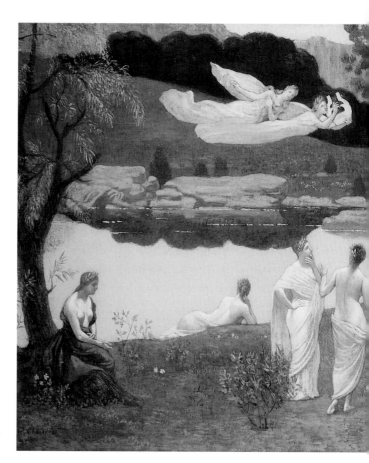

Figure 48. Puvis de Chavannes, *The Sacred Grove, Beloved of the Arts and of the Muses*, 1884–89. Oil on canvas, 36 ½ × 91 in. Art Institute of Chicago, Mr. and Mrs. Potter Palmer Collection, 1922.445. All Rights Reserved.

For Pissarro, as well as for France's premier muralist, Puvis de Chavannes, murals could succeed as decoration only when the painter and the architect worked together to create a harmonious ensemble, pictorially and coloristically.[77] This was not the case with Cassatt's commission. As far as is known she had no contact with Sophia Hayden, who virtually handed over the coordination of the decoration of the interior to Bertha Palmer and Candace Wheeler. Yet Cassatt was influenced by Puvis's use of allegory and personification, which she assimilated into her own naturalistic style. The landscape setting of *Modern Woman* is not imagined; it is the orchard and fields near her home at Bachivillers, and her models are local women in modern dress whom she hired to pose for her. But Cassatt's garden, however naturalistically conceived, remains an imaginary space, a female academy comparable to the academic grove Puvis de Chavannes created for two murals, *The Sacred Grove, Beloved of the Arts and the Muses* (1884), which was exhibited at the Salon of 1884, and *The Allegory of the Sorbonne* (1889). A replica of *The Sacred Grove* (figure 48) was bought by the Potter Palmers in 1890, and a replica of the other mural (figure 49) was purchased by the Havemeyers in 1889. Both replicas, painted by Puvis, were exhibited in New York

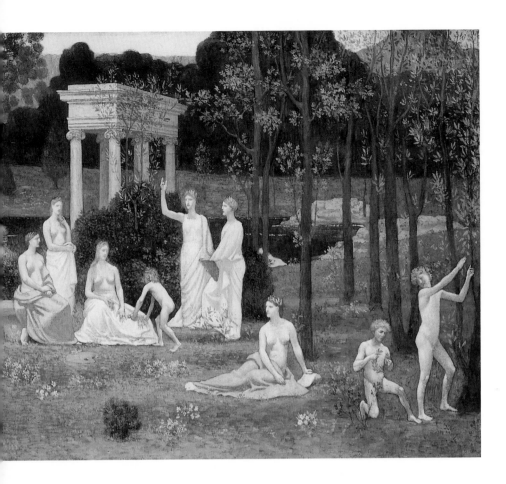

in the early 1890s.[78] This underscores the importance of the two murals for an American audience. They were also important for Cassatt.

The Sacred Grove is an oil-on-canvas mural designed for the stairway in the new wing of the Lyons Museum. Its subject, appropriate to a museum, is a mythological landscape where personifications of artistic and creative inspiration reside. A few years after beginning the mural, Puvis was invited to create a complementary project, *The Allegory of the Sorbonne*, a vast frieze for the back wall of the great lecture hall of the Sorbonne.[79] As a decoration for one of the preeminent European universities, Puvis's complex program contains personifications of many branches of learning, including the humanities, the arts, and the sciences. Similarly Cassatt has created a "sacred grove" for the intellectual and artistic ambitions of women. While Cassatt does not borrow stylistically from Puvis, the two share a dedication to knowledge and its transference from one generation to the next. Puvis's work represented a national enterprise; Cassatt's efforts, on the other hand, were more personal, yet at the same time her mural had universal appeal.

Yet there is a third painting by Puvis, *Inter Artes et Naturam* (figure 50), that, with

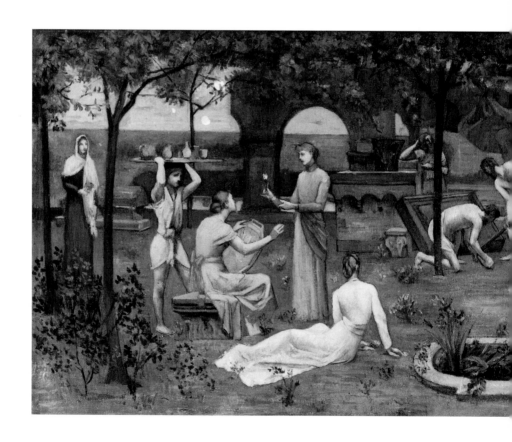

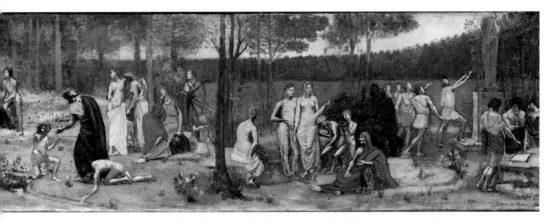

Figure 49. Puvis de Chavannes, *The Allegory of the Sorbonne,* 1889. Oil on canvas, 32 ⅝ × 180 ¼ in. Metropolitan Museum of Art, New York, H. O. Havemeyer Collection, Bequest of Mrs. H. O. Havemeyer, 1929, 29.100.117. All Rights Reserved.

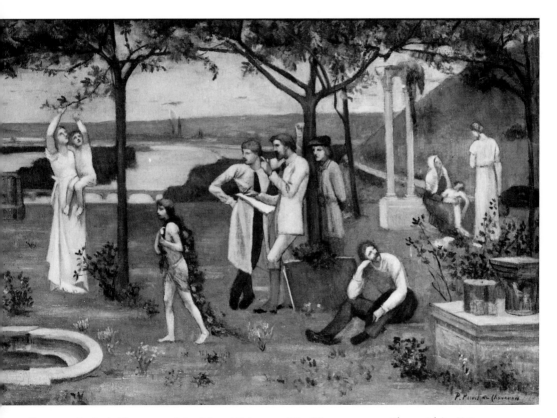

Figure 50. Puvis de Chavannes, *Inter Artes et Naturam,* 1889. Oil on canvas, 15 ⅞ × 44 ¾ in. Metropolitan Museum of Art, New York, Gift of Mrs. Harry Payne Bingham, 1958, 58.15.12. All Rights Reserved.

its orchard setting and central figures of a mother and child reaching upward for fruit from a tree, bears the closest correspondence among his works to Cassatt's mural.[80] In fact, the central pair of mother and child in Puvis's painting is repeated almost exactly in an 1893 painting by Cassatt called *Baby Reaching for an Apple* and in a color print called *Gathering Fruit* also completed in 1893. This is one of the rare instances in which Puvis's figures are clothed in modern dress. No longer the imagined land of ancient times, the background of Puvis's mural is a hilltop vista over the Seine and the city of Rouen beyond. In the foreground are ancient ruins and figures in numerous activities commemorating the rich cultural and artistic traditions of Rouen.

In addition to contemporary French sources, Cassatt was influenced by the works of Botticelli, specifically his *Primavera*, which, with its orchard setting, is often cited as a provocative source for Cassatt's central panel.[81] Botticelli was rediscovered as a part of the larger nineteenth-century excavation of the Italian Renaissance. The reputations of Raphael, Leonardo, and Michelangelo had never faded, yet an interest in lesser-known artists, particularly those "primitives" who preceded Raphael, was sparked in part by the first complete English translation of Vasari's *Lives*, by Mrs. Jonathan Foster, in 1850. The next decade witnessed the publication of *A New History of Painting in Italy from the Second to the Sixteenth Century* (1864–66), by the English writer J. A. Crowe and the Italian writer and artist G. B. Cavalcaselle, which for over a century was one of the most influential texts on Italian art. In 1875 in France, Charles Blanc, founding editor of the *Gazette des Beaux-Arts*, published a monumental history of Western painting that included a volume on Italy by Paul Mantz, which would be published as a separate book in 1883.

Walter Pater, perhaps the most influential of all these biographers, critics, and historians, in his book *The Renaissance* (1873) took the material facts of these earlier authors and created an appreciation of the fifteenth and sixteenth centuries that for its day was modern. In his book Pater shunned the sacred aspects of Renaissance art and focused more firmly on the pagan. For Pater no artist better represented the dualism between Christianity and paganism than Botticelli, who became the patron saint of the British Aesthetic movement. For that movement's adherents, Botticelli was a modern old master.

In France interest in Botticelli was galvanized when the Louvre announced in 1882 that it had purchased two newly rediscovered frescoes from the Villa Lemmi. The critic Charles Ephrussi wrote ecstatically about the purchase, noting that it made the Louvre's collection of Renaissance frescoes preeminent.[82] (We should recall that it was Mary MacMonnies's copies of Botticelli's Lemmi frescoes that brought her to Bertha Palmer's attention.) Yet of all Botticelli's works, the most acclaimed was his *Primavera*, which embodied the antimaterialist, antinaturalist, and secular qualities admired by British artists such as Burne-Jones and later by the French symbolists.

In Botticelli's *Primavera* (figure 51) spring's arrival takes place in an enchanted orchard. Spring is personified by a beautiful young woman in a flowing dress who tranquilly stands in the center. To her left is Flora, behind whom the North Wind blows. On Primavera's right are the Three Graces, and beside them Mercury plucks

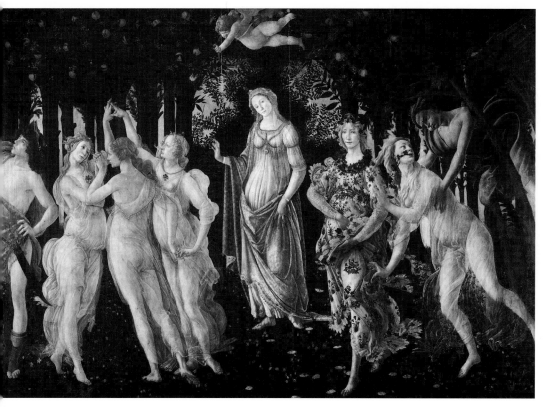

Figure 51. Sandro Botticelli, *Primavera*, 1477–78. Tempera on wood, 6 ft. 8 in. × 10 ft. 4 in. Uffizi Gallery, Florence. Photo, collection of the author.

fruit from an overhanging branch. The pose of Mercury recalls the gestures of two women reaching for apples in Cassatt's central panel, and the presence of the Three Graces may have inspired Cassatt to update them, calling them Art, Music, Dance.

While Cassatt doubtless had independent knowledge of Botticelli, it may have been Morisot who introduced her to the decorative potential of the *Primavera*. In 1888, while Morisot was staying in Nice, she decided to create a "decorative" picture "in the spirit of Botticelli's *Primavera*," which Charles Stuckey believes led her to explore the theme of the cherry tree.[83] Botticelli's painting had been on her mind for she had noted in her journal that she had seen a reproduction of "Botticelli's *Spring*" in a photographer's studio "on the corner of the rue de Beaune." She speculated that she perhaps understood it better because the reproduction was in black and white but then added that "the colors of the [Botticelli] frescoes in the Louvre, though, are so impressive."[84] (These are the frescoes that MacMonnies had recently copied.)

At the same time, shortly before Cassatt accepted the mural commission, the art critic Theodore Childs published his *Art and Criticism*, a book intended for an American audience. In it he declares the *Primavera* to be Botticelli's "greatest picture" and refers to it alternately as an "allegory of spring," a forest, an orchard, or a "Garden

of Eden."[85] Cassatt modified and Americanized Botticelli's Garden of Eden, and her decision to pay hommage to this old master, as well as to naturalism, japonisme, Puvis de Chavannes, and the Nabis, is entirely consistent with her project to help "fine things across the Atlantic."[86]

Although Cassatt has always been considered an expatriate artist, she never gave up her American citizenship. Most of her patrons were American and since the turn of the twentieth century she has been considered one the country's foremost women artists. She also worked passionately and diligently with Louisine Havemeyer to create one of the foremost collections of nineteenth-century French painting in the United States. This European/American bifurcation was important for Cassatt and for most serious American artists and collectors. The United States was without a high art tradition—the art schools and museums of today did not exist while Cassatt was growing up—and she consciously went about instructing American collectors in the only way she knew, by encouraging them to buy the best and most adventuresome of the new painting. It was impossible to import fine examples of mural painting—reductions and replicas excepted. The opportunity afforded her by the Woman's Building commission allowed her to demonstrate to an American audience mural painting's potential and effectiveness in decorating and ennobling interior public spaces. While neither patriotic nor specifically nationalistic, *Modern Woman* embodies an understanding of women's new status in the United States. In its representation of women's ambitions it is also semiautobiographical. The three panels of *Modern Woman* represent the three ages of woman: the child, the young woman, and the mature adult. They are shown not in their domestic roles as girl, wife, and mother but as aspiring scientists, intellectuals, and artists. These aspirations, traditionally associated with men, Cassatt claimed for herself and in Chicago for all womankind.

Notes

1. Cassatt to Palmer, October 11 [1892], Mathews, *Cassatt and Her Circle*, 238.

2. Monroe, "Chicago Letter," April 15, 1893, 240.

3. On Eve and women's history see Norris, *Eve*, and Barbara Taylor, *Eve and the New Jerusalem: Socialism and Feminism in the Nineteenth Century* (New York: Pantheon, 1983). See also Joy S. Kasson, *Marble Queens and Captives: Women in Nineteenth-Century American Sculpture* (New Haven: Yale University Press, 1990), and Bram Dijkstra, *Idols of Perversity: Fantasies of Feminine Evil in Fin-de-Siècle Culture* (New York: Oxford University Press, 1986).

4. Phillips, *Eve*, xiii–xiv.

5. John Milton, "Paradise Lost," in *The Complete Poetry and Selected Prose of John Milton* (New York: Modern Library, 1950), 175.

6. Behnke, *Religious Issues*, 2–3.

7. Weitzenhoffer, *The Havemeyers*, 195.

8. For more information on Cassatt and suffrage, see Kevin Sharp, "How Mary Cassatt Became an American Artist," in Barter et al., *Mary Cassatt: Modern Woman*, 169–70.

9. Leach, *True Love*, xi.

10. Stanton et al., *The Woman's Bible*, 214.

11. Ibid., 24–25.

12. Leach, *True Love*, 12.

13. E. Stanton, *Eighty Years and More*, 395. Later, when Stanton read Comte more fully, she would disavow his views on women. Speaking of her stay with her daughter in England she noted: "We read, too, Harriet Martineau's [1853] translation of the works of August Comte, and found the part on women most unsatisfactory. He . . . seems to think the subjection of women in modern civilization a matter of no importance." Earlier she had written approvingly on Comte; see "Positive Philosophy (Part I)," *The Revolution*, April 16, 1868, 228–29, and "Positive Philosophy (Part II)," *The Revolution*, April 30, 1868, 262–63.

14. Elizabeth Cady Stanton, "Peter and Paul at the Toledo Convention," *The Revolution*, March 25, 1869, 814–15.

15. Solomon, *In the Company of Educated Women*, 18 (second quote), 25 (first quote).

16. Ibid., 46.

17. Ibid., 56.

18. Ibid., 20. Also see George Cotkin, "Woman as Intellectual and Artist," in *Reluctant Modernism: American Thought and Culture, 1880–1900* (New York: Twayne, 1992), 74–99, for an excellent summary of the obstacles American women faced and the progress they made in the late nineteenth century.

19. See Peck and Irish, *Candace Wheeler*, 66–67.

20. For a full discussion of the commissioning of these paintings and biographical information on the artists see Garfinkle, "Women at Work," chapter 6; Peck and Irish, *Candace Wheeler*, 63–70; Martha J. Hoppin, *The Emmets: A Family of Women Painters* (Pittsfield, Mass: Berkshire Museum, 1982); and Tara Leigh Tappert, *The Emmets: A Generation of Gifted Women* (New York: Borghi, 1993).

21. According to Jeanne Weimann, this was an important topic at the 1893 fair. See Jeanne Madeline Wiemann, "Fashion and the Fair," *Chicago History* 13, no. 3 (Fall 1983): 48–56.

22. Reprinted in Mathews, *Cassatt and Her Circle*, 237–38. It has not been possible to identify the writer to whom Cassatt refers. The critic Mariana Van Rensselaer in the December 1892 *New York World* later voiced her opinion regarding Cassatt's use of fashions by Worth and Doucet.

23. For further information on dress reform in the late nineteenth century, see Sally Buchanan Kinsey, "A More Reasonable Way to Dress," in *"The Art That Is Life": The Arts and Crafts Movement in America, 1875–1920*, ed. Wendy Kaplan (New York: Little Brown, 1987), 358–69; and Elizabeth Wilson, *Adorned in Dreams: Fashion and Modernity* (London: Virago, 1985).

24. On dress reform and women's health, see Sarah Levitt, "From Mrs. Bloomer to the Bloomer: The Social Significance of the Nineteenth-Century English Dress Reform Movement," *Textile History* 24, no. 1 (1993): 27–37, and Newton, *Health, Art, and Reason*.

25. See Elaine Shefer, "Pre-Raphaelite Clothing and the New Woman," *Journal of Pre-Raphaelite Studies* 4, no. 1 (November 1985): 55–67; and Elizabeth Aslin, "The Fashionable Aesthete," in Aslin, *The Aesthetic Movement: Prelude to Art Nouveau* (New York: Praeger, 1969), 145–59.

26. The Rational Dress Society was formed in 1881 and sponsored exhibitions of healthy dress during the 1880s at the International Health Exhibitions. Its successor was the Healthy and Artistic Dress Union, formed in 1892. Its journal, the *Aglaia*, began publication in 1893 and its writers included Walter Crane and Arthur Lasenby Liberty. In addition to the *Aglaia* other important contemporary sources are Ada Ballin, *The Science of Dress in Theory and Practice* (London: Sampson and Low, 1885), and Mary Eliza Haweis, *The Art of Dress* (London: Chatto and Windus, 1879).

27. Arthur Lasenby Liberty, *Form and Colour Developments* (London: Liberty, 1890), 3.

28. Wilde contributed directly to the dress reform movement through his editorship of the short-lived magazine *Woman's World*. Published between 1888 and 1890, it contained many articles on women's emancipation, advocating professional training for women, women's collegiate education, and dress reform.

29. Katherine Cassatt to Alexander Cassatt, July 21, 1891, reproduced in Mathews, *Cassatt and Her Circle*, 222.

30. See Barbara Welter, "The Cult of True Womanhood: 1820–1860," *American Quarterly* 18 (Summer 1966): 151–74; and Carroll Smith-Rosenberg, *Disorderly Conduct: Visions of Gender in Victorian America* (New York: Oxford University Press, 1985).

31. Mary Virginia Terhune [Marion Harlan], *Eve's Daughters; or Common Sense for Maid, Wife, and Mother* (New York: John R. Anderson and Henry S. Allen, 1882), 61. Mary Terhune was one of Mary Kelley's "literary domestics." See Mary Kelley, *Private Woman, Public Stage: Literary Domesticity in Nineteenth-Century America* (New York: Oxford University Press, 1984).

32. Dio Lewis, *Our Girls* (New York: Harper, 1871), 71.

33. Jan Todd, *Physical Culture and the Body Beautiful: Purposive Exercises in the Lives of America Women, 1800–1870* (Macon, Ga.: Mercer University Press, 1998), 254.

34. E. Stanton, "Our Young Girls," 26.

35. Ibid., 27.

36. Ibid., 44.

37. Ibid., 58.

38. Elizabeth Wilson, *Fifty Years of Association Work among Young Women, 1866–1916: A History of the Young Women's Christian Association in the United States* (New York: National Board of the Young Women's Christian Association, 1916), 100–101, 198.

39. "On both sides of the Atlantic, the 'Greenaway vogue,' as it was known, was launched at the appearance of *Under the Window*, 1879, Kate Greenaway's first full-length illustrated book." Thomas E. Schuster, *Printed Kate Greenaway: A Catalogue Raisonné* (London: T. E. Schuster, 1986), 9.

40. This review was republished in 1883 in a collection of Huysmans's writings on art called *L'Art moderne* (Paris: G. Charpentier, 1883). At the time, Huysmans was still an active and influential supporter of the impressionists, particularly the work of Degas, and was a great admirer of Cassatt's. As a novelist he was close to the naturalist school of Emile Zola. It was only later that Huysmans became identified as one of the leading Decadents through the publication of his most famous book, *A Rebours* (Against the grain, 1884). In this plotless novel of sensuous description, Huysmans, through his character Des Esseintes, expresses his profound disenchantment with the modern world.

41. Unless noted otherwise, translations in this chapter are mine. "Sur cette mixture [of Alma-Tadema and Hokusai] habilement battue, surnage une affectueuse distinction, une souriante délicatesse, une préciosité spirituelle, qui marquent son oeuvre d'une empreinte féminine toute de dilection, toute de grâce." Huysmans, *L'Art moderne*, 201.

42. "La femme seule peut peindre l'enfance. . . . il [Crane] manque à ses aquarelles ce que je trouve chez Miss Greenaway, une sorte d'amour attendri, de ferveur maternelle." Ibid., 201–2.

43. Ibid., 201–2.

44. "Le peintre dispose les tasses à thé des personnes en scène et use comme de fleurons des volants qui passent au-dessus des vers imprimés, à la grande joie des enfants brandissant leurs raquêttes, dans le bas de la page." Ibid., 202.

45. Quoted in Barter et al., *Mary Cassatt: Modern Woman*, 69.

46. Barter notes: "Cassatt's great color-print suite marks a watershed in her career, for, in the process of its creation, her fidelity to the description of physical reality became secondary to the evocation of mood and suggestion of larger meanings. The direction her art now took had a name—Symbolism." Ibid., 85.

47. Monroe, "Chicago Letter," April 15, 1893, 240.

48. "The Mural Decoration of the Exposition," *The Graphic* (Chicago), March 25, 1893, 199.

49. *International Encyclopedia of Dance*, vol. 3 (New York: Oxford University Press, 1998), 92. Also see Clara de Morinni, "Loïe Fuller, The Fairy of Light," in *Chronicles of the American Dance*, ed. Paul Magriel (New York: Da Capo Press, 1978), 203–20.

50. Ruyter, *Reformers and Visionaries*, xiv.

51. According to Ruyter, "It was one of the three most prominent systems, along with Ger-

man and Swedish (Ling) gymnastic, to be discussed and used in the burgeoning physical education movement in the 1880s and 1890s" (ibid., 28).

52. Books by Genevieve Stebbins include *Society Gymnastics and Voice Culture* (c. 1888); *Delsarte System of Expression* (1886); and *Dynamic Breathing and Harmonic Gymnastics: A Complete System of Psychical, Aesthetic and Physical Culture* (c. 1892).

53. *International Encyclopedia of Dance*, vol. 2, 372.

54. According to Karen Linn, *That Half-barbaric Twang: The Banjo in American Popular Culture* (Urbana: University of Illinois Press, c. 1991): "By the 1880s, the banjo was a fad among young women from the upper classes in many parts of the country" (6).

55. Cassatt to Palmer, October 11 [1892], Mathews, *Cassatt and Her Circle*, 238.

56. In the third century, the wealthy young Roman woman Cecelia persuaded her husband, Valerian, to respect her chastity on their wedding night. He remained celibate and accepted his wife's Christian faith but was beheaded for his devotion. Cecelia, whose fortune was coveted by Roman officials, was "thrown into her bath filled with boiling water." Cecelia was later adopted as a patron saint by sixteenth-century musicians and also honored as a martyr. Clara Erskine Clement, *A Handbook of Legendary and Mythological Art* (New York: Hurd and Houghton, 1876), 70.

57. For the fullest discussion and illustrations of the cartoons of this faïence panel see Joel Isaacson, *The Crisis of Impressionism, 1878–1882* (Ann Arbor: University of Michigan Museum of Art, 1979–80), 58–67.

58. Ibid., 61 n. 9.

59. "My object was to reduce the huge space as much as possible by a border in such a way as to enable me to paint a picture in each of the spaces left where the figures would be rather under life size." Mathews, *Cassatt and Her Circle*, 243.

60. "Decorations for the Woman's Building," *The Graphic*, May 6, 1893, 301.

61. Cassatt to Paul Durand-Ruel, Mathews, *Cassatt and Her Circle*, 244–45.

62. Enid Yandell, Jean Loughborough, and Laura Hayes, *Three Girls in a Flat* (Chicago: Knight, Leonard, 1892), 69.

63. Cassatt to MacMonnies, Wednesday [December 1892], Mathews, *Cassatt and Her Circle*, 244.

64. Cassatt to Palmer, October 11 [1892], ibid., 244.

65. Cassatt to MacMonnies, Wednesday [December 1892], ibid., 238.

66. Seven years later Bing opened his gallery, L'art Nouveau, which gave its name to the new style, and wherein were sold Japanese arts and crafts as well as ceramics, textiles, and furniture by European artists who shared Bing's aesthetic concerns. See Gabriel P. Weisberg, *Art Nouveau Bing: Paris Style 1900* (New York: Abrams, 1986), 26.

67. Mathews and Shapiro, *Mary Cassatt*, 62–63.

68. Judith A. Barter, "Mary Cassatt: Themes, Sources, and the Modern Woman," in Barter et al., *Mary Cassatt: Modern Woman*, 45–107; and Elliott Bostwick Davis, "Mary Cassatt's Color Prints," *The Magazine Antiques*, October 1998, 484–94.

69. Monroe, "Chicago Letter," April 15, 1893, 241.

70. Martha Ward, *Pissarro, Neo-Impressionism, and the Spaces of the Avant-Garde* (Chicago: University of Chicago Press, 1996), 20.

71. Anne Higonnet has gone so far as to call it "the most monumental project of her entire career" and "the most professionally ambitious." Anne Higonnet, *Berthe Morisot's Images of Women* (Cambridge, Mass.: Harvard University Press, 1992), 13. Charles Stuckey made a similar assessment: "Morisot's *Cherry Tree* [is an] important decorative project that she would begin in earnest in 1891." Stuckey, *Berthe Morisot, Impressionist* (New York: Hudson Hills, 1988), 138.

72. Stuckey, *Berthe Morisot*, 152–55. Higonnet, *Berthe Morisot's Images*, 182–83, also makes this connection.

73. Other related work by Denis, done after Cassatt had completed work on her mural, are *The Muses: Decorative Panel* (1893, Musée d'Orsay) and a second, tondo version of *April* (1894,

private collection) and include depictions of the now familiar subjects of women in contemporary dress, out of doors, gathering and harvesting fruit and flowers.

74. Nicolas Watkins, "The Genesis of the Decorative Aesthetic," in *Beyond the Easel: Decorative Paintings by Bonnard, Vuillard, Denis, and Roussel, 1890–1930*, ed. Gloria Groom (New Haven: Yale University Press, 2001), 2.

75. Cassatt to Pissaro, June 17 [1892], Matthews, *Cassatt and Her Circle*, 229.

76. Rewald, *Pissarro Letters*, 204.

77. See Aimee Price Brown, "The Decorative Aesthetic in the Work of Pierre Puvis de Chavannes," in Argencourt et al., *Puvis de Chavannes*, 21–28.

78. *Sacred Grove* was exhibited in 1890 in New York at the Durand-Ruel Gallery. According to Weitzenhoffer, the replica of *The Allegory of the Sorbonne* was among fifteen of the Havemeyer paintings that were on view at the Metropolitan Museum of Art from November 1890 to April 1891. Weitzenhoffer, *The Havemeyers*, 66.

79. Puvis's mural was intended as a pendant to Paul Delaroche's earlier mural called the *Hemicycle for the Ecole des Beaux-Arts* (1837–41). This work, in which Delaroche constructs a vast pantheon of the great artists of the past, was so highly admired that a replica of it was purchased in 1871 by William Walters of Baltimore. Later, it was the inspiration for plaques used as sculptural decoration on the exterior of Frank Furness's Pennsylvania Academy of the Fine Arts (1872–76) in Philadelphia, which was one of the first public museums in the United States.

80. *The Sacred Grove* was exhibited earlier in 1890 at the Salon of the Société Nationale des Beaux-Arts.

81. See Webster, "Mary Cassatt's Allegory," and Barter, "Mary Cassatt: Themes, Sources, and the Modern Woman," 90–91.

82. Charles Ephrussi, "Les deux fresques du musée du Louvre," *Gazette des Beaux-Arts* 25 (1882): 475–83.

83. Stuckey, *Berthe Morisot, Impressionist*, 152. "The fulfillment of an idea that Morisot had formulated in Nice in 1888, to make a decorative picture in the spirit of Botticelli's *Primavera, The Cherry Tree* . . . was developed from the largest group of preliminary studies Morisot had ever made for any of her paintings."

84. Quoted in Higonnet, *Berthe Morisot*, 191. Louise King Cox, wife of the American muralist Kenyon Cox, exhibited a panel called *Primavera* (#1025) in the Fine Arts Building at the World's Columbian Exposition.

85. Theodore Childs, *Art and Criticism* (New York: Harper, 1892), 8, 9.

86. See Erica Hirshler, "Helping 'Fine Things across the Atlantic': Mary Cassatt and Art Collecting in the United States," in Barter et al., *Mary Cassatt: Modern Woman*, 177–211.

CRITICAL RECEPTION AND AFTERLIFE

Just as Cassatt's allegory of modern woman can best be understood within an American framework, so too should the painting be considered specifically within the context of American mural painting. The tradition of mural painting in America was just beginning at the time of the Columbian Exposition. Montague Marks, an art critic and noted connoisseur of decoration and the decorative arts, noted this new enthusiasm months before the fair opened: "there is an unparalleled interest in artistic mural decoration just now in this country. All our figure painters are crazy on the subject. The ball was started rolling at Chicago."[1] There had long been painted decoration in churches and some private homes in America but there was little of it in civic buildings, with the exception of the murals for the United States Capitol by the Italian painter Constantin Brumidi and the German-born artist Emanuel Leutze, and those for the Albany State Capitol completed by William Morris Hunt in 1878.

The architectural firm of McKim, Mead, and White ushered in a new era with projects for the Boston Public Library (1887–95) and Bowdoin College (1891–95) in Maine, both of which included plans for mural decorations. It was in Chicago, however, that a broad public was introduced to the beauty and effectiveness of painted decoration for public buildings. Over thirty painters participated in decorating the interiors of exposition buildings, most of them European-trained and many of them women.[2] The artists' enthusiasm for both mural painting's future and further commissions of their own led them to form the National Society of Mural Painters.[3] While the real cultural importance of the World's Columbian Exposition is still to be written, it is clear that the fair contributed to the development of American mural painting, the elevation of popular taste, and the promotion of municipal betterment.

Cassatt's contribution to this art form was significant enough to be acknowledged in the first history of American mural painting, published in 1902. The author, Pauline King, included this glowing description of Cassatt's mural along with two illustrations: "The subject *Modern Woman* was carried out with the individual force and distinguished methods, by which she dignifies the simplest theme. One panel showed a group of girls in an orchard, another a girl dancing, the third a band of maidens run-

ning in happy fashion. Familiarity only with the artist's style can fill this meager outline to anything approaching the true interest of the compositions."[4]

Ironically, Cassatt showed little interest in the mural's fate and only briefly considered another such undertaking, a mural for the Pennsylvania State Capitol in Harrisburg. As a native daughter, she was approached to do some decorations for the new state house. Little is known about this overture and no sketches have been identified that might relate to the commission. Another woman, Violet Oakley, was hired to create murals for the capitol's Senate Chamber (1905) and Supreme Court (1911).[5]

Just as American artists, including Cassatt, were feeling their way with the new demands of mural painting, American critics were establishing specific criteria to assess them. Their opinions contained ideas related to the European notion of the decorative. Even with so few native examples, it was understood that a mural should be harmonious with its architectural environment, in terms of its color, style, frame, and content. As early as 1879, the architect and critic Henry Van Brunt provided an astute analysis of William Morris Hunt's murals in Albany and John La Farge's painted interior for Trinity Church in Boston. Significantly, Van Brunt's assessment, titled "The New Dispensation in Monumental Art," was published not in a professional journal but in a popular national magazine, the *Atlantic Monthly*. He described and evaluated each artist carefully, praising his efforts and candidly discussing each decoration's shortcomings. His analysis reflected his broad familiarity with European, mainly modern French, standards regarding contemporary mural painting. His primary concern was how effectively a mural's color complemented a building's interior. A good example of Van Brunt's insights is the following passage in which he describes two figural groups by La Farge for Trinity Church as being too illusionistic. Their effect was saved, however, through their harmonious color:

> These compositions have light, shade, shadows, and perspective, and as such are an offense to the higher aesthetics which do not recognize as correct any wall decorations which are not flat. But the purist could hardly find it in his heart to blame a fault which is condoned by the fact that there is no distance to the pictures, the figures being defined against a screen surface or wall in each case,—by the fact that they make no marked spot on the wall, and that they form an integral and not an exceptional part of the general scheme of color.[6]

Van Brunt's advocacy of well-appointed religious and civic buildings began to be shared. While there were few projects done on the scale of Trinity Church or the New York State Capitol, during the 1880s interest in interior decoration was high. Beginning in 1881 the Architectural League of New York sponsored important exhibitions of architectural sculpture and decorative arts. Many influential American artists, designers, writers, architects, and patrons traveled abroad, bringing back primarily from France and Great Britain a sophisticated, cosmopolitan interest in interior design.

Bertha Honoré Palmer was among these connoisseurs and went to great lengths to ensure that the Woman's Building at the Columbian Exposition was beautifully decorated. She was also committed to seeing that the building competed favorably with the other fair structures, most of which were designed and appointed by men.

Seventeen years earlier there had been a Woman's Pavilion, designed by Herman Schladermutt, at the Philadelphia Centennial, where relatively little attention was paid to the fine or decorative arts created by women. In Chicago, however, a commitment was made early in the planning that the Woman's Building be designed by a woman as a showcase of women's accomplishments, including the participation by professional women artists in the decoration of the building.

Yet the final product was dissatisfying to some. As a close friend of Palmer's, Mary Logan, an important member of the Board of Lady Managers and representative from the State of Illinois, confessed to Palmer even before the fair opened, "Like yourself I am greatly disappointed in the Gallery of Honor . . . and wish from the bottom of my heart that I could have helped you to bring this up to your expectations. The decorations at the ends of the Hall were humiliating to me, and most disappointing in every way, and when compared with the decorations by women in the Illinois building, they are almost caricature."[7] Nevertheless the Woman's Building was immensely popular and received a great deal of press attention.

CRITICAL RECEPTION

Cassatt's mural garnered its own share of critical notice, primarily because the Woman's Building and the World's Columbian Exposition were such celebrated endeavors. Articles that described the world's fair frequently referred to the Woman's Building and Cassatt's mural. In fact it is surprising, given the number of buildings and displays throughout the fair, how much attention the mural attracted.

Mariana Van Rensselaer, the art critic for Joseph Pulitzer's *New York World*, was among the first to draw attention to the enterprise and described the progress of both Cassatt's and MacMonnies's commissions from the outset. As early as July 1892 in her column "Current Questions of Art," she detailed Bertha Palmer's success in securing the services of Cassatt and MacMonnies "to adorn the Woman's Building in Chicago." At the same time she wondered "what either of them may be able to do in the way of monumental decoration." She went on to relate Cassatt's standing among the impressionists and praised her highly as "an artist's artist." She also admitted to knowing nothing of MacMonnies except that she was the sculptor's wife.[8]

Five months later, while both painters were hard at work, Van Rensselaer summarized Sara Hallowell's report on the artists' progress, primarily Cassatt's. "Of Mrs. MacMonnies' work I have heard but little," she wrote, but she detailed her enthusiasm for Cassatt's subject, modern woman, noting that she "very wisely determined . . . to paint her in the most . . . fashionable garments of the current year 1892."[9]

Similar anticipatory notices followed. In January 1893, Montague Marks, writing for the New York–based *Art Amateur*, noted that with regard to mural painting, "the ladies are also 'in it.' . . . Large canvases . . . are being painted in Paris by Miss Cassatt and Mrs. MacMonnies."[10]

Another short notice, titled "The Mural Decoration for the Exposition" and

published in *The Graphic* of March 25, 1893, coincided with the arrival and installation of the murals in late March and early April. It described Cassatt's mural in some detail:

> The picture by Miss Mary Cassatt, whose subject is "Modern Woman," is a tryptich [*sic*]. In the center panel a number of fashionable young women, in costumes of the most stylish character, are plucking apples from trees and are eating them. This is suggestive of the episode in connection with the tree of knowledge. In the side panel at the left we see a young girl in pursuit of a figure representing Fame, while on the right is the representation of the modern "skirt-dance." The border of the painting contains figures of babies eating apples, worked into the general design.[11]

It was also in the Chicago edition of *The Graphic* that reproductions from Cassatt's mural first appeared, including two rondels of "cupids" and the central panel with its decorative border. The illustrations were accompanied by a short notice on Cassatt's career and a description of her mural:

> We reproduce this week the striking group of Miss Mary Cassatt's panel for the mural decoration of the Woman's Building. Her panel is called "Modern Woman" and forms a contrast to Mrs. MacMonnies' subject "Primitive Woman." She represents an orchard scene. Young women and children, all in costumes of the day, are seen in various attitudes of apple-gathering. The lower border of the panel contains baby-figures, framed in medallions and a garland of conventionalized leaves. Miss Cassatt is an impressionist, and is appreciatively noticed in George Lecomte's "Impressionistic Art," where her picture of mother and child in M. Durand-Ruel's collection is reproduced and described. The French critic says of Miss Cassatt's style that she extracts from the momentary and casual its characteristic aspects. He speaks of her gracious suppleness of movement and of the attitudes of her babies as exquisitely uncertain and awkward.[12]

Lucy Monroe wrote two articles on the murals for *The Critic*, one before they were installed and one after.[13] As it turns out, Monroe's description of Cassatt's mural is the best firsthand account.

Monroe began by noting that the decoration of the Woman's Building "will be more complete and elaborate than that of the larger structures in Jackson Park." She further observed that because of its smaller size, the Woman's Building was better suited for an integrated decorative scheme inside and out.[14]

She went on to discuss the types of decoration that were planned for the Woman's Building interior, particularly the Hall of Honor. Prior to the official opening she had found the hall "rather colorless," anticipating that "the decorative paintings will assist much in giving it warmth and tone." Writing on Cassatt specifically, she noted that the artist was "the talented pupil of Degas" and that she was "more famous in France than in her native country." Monroe declared herself "fortunate" to see Cassatt's mural "after it was unpacked."[15]

She found the mural "striking," with enough color "to give character to the entire gallery," yet she speculated that "it may focus one's attention too sharply upon itself." Given the fact that the mural is lost, Monroe's is the only description that contains what can be thought of as an accurate account of the colors Cassatt used.[16]

In Miss Cassatt's scheme, a bright grass green is the prevailing tone of the pictures themselves, and in brilliant contrast with this she has used in the wide borders around each panel a deep, rich blue. The result is admirably decorative, varied as it is by notes of dull red and of many gay and sunny colors in the costumes of the women. . . . Her entire work is conceived decoratively and painted flatly without shadows. The space is admirably filled, simply and naturally; but it is in the coloring after all that this impressionist has shown herself a true decorator.[17]

Monroe then described the mural's subject:

The central panel represents an orchard with the apples red upon the trees and a group of graceful women engaged in gathering them—significant, of course, of the fruit of the tree of knowledge. A smaller panel at the right suggests the arts of music and dancing very charmingly, with its corn-color and violet against the green. On the other side of the central picture several rustic maidens pursue a flying figure,—of Fame perhaps, in the elusive, unattainable ideal. The borders are interrupted at the corners by medallions, and in these the babies are given place, and Miss Cassatt can paint most cherubic infants.[18]

Monroe's is also the first full description of MacMonnies's mural, which like Cassatt's was painted in France. Monroe praises it lavishly while acknowledging the painter's indebtedness to Puvis de Chavannes. This same kind of fulsome praise was included in a longer article on MacMonnies written by Eleanor Greatorex for *Godey's Magazine.*[19]

Among the many articles published in May 1893 in anticipation of the fair's opening was Candace Wheeler's "A Dream City," written for *Harper's Monthly Magazine.* Wheeler had not only supervised the decoration of the Woman's Building but would go on to write several books on home decoration. She was already a popular American authority on art and decoration and thus was ideally suited to write on the exposition and its attractions. Like many of the commentators on the fair, Wheeler is lavish in her appreciation and compares Chicago and its efforts to the "white blossom of a lily shedding in the wide-open, sun-illumined air the perfume and saintliness which its grubbing roots send up from the mysterious sources which they follow in the ground. The ideal city is the blossom, and Chicago is the root."[20] While her prose is overblown, her discussion of the impact of the murals at the World's Columbian Exposition is prescient: "Every public library, every university, every great building belonging to the city of Chicago, will be enriched with one or more of the great paintings called into being by the fair, and in this way the city will benefit far beyond any mere commercial advantage attained by possession of the enterprise." Following this prediction, she singled out Cassatt's efforts: "Miss Cassatt, who has a place among painters who sit in high places, has painted . . . a picture which enriches not only Chicago, but the whole country."[21]

Ernest Knaufft in his article "Art at the Columbian," published in the *Review of Reviews,* noted as early as May 14 that the paintings exhibited in the Woman's Building made "a rather feeble showing." Nonetheless, he said, "The mural decorations . . . especially those by Mrs. MacMonnies, Mrs. Sewell and Miss Mary Cassatt, are equal, if not superior, to what the men have done."[22]

Yet after the fair opened, criticism of Cassatt's mural turned negative. Marks, who reported extensively on the fair and wrote several columns on "women's work in the fine arts," offered a respectful critique of the Woman's Building. After giving an overall account of the building and its function, he described the Hall of Honor and assessed the negative effect of Cassatt's mural:

> This color scheme of light tones of white, gold and yellow it was first intended should be adhered to strictly in the main hall and in some degree throughout the building. But the pictorial decorations of the hall, though not many, are important from their size and position, and one of the artists entrusted with them, Miss Mary Cassatt, has chosen for her large elliptical lunette at one end of the hall a scheme in which dark blue and green predominate. This makes her painting unduly conspicous, which is the more to be regretted as it is more pictorial than decorative in feeling.[23]

Marks was appreciative that the figures in the central panel were "very well grouped for a purely pictorial composition, and are drawn and painted with delightful verve," yet he was critical that Cassatt did not unite all three panels by a common setting: "As all three are open-air subjects, the painter had an opportunity—which she has neglected—to secure unity by carrying the one landscape background behind all the figures." MacMonnies's efforts were, to his mind, more appropriate: "Her composition, all in one piece, is held together by long horizontal lines of river and distant wooded hills, and is agreeably divided without too much regularity. . . . Her forms are academically correct, but are dignified and easy, and warm tones prevail in her coloring, as was demanded by the general scheme adopted for the building."[24]

Another negative review was written by Ellen Henrotin, the first president of the General Federation of Women's Clubs. Her article entitled "An Outsider's View of the Woman's Exhibit" is an overview of the works exhibited in the Woman's Building. In it she called Cassatt's panel "cynical," meaning, with its discordant colors, modern. She much preferred MacMonnies painting, calling it "reverent in tone and dignified in treatment. . . . if hung where it could be seen to better advantage, would be the most successful example of mural decoration in the building." She said of the Cassatt and MacMonnies murals that "both decorations are too high to be effective, and the space is too small in which they are placed."[25] Henrotin was an old friend of Palmer and both had been active members of the Chicago Woman's Club since the 1880s, which makes her negative review surprising.

The most damning evaluation of all was given by Florence Fenwick Miller, a writer for the London edition of the *Art Journal*. She began her article by decrying the small size of the Woman's Building, noting that "more money was expended in several cases on the decoration of the principal doorway of a great building than the whole Woman's Building cost."[26] She was complimentary about MacMonnies's mural in relation to the color of the interior but found Cassatt's work a "singular failure."

> The central panel . . . shows "Modern Woman" engaged in no more characteristic an occupation than gathering apples off trees. Now, we are all too sadly aware that Eve herself gathered apples, and there is nothing whatever modern about this group of

young women, who are nearly all in pink frocks, and standing upon the most vivid green grass. One of the side panels displays the "Modern Woman" doing a skirt dance; one girl is seated upon the ground and plays a banjo, while another young woman holds her accordion-plaited heliotrope skirt quite up to her nose, her head languishing on one side, and the high kick evidently just about to be given. Eve, perhaps, did not dance a skirt dance, but her early successors, the degraded women in the Orient, as certainly were required to perform some such evolutions for the diversion of their masters; and the development of modern woman has every tendency opposed to such displays. But the third panel is the most curious. There we see an objectionable female nude figure, her back cut off on one side in a most ludicrous manner by a sleek thick tail of black hair, reaching to the waist; her hands are stuck out, grasping what at first appears to be the end of one cord of a giant stride, and as the young woman is soaring in the sky without wings, and her legs are "flying all abroad," she bears the appearance of being engaged in that gymnastic exercise. Further consideration, however, leads to the conclusion that this handle is the fag-end of a trumpet, and this appears to be the intention, for far below her are three hideous girls, running and vainly reaching up after the flying phantom, and one gathers the idea that this is "Modern Woman" in the useless pursuit of fame. To complete the sarcasm, the artist has placed behind the stretching, running girls four cackling geese stretching their necks and running too, and distinctly expressing derision. Miss Cassatt is evidently a joker, and has been "taking a rise" out of the enthusiastic ladies who have employed her.[27]

Although she devoted much less space to MacMonnies's efforts, Miller found her work to be "of a more superior order," noting that "this painter has the true spirit of mural decoration."[28]

Without the evidence of the mural itself, let alone being able to evaluate it in place, it is difficult to dispute these critiques. The critics were in general agreement that as decoration, Cassatt's mural had failed in comparison with MacMonnies's painting, which they regarded more successful as a unified composition. Today Cassatt's mural with its clashing palette and controversial subject matter would be lauded as modern and progressive. It would be ill-advised, however, to accuse contemporary reviewers of being retrograde since their support of MacMonnies's accomplishment, which was inspired by Puvis de Chavannes, in itself denotes a sophisticated understanding of modern mural painting. Cassatt's naturalistic composition revealed a more subtle indebtedness to the French master that went unnoticed. Adding to our inability to fairly evaluate Cassatt's efforts as mural decoration is that Cassatt herself expressed only the most general criteria with regard to her intentions, let alone any ambition to continue in this realm of decorative painting.

THE DECORATIVE AESTHETIC

Cassatt was admonished for *Modern Woman*'s lack of compositional unity in violation of the precepts of mural art as articulated by Puvis de Chavannes. What went unremarked was that she did look to the work of the French master of mural painting as a model for modern allegorical painting. Nor were Americans aware, at this early date, that *Modern Woman* reflected the decorative aesthetic of the Nabis—prin-

cipally the artists Bonnard, Vuillard, and Maurice Denis—and other post-impressionists, who attempted to extend painting "beyond the easel." This new aesthetic was articulated in an exhibition titled *Beyond the Easel* in which Nicholas Watkins in his essay, "The Genesis of the Decorative Aesthetic," lays out the history of these ideas, ones that emerged at the precise moment Cassatt was undertaking her mural.[29]

In the early 1890s among members of the vanguard, there was a shift away from the nationalist and historical, which Puvis's mural art represented, and toward the spiritual and personal. That did not mean these artists embraced the small and insignificant. The ambition to create monumental works of art remained. Disenchanted with the materialist, political, and social disarray of the turn of the last century, artists and writers were prompted to turn inward, often creating large-scale images of a lost paradise with the hope of promoting reflection and renewal.[30] There are numerous examples by the Nabis that have the same content as Cassatt's mural—women in landscape (often in orchards, picking fruit) engaged in ritualized activity.[31]

One of the important and essential elements of late nineteenth-century decorative painting was its break with naturalism, that is, the illusionistic representation of pictorial space. This was achieved by the flattening of the picture plane and often the employment of an arabesque that compositionally linked figures and forms. For some, such as the Nabis, Gauguin, and, later, Matisse, it also involved the adoption of antinaturalist, or complementary, colors. The employment of this convention furthered the impact of the pictorial design and, in Cassatt's case, held the promise of projecting the image from afar. It is in her choice of bright, well-saturated color that she most distanced herself from the pale fresco tonalities of Puvis de Chavannes as well as from the style of MacMonnies. Thus Cassatt is not as doctrinaire in her approach to decorative painting as Puvis nor as experimental as the Nabis. In fact her work is a pastiche of elements—naturalism, postimpressionism, japonisme, and symbolism—and perhaps it is this lack of integration that put critics off. If she had continued her commitment to decorative or mural painting, her work might have become more harmonious and refined.

Cassatt's exploration of the new decorative aesthetic and symbolic content is apparent too in a cluster of works—paintings and prints—done between 1890 and 1893: *Woman with a Red Zinnia*, or *Revery; Young Women Picking Fruit; Gathering Fruit*, or *The Kitchen Garden*; and *The Family*. All of these, including her mural, are related to an important suite of ten color prints begun in 1890.[32] The pivotal role of these most admired prints has been documented by many scholars, including Barbara Shapiro, Colta Ives, Nancy Mathews, Judith Barter, and Elliott Davis. Barter, in particular, not only identifies the specific Japanese sources for Cassatt's prints, but discusses at length their new subject matter. For Barter this suite of prints signals Cassatt's move from the objective world of naturalism to the more interior, subjective one of symbolism.[33]

Following her work on this suite of prints, which renders women in both domestic and urban locales, Cassatt confines her models to landscape settings, specifically the orchard and garden of her home in Bachivillers. This is the same environment found

in her mural. This was not the first time Cassatt depicted women out of doors but in the early 1890s, as evidenced by this group, the orchard and garden become sites of reverie in her work. The painting that exemplifies this idea and comes closest to the symbolist program is the earliest, *Woman with a Red Zinnia* (figure 52). (According to a nineteenth-century convention about flower symbolism, the zinnia signifies "thoughts of absent friends.") In this painting the emphasis is on a single figure rather than the orchard setting. The model is cut off from the background by the strong, dark horizontal of the bench's back slat. The midground is only generalized; more pronounced are the stands of trees that suggest the shaded, wooded areas behind Cassatt's home in Bachivillers. The dominant element is the young woman who sits sideways on the bench contemplating the zinnia she holds in her right hand. She rests her cheek on her left hand and with her index finger points to her temple, perhaps indicating her mind, the world of the imagination.

The next in the series, *Young Women Picking Fruit* (figure 53), is half again as large and, as best as can be determined, painted before the mural. Its title, so similar to that of the mural's central panel, suggests that this static, contemplative image contained the germ of *Modern Woman*. In a two-figure composition the model from the previous painting now stands looking toward her raised right hand, which grasps what looks to be a golden pear. A pear symbolizes affection; a pear tree, comfort. These attributes are reinforced by the intimate presence of her companion, who sits sideways on a low slatted chair holding a pear in her lap, given to her, we assume, by her friend. This gesture of friendship is reinforced by the pear's symbolic meaning.

In both of these paintings the static, almost regal air found in *Modern Woman* prevails. Similar too are the beautifully textured and printed fabrics of the models' gowns. Additionally, in *Young Woman Picking Fruit* pears, not apples, are a subtle reference to Eve and the Genesis story and a direct link to Cassatt's mural. In *Woman with a Red Zinnia*, Cassatt endows woman with an active imagination. In *Young Women Picking Fruit*, she takes this idea a step further, replacing the zinnia with a pear. Here she suggests the plucking of the forbidden fruit, which in her mural becomes a positive, assertive act of female empowerment.

The last images in the series are a print, *Gathering Fruit* (figure 54), and two paintings, *Baby Reaching for an Apple* (figure 55) and *The Family* (figure 56). All were done either at the same time as the mural or shortly thereafter.[34] What sets them apart from the two earlier paintings is that they include a baby, the focus of all three works. Of these, the print and *Baby Reaching for an Apple* are the most closely related. In fact the same activity takes place—an infant reaches out to grasp a piece of fruit—and the model who holds the baby wears the same dress in both works. In the print, *Gathering Fruit*, a woman climbs a ladder that is placed against a wall with an espaliered pear tree and a grapevine. While the pear tree, with its dangling fruit, is clearly rendered, the grapevine is implied by the bunch of grapes (perhaps a symbol of the Eucharist, a Christian theme that is furthered in *The Family*), which the woman hands to the infant. The painting *Baby Reaching for an Apple* is different. The focus is on the interchange between the two figures. Instead of handing the fruit to the child,

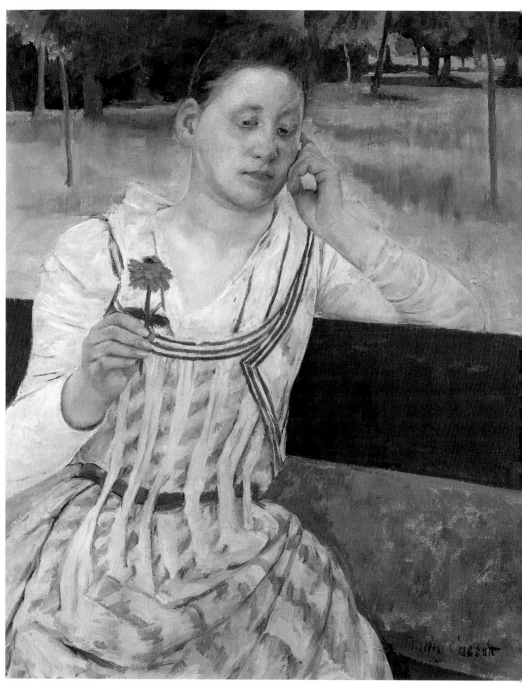

Figure 52. *Woman with a Red Zinnia*, 1891. Oil on canvas, 29 × 23 ¾ in. National Gallery of Art, Washington, D.C., Chester Dale Collection. Photo © Board of Trustees, National Gallery of Art, Washington.

Facing page: Figure 53. *Young Women Picking Fruit*, c. 1891. Oil on canvas, 51 ½ × 35 ½ in. Carnegie Museum of Art, Pittsburgh, Patrons Art Fund, 22.8

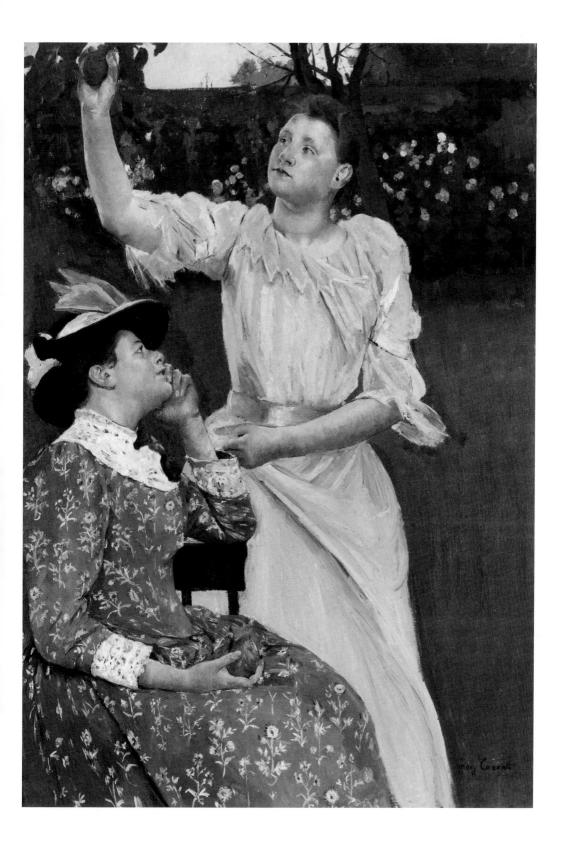

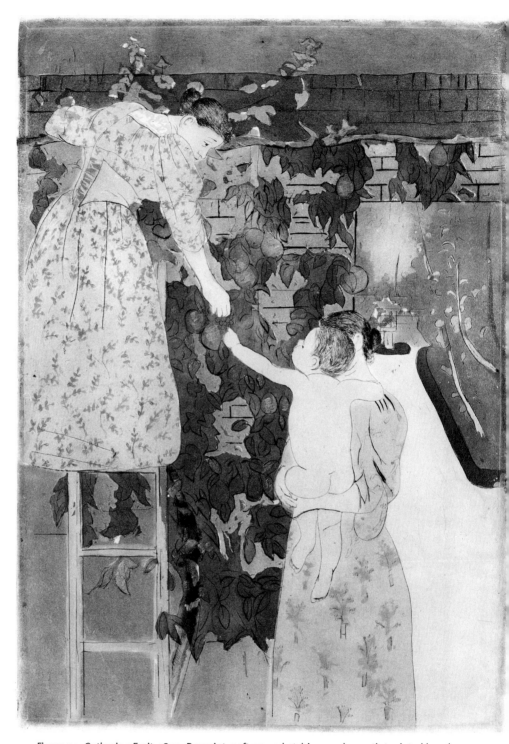

Figure 54. *Gathering Fruit*, 1893. Drypoint, soft ground etching, and aquatint printed in colors. Fifth state. Metropolitan Museum of Art, New York, Rogers Fund, 1918 (18.33.4).

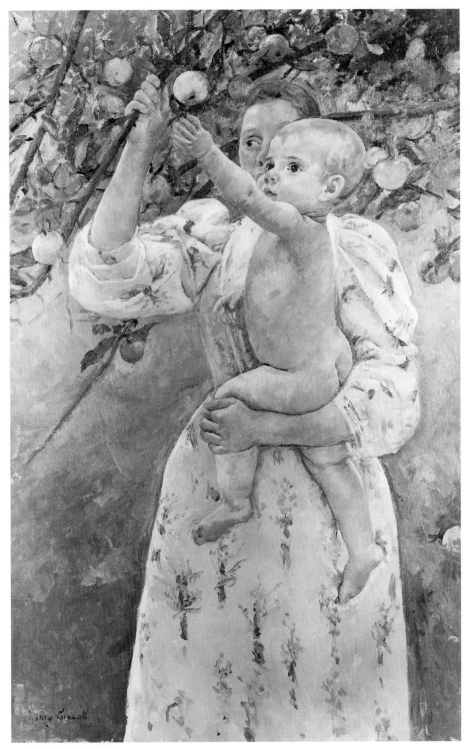

Figure 55. *Baby Reaching for an Apple,* 1893. Oil on canvas, 39 ½ × 25 ¾ in. Virginia Museum of Fine Arts, Richmond, Gift of Ivor and Anne Massey. Photo © Virginia Museum of Fine Arts.

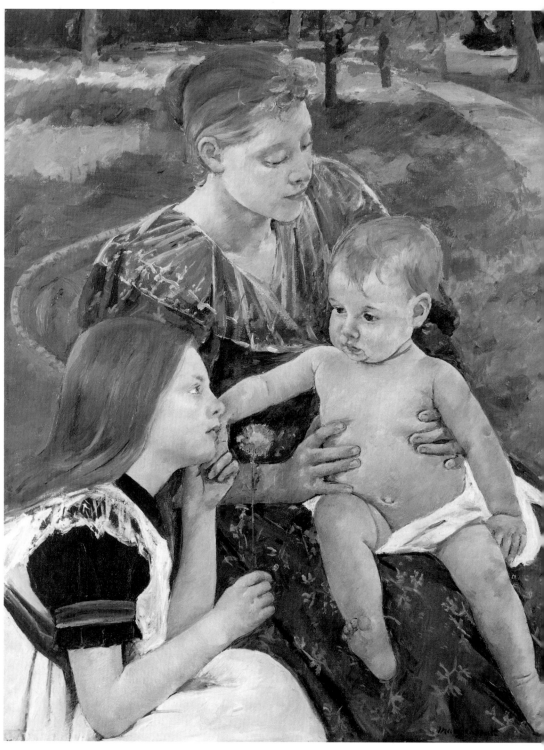

Figure 56. *The Family*, c. 1892. Oil on canvas; 32 ¼ × 26 ⅛ in. Courtesy Chrysler Museum of Art, Norfolk, Virginia, Gift of Walter P. Chrysler Jr., 17.498.

the woman holds down a branch of an apple tree so that the baby can reach the fruit for himself (the close-cropped haircut of the nude child suggests the male gender). These two images are the most naturalistic of the series and are less symbolic than either the mural or the earlier paintings.

In the final work, *The Family*, the static, reverential air returns. The three figures in this composition—a mother, a young girl, and baby—dominate the foreground. The mother sits in a wicker chair whose rounded back echoes the swinging curve of the path off to the right. Against this rich garden scene the pyramidal grouping re-calls the traditional composition of Mary, the Christ child, and St. John in Renais-sance paintings. The young girl (occupying the position of St. John in the composi-tion) holds a flower that reads as either a small carnation or a large head of clover, or maybe the zinnia again. She is a conflation of the seated women in *Young Women Pick-ing Fruit* and *Woman with a Red Zinnia*. The model for the mother is also the model found in these earlier paintings. The baby, a charming, fleshy cherub, is similar to the infants found in the rondels along the bottom of the frame of *Modern Woman*. *The Family* is close to *Modern Woman* in another, significant way. Here in close up, Cassatt takes on one of the most sacred images of Christian art, the Madonna and child. While others have made this association about Cassatt's work in general, this particular image is called *The Family* (and significantly not *The Holy Family*, which would imply the presence of Joseph) and with its triangular design closely recalls its Renaissance prototype. Yet how carefully Cassatt has converted its meaning in ways that parallel her rereading of the Temptation story; no father or fatherly figure is present and St. John the Baptist is now a young girl who offers a flower, not a cross, to the Christ child, now a healthy modern baby. In this painting and her mural Cassatt challenges the conventions of traditional religious imagery. In *The Family*, it is the icon of the Madonna and child; in *Modern Woman*, it is the Genesis story. Just as she reinvents the image of the Holy Family for a secular age, so too does she transform the Temptation into a parable for modern women.

Like the work of the Nabis, Cassatt's mural reflects a broad range of sources—new color theories, japonisme, renewed emphasis on pictorial structure, and personal content. The aesthetic power of these new paintings came from a dedication to the primacy of color and an abandonment of naturalism. An allegiance to realism was replaced by the expression of pictorial ideas related to religion, the spiritual, or the classical past.[35]

Cassatt's mural, painted during the period that saw the flowering of modern al-legory before it hardened into the decadence of century's end, contains an amalgam of the imaginary and the naturalistic. This "synthesis" was the program for the na-scent symbolist aesthetic found in the work of the Nabis, whose champion, the critic G.-Albert Aurier, helped define symbolism for the artists of the early 1890s. Sym-bolism demanded an aesthetic alternative to realism that Aurier defined as decora-tive. In an influential article on Gauguin, "Symbolism in Painting: Paul Gauguin," published in the *Mercure de France*, Aurier laid out his definition of the decorative as embracing all the symbolist currents of the time: "Decorative painting in its proper

sense, as the Egyptians and, very probably, the Greeks and the Primitives [Italian artists before Raphael] understood it, is nothing other than a manifestation of art at once subjective, synthetic, symbolic and ideist."[36]

This definition describes equally the murals of Puvis de Chavannes, the Tahitian paintings of Gauguin, and Cassatt's mural. Symbolism of the early 1890s canceled the breath of realism, monumentalizing the mores of modern men and women as if for a Minoan frieze. Such an impulse is seen in Gauguin's mighty *Where Do We Come From? What Are We? Where Are We Going?* (1897, Museum of Fine Arts, Boston), which seeks to universalize the human questioning of life. Cassatt's meditation on modern woman takes its place somewhere between Puvis de Chavannes's *Allegory of the Sorbonne* and Gauguin's great painting.

The use of personification and allegory are familiar strategies of symbolism, and the closest link in Cassatt's mural to contemporary symbolist painting is the implied presence of Eve in the central panel. Dressed in a healthful, loose-fitting gown, Cassatt's Eve is a responsible woman, not a femme fatale, who derives sensual pleasure from her tasks and the companionship of other women.[37] These are mature women who find purpose in passing on to future generations of women the "fruits of knowledge." Cassatt's aspiration, however, is different from that of the symbolists. In *Modern Woman*, tradition is put into the service of woman's self-knowledge, not to evoke a dream state or to offer an escape from reality.

As Cassatt's achievement is placed alongside that of her contemporaries, one is struck by the fact that the women in paintings by Pissarro, Puvis de Chavannes, or Gauguin are symbols, not agents acting on their own behalf. Cassatt's women in modern dress are not Pissarro's working-class apple pickers or Puvis's marmorean republican figures or Gauguin's exotic Tahitians. Instead, they are contemporary, self-actuating women whom Cassatt created by drawing upon her own experience and life.

As male artists strived to create a new visionary art, Cassatt labored to provide a new, optimistic vision for women. She celebrated the era of their emergence as agents of their own destinies, but her mural had no more immediate public impact than did Gauguin's *Where Are We Going?* Luckily for Gauguin, his work survived and succeeding generations have admired and appraised it, claiming it, rightly, as his masterpiece. Cassatt's experience was less fortunate.

AFTER THE FAIR

On October 31, 1893, the World's Columbian Exposition closed, and the dreary job of dismantling the exhibits and tearing down the buildings began. Bertha Palmer wrote to Harlow Higginbotham, president of the board of the World's Columbian Exposition, in November asking him to "make sure that these paintings [MacMonnies and Cassatt's murals] were saved from the wrecker. . . . They are very enormous in size, and it is doubtful that they can ever be used anywhere, but I think they are about worth the cost of salvage, and I am willing to take them down and store them just to

preserve them."[38] Still concerned about the disposition of the murals, Palmer wrote at the end of January 1894 to Amey Starkweather, who had in April 1893 replaced Candace Wheeler as chief of installation and superintendent of exhibits: "Who is storing the Cassatt and MacMonnies paintings and why? . . . They should be released and put with the things stored by Mrs. Shepard."[39] Like many other paintings and objects from the fair, the Cassatt and MacMonnies murals had been sent temporarily to the Fine Arts Building, or Palace of Fine Arts, which, of all the buildings in the White City, was the only one saved. (Subsequently housing the Field Columbian Museum and rebuilt in stone, today it is the Museum of Science and Industry.)

Initially there were plans to relocate many of the items from the Woman's Building to a permanent museum for women's art and handicrafts. Potter Palmer had offered $200,000 toward the construction of such a building.[40] Among the items to be included were MacMonnies's and Cassatt's murals, which were specifically recorded in Starkweather's inventory as "#89 1 Box Cassatt Decorations" and "#90 1 Box MacMonnies Decorations."[41] Nonetheless, neither mural made it from the Fine Arts Building to the Hiram Sibley Warehouse, where a number of other items exhibited in the Woman's Building were placed in storage in March 1894.[42] Unfortunately, the enthusiasm that was so instrumental for the success of the fair's Woman's Building could not be sustained and plans for a permanent woman's museum never materialized.

Not until 1966, more than seventy years after the close of the fair, did anyone publicly ask what had happened to the murals. John Kysela speculated that Cassatt's mural might have been sent to Ernest Fenellosa at the Museum of Fine Arts.[43] Jeanne Weimann knew from the papers of the Board of Lady Managers that the murals had been removed from the Fine Arts Building and assumed that they disappeared. She summarized the speculations of others: "It has been suggested that Sara Hallowell dispatched them to Paris: a doubtful suggestion because of the expense their great size would have entailed. Possibly they were destroyed in a fire. It has been suggested even that Mary Cassatt herself destroyed her mural; a far-fetched suggestion."[44]

I have found in the correspondence of William M. R. French, the first director of the Art Institute of Chicago, the first concrete evidence that both murals had been kept in storage. The trail begins in 1905 with copy of a reply French sent to MacMonnies in response to her request to borrow her mural for exhibition in Paris. "Mrs. Palmer ought to know about your painting for it is in our keeping in her name. . . . We keep a register of everything in the museum which does not belong to us, on what we call a 'loan file.' . . . The painting is rolled up on a big roller in our attic. . . . I am afraid the picture has not been wholly unrolled for ten years."[45] (That it went to the Art Institute in 1895 coincides with the shipment of other Woman's Building items from the Art Building to the Sibley Warehouse in September of that year.)

French then wrote to Hallowell, who was still serving as a liaison between Chicago and artists in Paris, enlisting her help in getting Bertha Palmer to release the painting for shipment to MacMonnies: "Mrs. MacMonnies has written requesting

me to send her decorative painting which was in the Women's Building of the Columbian Exposition which we have in storage. We have held it in Mrs. Potter Palmer's name, but Mrs. MacMonnies says that Mrs. Palmer [who was in France at the time] has told you that she has nothing to do with it. Perhaps you had better confirm this when you write. I shall send the painting immediately to Mrs. MacMonnies if our people think it proper for me to do so."[46] Mary MacMonnies had requested the painting because she wished to exhibit it at the 1906 Salon of the Société Nationale des Beaux-Arts.[47] Her desire to do so twelve years after the exposition was probably prompted by her trusted relationship with the painter Will Low, whom she would marry in 1909. Low, one of the leading American muralists of the period, had been a close friend of both Mary and Frederick MacMonnies since about 1901.[48]

Presumably MacMonnies's mural remained in Paris until at least 1910 when she was invited by Halsey C. Ives, director of the St. Louis Art Museum, to lend her mural for an exhibition devoted to the art of mural painting.[49] Ives and Mary MacMonnies Low had been friends since the early 1880s when she took art classes with him at the St. Louis Museum Art School. It was he who had encouraged her to go abroad for further training and the two had remained in contact. Aside from his mentoring of MacMonnies, Ives, as director of the art department at the Columbian Exposition, would have had firsthand knowledge of MacMonnies's mural. The exhibition he was planning was titled *A Collection of Decorative Works by Three American Painters* and would ultimately include not only Mary Low's mural (figure 57) but also drawings, sketches, cartoons, and reproductions of decorative work by her husband and by another well-known mural painter, Edwin Blashfield. Quite sadly the exhibition, which opened May 21, 1911, also served as a memorial for Halsey Ives, who died unexpectedly.

Even before the exhibition had been planned William French had written to Will Low to ask the whereabouts of Mary Low's mural so that he might install it over the central staircase at the Art Institute of Chicago. To this end he wrote Mary Low on November 23, 1910: "In writing to Mr. Low a day or two ago, I asked him to inquire where your large decoration is. The idea grows upon me that we shall have some great blank spaces over our new central stairway until the time comes when the dome is completed, probably several years hence. I do not know what our Art Committee would think of it, but it is quite conceivable that the decoration might be placed there. The matter therefore seems worthy of our attention."[50]

French might have been reminded of Mary Low's mural by Will Low, who had been invited in 1910 to give the Art Institute's prestigious Scammon Lecture and may have suggested his wife's mural, now framed, for the central stairway.[51]

French continued his correspondence with both Will and Mary Low on the subject of acquiring her mural, yet with each letter he provides less assurance that such a scheme would ever materialize:

> I have received your letter of November 2 [?] which crossed a letter of mine, upon the same subject to Mrs. Low. I have not ventured to speak of the decoration to Mr. Hutchinson, who is of course deeply interested in the construction of the grand stair-

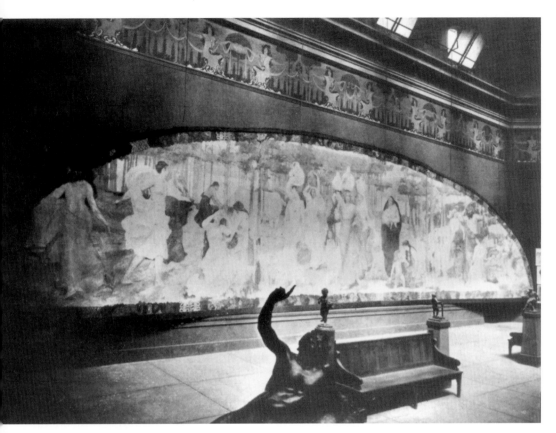

Figure 57. Mary MacMonnies, *Primitive Woman*, 1892–93. Installed, St. Louis Art Museum, May 1911. Photo, collection of the author.

case, until I should know whether the canvas was available. It would necessarily be a temporary one, although it might stay for a number of years, and I do not suppose our people would want to pay anything for it. I understand the canvas to be subject to Mrs. Palmer's orders, and might find myself in trouble if her control of it were called in question. I have always thought and said that it was the best decorative painting, at least among the large ones, in the Exposition. Our staircase is far from finished and I dare say we should not be ready for the painting till after Professor Ives' exhibition.[52]

French did not follow up on his idea until February 1911 when he wrote to Ives to inquire if the mural was presently in St. Louis.

Sometime ago I wrote to Mr. Will H. Low, respecting Mrs. Low's decoration for the Woman's Building, which Mrs. Palmer allowed to be sent to her for exhibition in Paris. Mr. Low replied that you expected to exhibit the work in St. Louis in March. I write to inquire whether you are in possession of the decoration and when it can come here. After the Fair it passed into Mrs. Palmer's keeping, and she deposited it in the Art Institute, in my care. I have thought that we might find a place for it temporarily in our grand staircase, but I do not suppose anybody would think of making any such

use of it without the assent of the artist. "Temporarily" might mean a long time. Our temporary staircase has now been in use about eighteen years, so that the marble treads show decided marks of wear.[53]

Another two months went by before French wrote again to Will Low regarding the specifics of his wife's decoration.

> With regard to Mrs. Low's decoration for the Woman's Building, I have it in mind, but I am not sure it would go into our space. Could you give me the dimensions both the length and the height? We have a very good space 56 or 60 ft. long, if the decoration is not too high. This space, however is temporary, and will disappear when the dome is completed; that probably is some years hence. If I had it, and if Mrs. Low consented, and if it would fit, I should put it up immediately. I was wondering when that St. Louis show will come off.[54]

French's apprehension about the size of the mural and its suitability for the Art Institute staircase grew after he went to St. Louis to deliver the memorial address for Ives. "When I went to St. Louis two or three weeks ago, to deliver a memorial address for Professor Ives, I saw the decoration for the Woman's Building. I did not remember it was so large in scale. I am afraid it could not be used in our building with propriety, and this is a disappointment to me. I have always admired it very much."[55]

As an appeasement for the embarrassing situation he had created, French offered to place the mural on temporary display.[56] From July 18 to August 15, 1911, *Primitive Woman* was exhibited on the side wall of the staircase at the Art Institute in conjunction with exhibition titled *Exhibition of Decorative Works by Will H. Low* (figure 58).

After the mural was installed French wrote discouragingly to Mary Low:

> The great decoration has been put up in our grand stairway, and certainly presents a very inspiring appearance. It is too large for the place both in scale and in actual dimensions. If it were about three-fifths as large, it would be fine, but even then it could not be accommodated in our ultimate plan, in which the spaces are a good deal cut up. I hope it will serve to demonstrate to our rich friends how immensely mural paintings will ornament and enliven the center of our building. I have put it up as a temporary exhibition, but I think I will wait and see how long it will be before they want me to take it down. We found it a considerable job to put it in place. I wish you and Mr. Low could see it. The spectator can get about seventy-five feet away from it, but this is hardly enough.[57]

While Mary Low's mural had been in storage at the Art Institute until 1905, Cassatt's mural had found another home. Evidently it had been in Bertha Palmer's possession for eighteen years, although it is not certain when it was sent to her. Prompted by the exhibition of MacMonnies's mural at the Art Institute, Palmer contacted the museum's trustees asking them to place the Cassatt on view. According to the minutes of the Art Committee dated October 10, 1911, it was agreed: "To accept for temporary exhibition, if a place can be found for it, the decoration painted by Mary Cassatt for the Woman's Building in the Columbian Exposition offered by Mrs. Potter Palmer."[58] The next day French wrote Palmer: "I brought the matter of

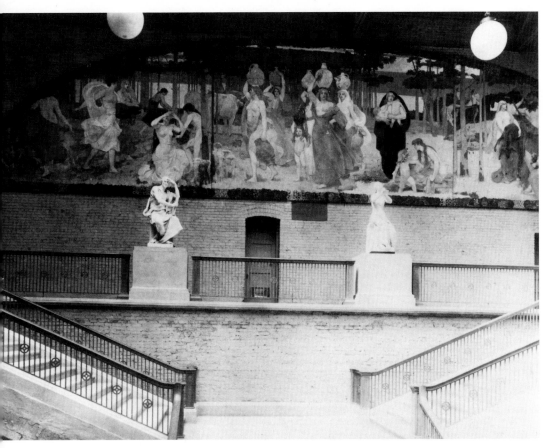

Figure 58. Mary MacMonnies, *Primitive Woman*, 1892–93. Installed, Art Institute of Chicago, Fall 1911. Photo, collection of the author.

Miss Cassatt's large decorative painting before our Art Committee, at a meeting held Thursday afternoon. The Committee expressed a wish to exhibit the decoration, if possible, and instructed me to make the necessary arrangements. Will you be kind enough to let me know when the work is prepared for exhibition?"[59]

Two weeks later he described the condition of the Cassatt in a letter to Will Low: "Mrs. Potter Palmer surprises me by telling me that she has Miss Cassatt's decorations in her possession at her house. It has been less carefully stored than Mrs. Low's, and has suffered some damage from wet. She proposes to have it repaired and put it on the other side of our hall, but there are some difficulties, because we have large sculptured reliefs attached to that wall, so high that there is not room for the decoration over them."[60]

Nothing further was done, probably because Palmer was now spending most of her time at her new home, The Oaks, in Sarasota, Florida. The following fall, Palmer once again tried to place the Cassatt mural and contacted French, who wrote to her regarding the poor condition of the painting:

I spoke with your secretary about the repairs of the Cassatt decoration. I think it will be difficult to repair it so that it can be transported, but I think if a permanent place is found for it, it can be repaired in place on the wall without very great difficulty. . . . I have had a conversation with Mr. W. Garbys Zimmerman, the State architect, and he says that there are large halls in the University of Illinois at Champaign, where the pictures could be installed, and he thinks they would be welcomed by the authorities of the University. At the end of the Columbian Exposition some of the other decorations were dispersed among such institutions. I remember finding a place for some of them in Knox College, Galesburg, Ill. Will you be kind enough to consider whether such a disposition of the works would be satisfactory to you and to the artists? It commends itself rather decidedly to me.[61]

The previous day French had, in fact, made an effort to place both the Mary Low and Cassatt murals at nearby Notre Dame. He made the suggestion to John Worden, who had been in correspondence with French regarding an exhibition of student work from the school of the Art Institute:

I write now upon another subject. We have upon the wall of our monumental staircase a large decoration, which was in the Woman's Building of the Columbian Exposition. It was painted by Mrs. MacMonnies, and I thought it the most successful large decoration in the Exposition. It is temporarily exhibited with us. When our building is finished there will be no space large enough for it, for it is about 64 ½ ft. long and 15 ft. high; a flattened lunette in shape. There is a companion picture painted by Mary Cassatt, of the same shape and dimensions, in the keeping of Mrs. Potter Palmer, who was Chairman of the Committee in charge of the Woman's Building at the Exposition. Have you any great hall which offers wall space sufficient to accommodate these works, and, if so, would your authorities probably accept these works as a gift? There would be some expense in putting them in place, but probably not very great. The one we have is very beautiful in color, and represents draped female figures, bearing jars, with trees, sky, etc. The subject of the other, as I remember it, is girls in white dresses in an orchard or garden.[62]

Worden, no doubt excited about the prospect of acquiring the two murals for Notre Dame, promptly answered French, who, in turn, gave a less than encouraging reply: "I have received your letter of November 20. I ought to say that the large decorations, of which I spoke, are controlled by Mrs. Potter Palmer, and I do not know whether she will assent to have them placed in an educational institution, as I advised, or what institution she will prefer. She is just leaving the city, and the whole matter will have to remain in suspense for sometime."[63]

Worden wrote again a month later and received a similar reply from French: "I do not think it would be worth while to write to Mrs. Potter Palmer at present, since she is absent from Chicago, and probably will give no attention to the subject until she returns sometime next spring."[64]

There the trail ends. There is no further reference to the murals in French's correspondence and no such murals have been found at Notre Dame or at the University of Illinois at Urbana-Champaign, nor is the MacMonnies any longer at the Art Institute of Chicago. There is no mention of the murals in Mrs. Palmer's papers. It is not out of the question that the MacMonnies and Cassatt murals exist somewhere high

on a library wall, covered in grime, in some midwestern college building within a hundred-mile radius of Chicago. If this is not the case then it can only be assumed that the Cassatt was disposed of sometime following Bertha Palmer's death in 1918. In 1922 many paintings from the Palmers were given to the Art Institute of Chicago. When their Lake Shore mansion was demolished in 1950, other items were placed in storage and auctioned off in 1989. Conversations with a descendant have confirmed that there was never a mention of the Cassatt mural's being in Palmer's possession at the time of her death. The whereabouts of the MacMonnies mural also remains a mystery. When last mentioned by French, on November 19, 1912, in his letter to Worden, it was still on the walls of the Art Institute. No further correspondence or records have been located to document its return to Mary Low. It may be somewhere in Bronxville, New York, or in the Catskills, where she moved following Will Low's death in 1932.

CASSATT'S ACHIEVEMENT

Although it may seem a fool's errand to try to evaluate Cassatt's achievement on so little evidence, my investigation has provided new insights into Cassatt's distinctive place as a modern artist.[65] Specifically, *Modern Woman* verifies Cassatt's rejection of naturalism and exposes her exploration of the new aesthetic territory being mapped out by the Nabis and the symbolists. Cassatt's achievement is not only that she contributed to a new direction in nineteenth-century mural painting but, even more important, that she created a unique allegory for modern woman cast in a vanguard style consistent with its content. Furthermore, this ambition to monumentalize women's worldly existence connects her mural to the lofty ideals of the new French avant-garde.

One of the striking aspects of *Modern Woman* is how unexpected it is, how unlike her other works; it is by far the largest and most ambitious painting she ever undertook. In the first panel, *Young Girls Pursuing Fame*, she transforms a landscape setting, found in the work of Morisot and Pissarro, into the nursery world of Kate Greenaway where young girls are not only nurtured but encouraged to test their wings. In the middle panel, *Young Women Plucking the Fruits of Knowledge or Science*, simultaneously the Garden of Eden and Botticelli's *Primavera*, contemporary women claim the gifts of reason. On the right, in *Art, Music, Dancing*, she represents a contemporary Mount Parnassus where women perform for their own pleasure and entertain themselves as three muses; Apollo need not apply. Together the three panels that comprise *Modern Woman* are a fitting tribute to women's achievements in the nineteenth century. As great painters had done in the past, Cassatt took as her subject one of the most important concerns of the day; in Cassatt's case it was the rights and welfare of women. By the end of the century, suffrage as well as women's education, professional advancement, and central role in the development of their communities were issues changing the fabric of contemporary society. These Cassatt encoded in a complex allegory that celebrated the new status of women in her own era, one that endures over a century later.

Notes

1. Marks, "My Note Book," *Art Amateur,* January 1893, 42.

2. Richard Murray, unpublished checklist of American Renaissance mural painting, Smithsonian American Art Museum, n.d., 21–25.

3. Founded in 1895 by the muralist and stained-glass artist Frederick Lamb, it was known originally as The Mural Painters and later as the National Society of Mural Painters. Artists dedicated to decorative and civic sculpture formed the National Sculpture Society in 1893 even before the fair was over. Lay people worked with artists and architects to improve civic life and, before the end of the decade, created municipal art societies in New York, Cincinnati, Cleveland, Chicago and Baltimore.

4. King, *American Mural Painting,* 88.

5. The following announcement was contained in "Mary Cassatt Exhibits Paintings," *Public Ledger* (Philadelphia), March 6, 1910, 1: "She once told how it was that the oral contract which she had with some one in authority in Pennsylvania to paint a decorative piece for the State Capitol at Harrisburg came to naught. She had already done much work upon the task when an emissary of the Capitol 'ring' came to her and said that the contract would be canceled unless she gave 50 percent of the price she was to receive to those whom he represented. Miss Cassatt sharply ordered him to leave her presence and ceased work at once on the picture for the Capitol." I am grateful to Professor Marlene Park, who brought this article to my attention. Violet Oakley did a great number of murals for the Pennsylvania State Capitol, including those in the Governor's Reception Room (1902–6), the Supreme Court (1917–27), and the Senate Chamber (1911–20).

6. Henry Van Brunt, "The New Dispensation in Monumental Art: The Decoration of Trinity Church, Boston, and of the New Assembly Chamber at Albany," *Atlantic Monthly,* May 1879, 633–41; reprinted in *Architecture and Society: Selected Essays of Henry Van Brunt,* ed. William A. Coles (Cambridge, Mass.: Harvard University Press, 1969), 138.

7. Quoted in Weimann, *Fair Women,* 313.

8. Van Rensselaer, "Current Questions of Art," July 31, 1892, 27.

9. Van Rensselaer, "Current Questions of Art," December 18, 1892, 24.

10. Marks, "My Note Book," *Art Amateur,* January 1893, 42.

11. "The Mural Decorations of the Exposition," 199.

12. "Decoration of the Woman's Building," 299 (quote), 301 (illustrations).

13. Monroe, a perceptive writer on art, continued to write for about ten years after the fair, until 1904, when she married and moved with her husband to China.

14. Monroe, "Chicago Letter," April 15, 1893, 240.

15. Ibid.

16. Ibid.

17. Ibid.

18. Ibid., 241.

19. See Greatorex, "Mary Fairchild MacMonnies."

20. Wheeler, "A Dream City," 830.

21. Ibid., 842.

22. Knaufft, "Art at the Columbian Exposition," 563.

23. Marks, "Woman's Work in the Fine Arts," 10.

24. Ibid.

25. Henrotin, "Outsider's View," 561.

26. Miller, "Art in the Woman's Section," xiii.

27. Ibid., xiv.

28. Ibid.

29. Watkins's essay appears in Groom, *Beyond the Easel,* 1–28.

30. For a recent study of these issues see Carol Zemel, *Van Gogh's Progress: Utopia, Modernity, and Late-Nineteenth-Century Art* (Berkeley: University of California Press, 1997).

31. See, for example, Pierre Bonnard's *Women in a Garden* (1891, four panels, Paris, Musée d'Orsay); Maurice Denis's *Suite of Paintings on the Seasons* (1891–92, four panels, various owners), *Ladder in Foliage*, or *Poetic Arabesques for the Decoration of a Ceiling* (1892, St. Germain-en-Laye, Musée Départmental Maurice Denis "le Preiuré"), and *April* (1894, private collection); and Ker-Xavier Roussel's *The Seasons of Life* (1892–93, Paris, Musée d'Orsay), *Conversations on a Terrace* (1893, private collection), and *Meeting of Women* (1892/93, Pasadena, Norton Simon Art Foundation).

32. This same observation is made by Judith Barter. See Barter et al., *Mary Cassatt: Modern Woman*, 82–99.

33. "The meditative mood of her model in *Revery [Woman with a Red Zinnia]* reflects the symbolist belief that contemplation, quiet and daydream help to access the spiritual state." Ibid., 86.

34. The dates of all these paintings are drawn from the exhibition catalog *Mary Cassatt: Modern Woman* by Barter et al.

35. An important articulation of these ideas can be found in *Lost Paradise: Symbolist Europe* (Montreal: Montreal Museum of Fine Arts, 1995).

36. Reprinted in Herschel B. Chipp, *Theories of Modern Art: A Sourcebook by Artists and Critics* (Berkeley: University of California Press, 1968), 92.

37. For a study of representations of Eve and others as "perverse women," see Bram Dijkstra, *Idols of Perversity: Fantasies of Feminine Evil in Fin-de-Siècle Culture* (New York: Oxford University Press, 1986).

38. Quoted in Weimann, *Fair Women*, 592.

39. Ibid. Mrs. Shepard was Frances Shepard, an Illinois delegate to the Board of Lady Managers. Palmer had assigned her and Starkweather the job of dismantling the Woman's Building.

40. Weimann, *Fair Women*, 588–89.

41. "Report of Amey M. Starkweather," February 1894, 415, Board of Lady Managers Collections, Chicago Historical Society.

42. Weimann, in *Fair Women*, writes, "There boxes and crates were delivered . . . by the Adams Express Company and entered in Bertha Palmer's name" (591–92).

43. Kysela, "Mary Cassatt's Mystery Mural," 129–45.

44. Weimann, *Fair Women*, 592.

45. French to MacMonnies, August 7, 1905, William M. R. French letterbooks, Archives of the Art Institute of Chicago. Unless noted otherwise, all correspondence in this chapter to or from French is from these letterbooks. No extant loan file now at the AIC records the presence of either the Cassatt or the MacMonnies mural.

46. French to Hallowell, September 5, 1905. Hallowell was under contract to the Art Institute of Chicago to organize the art work of Americans living in France for the Annual Exhibition of American Arts shown each fall.

47. The listing for the painting, number 819 in the 1906 Salon catalog, reads as follows: "*La femme aux temps primitifs* (panneau décoratif pour une salle d'exposition du travail de la femme). App. à l'Art Institute de Chicago. Ce tableau est exposé dans la salle des auditions musicales."

48. Shortly after his wife, Berthe Eugenie Marie Julianne, died in April 1909, he married Mary MacMonnies, who had divorced her husband in 1908. Smart, "Sunshine and Shade," 24–25.

49. In his letter Ives informed Mary Low that he was having problems with U.S. customs. "I herewith enclose your copy of a document from the Custom House Brokers, who take exception to your signature before an ordinary notary. As you will note from the enclosed communication they write that it is necessary to have these documents signed before a 'Customs notary' and that they have placed the matter with their correspondents in New York, with the request that they secure the signature in the proper manner." Ives to Low, July 20, 1910, Halsey

C. Ives Papers, Archives of the St. Louis Art Museum, St. Louis, Missouri. This was also the same year Will and Mary Low (she now used this name professionally) moved back to the United States, where they lived in Lawrence Park, an artists' colony in Bronxville, New York, until Will Low died in 1932. For information on the Lows' life in Bronxville see Barbara Ball's essay in *The Artists of Bronxville: 1890–1930* (Yonkers, N.Y.: Hudson River Museum, 1989–90), 7–20.

50. French to Mary Low, November 23, 1910.

51. Low's lecture was later published as *A Painter's Progress* (New York: Scribner, 1910).

52. French to Will Low, November 30, 1910.

53. French to Ives, February 14, 1911.

54. French to Will Low, April 21, 1911.

55. French to Mary Low, June 8, 1911.

56. French to Will Low, June 13, 1911: "With regard to Mrs. Low's decoration, I am in a puzzle. It becomes obvious to me that it was on too large a scale for our central stairway. It has occurred to me to try it, however, by putting it on temporary exhibition. If our Art Committee accedes to that, and if it commends itself to you, we will do it."

57. French to Mary Low, July 21, 1911.

58. Minutes of Art Committee, Board of Trustees, Archives, Art Institute of Chicago, 71.

59. French to Palmer, October 11, 1911.

60. French to Will Low, October 25, 1911.

61. French to Palmer, November 20, 1912. Eight murals from the Manufactures and Liberal Arts Building had been taken down and saved. In November 1895 Walter McEwen's *Life* and Lawrence Earle's *The Glass Blowers* were sent to Knox College, Galesburg, Illinois (they are still at Knox College but not on display); Frank Millet's *Weaving* and McEwen's *Music* were sent to Beloit College, Beloit, Wisconsin, and are unlocated; Gari Melchers's two paintings *The Arts of Peace* and *The Arts of War* were sent to the University of Michigan, Ann Arbor, where they remain. Millet's *Homer*, or *Spinning*, and Earle's *Pottery* were first installed in the Field Columbian Museum (now the Museum of Science and Industry); in May 1908 they were sent to the University of Illinois, Urbana-Champaign, but as far as is known they have both disappeared.

62. French to John Worden, November 19, 1912.

63. French to John Worden, November 22, 1912.

64. French to John Worden, December 4, 1912.

65. I have benefited from the work of other scholars—Wanda Corn, Nancy Mathews, Judith Barter, Griselda Pollock, and Linda Nochlin—who share my belief that Cassatt's mural confirms her stature as a vanguard artist. See especially, Corn, "Women Building History"; Mathews, *Mary Cassatt: A Life*; Judith A. Barter, "Mary Cassatt: Themes, Sources and the Modern Woman," in Barter et al., *Mary Cassatt: Modern Woman*; Pollock, *Mary Cassatt, Painter of Modern Woman*; and Nochlin, *Representing Women*.

Archival Sources

Board of Lady Managers Records. World's Columbian Exposition. Manuscript Division, Chicago Historical Society.
Cassatt, Mary. Letters. Archives of the Metropolitan Museum, New York.
———. Papers. Archives of American Art, Smithsonian Institution, Washington, D.C..
Durand-Ruel Archives. Paris, France.
French, William M. R. Letterbooks. Archives of the Art Institute of Chicago.
Nancy Hale Research Materials on Mary Cassatt. Archives of American Art, Smithsonian Institution, Washington, D.C..
Sweet, Frederick. Papers. Archives of American Art, Smithsonian Institution, Washington, D.C..

Contemporary Commentary on the Woman's Building Murals

Bancroft, Hubert. *The Book of the Fair.* Chicago: Bancroft, 1893.
"Chicago. Women's Work in the Woman's Building." *American Architect and Building News* 51, no. 914 (July 1, 1893): 13.
"Decoration of the Woman's Building." *The Graphic*, May 6, 1893, 299, 301.
Elliott, Maud Howe. *Art and Handicraft in the Woman's Building of the World's Columbian Exposition, Chicago, 1893.* Paris: Goupil, 1893.
Greatorex, Eleanor E. "Mary Fairchild MacMonnies." *Godey's Magazine*, May 1893, 624–32.
Henrotin, Ellen M. "Outsider's View of the Women's Exhibit." *The Cosmopolitan*, September 1893, 560–66.
King, Pauline. *American Mural Painting: A Study of the Important Decorations by Distinguished Artists in the United States.* Boston: Noyes, Platt and Co., 1902.
Knaufft, Ernest. "Art at the Columbian Exposition." *Review of Reviews* 7, no. 41 (June 1893): 551–82.
Marks, Montague. "My Note Book." *Art Amateur* 28, no. 2 (January 1893): 42; 29, no. 1 (June 1893): 2; 32, no. 3 (February 1895): 76.
———. "The Woman's Art Club Exhibition." *Art Amateur* 30, no. 4 (March 1894): 102.
———. "Woman's Work in the Fine Arts." *Art Amateur* 29, no. 1 (June 1893): 10.
———. "The World's Fair: Women's Work in the Fine Arts." *Art Amateur* 29, no. 6 (November 1893): 154–55.
Meredith, Virginia C. "Woman's Part at the World's Fair." *Review of Reviews* 7 (May 1893): 417–19.

Miller, Florence Fenwick. "Art in the Woman's Section of the Chicago Exhibition." *Art Journal*, n.s. 104 (London. Fair supplement, 1893): xiv–xvi.

[Minton, Maurice M.] "The World's Fair. Woman." *Illustrated American*. Special number, "The Columbian Exposition, Chicago." (May–November 1893): 41–43.

Monroe, Lucy. "Chicago Letter." *The Critic* 19, no. 582 (April 15, 1893): 240–41; 19, no. 584 (April 21, 1893): 279; 23, no. 601 (August 26, 1893): 140–41.

"The Mural Decoration of the Exposition." *The Graphic* (Chicago), March 25, 1893, 199.

"Paintings for the Woman's Building." *Chicago Tribune*, May 7, 1893, 37.

Palmer, Mrs. Potter. *Addresses and Reports*. Chicago: Rand, McNally, 1894.

Riordan, Roger. "Miss Mary Cassatt." *Art Amateur* 38, no. 6 (May 1898): 130–33.

Van Rensselaer, Mariana Griswold. "Current Questions of Art." *New York World*, July 31, 1892, 27; December 18, 1892, 24.

Walton, William. "Miss Mary Cassatt." *Scribner's Magazine*, March 1896, 353–61.

Wheeler, Candace. "A Dream City." *Harper's New Monthly Magazine*, May 1893, 830–46.

Willard, Frances E. "Woman's Department of the World's Fair." In William Cameron, *The World's Fair: Being a Pictorial History of the Columbian Exposition*, 448–70. Chicago: Columbian History Co., 1893.

Other Selected Sources

Anthony, Susan B., and Ida Husted Harper. *History of Woman Suffrage*. Vol. 4. Rochester, N.Y.: Susan B. Anthony, 1902.

Argencourt, Louise d', et al. *Puvis de Chavannes*. Exh. cat. Ottawa: National Gallery of Canada, 1977.

Badger, R. Reid. *The Great American Fair: The World's Columbian Exposition and American Culture*. Chicago: Nelson Hall, 1979.

Barter, Judith, et al. *Mary Cassatt: Modern Woman*. Catalog of exhibition organized by Judith A. Barter. With contributions by Judith A. Barter, Erica E. Hirshler, George T. M. Shackelford, Kevin Sharp, Harriet K. Stratis, and Andrew J. Walker. New York: Abrams, 1998.

Behnke, Donna A. *Religious Issues in Nineteenth-Century Feminism*. Troy, N.Y.: Whitston, 1982.

Boggs, Jean Sutherland, et al. *Degas*. New York: Metropolitan Museum of Art, 1988.

Breeskin, Adelyn Dohme. *Mary Cassatt: A Catalogue Raisonné of the Graphic Work*. Washington, D.C.: Smithsonian Institution Press, 1979.

———. *Mary Cassatt: A Catalogue Raisonné of the Oils, Pastels, Watercolors and Drawings*. Washington, D.C.: Smithsonian Institution Press, 1970.

Carr, Carolyn Kinder. "Prejudice and Pride: Presenting American Art at the 1893 Chicago World's Columbian Exposition." In *Revisiting the White City*, 62–123. Washington, D.C.: Smithsonian Institution, 1993.

Carr, Carolyn Kinder, and Sally Webster. "Mary Cassatt and Mary Fairchild MacMonnies: The Search for Their 1893 Murals." *American Art* 8, no. 1 (Winter 1994): 53–69.

Cartwright, Derrick R. "Beyond the Nursery: The Public Careers and Private Spheres of Mary Fairchild MacMonnies Low." In *An Interlude in Giverny*, 35–57. University Park, Pa.: Palmer Museum of Art, Pennsylvania State University, 2000.

Corn, Wanda. "Women Building History." In *American Women Artists, 1830–1930*, 26–34. Washington, D.C.: National Museum of Women in the Arts, 1987.

Dillon, Millicent. *After Egypt: Isadora Duncan and Mary Cassatt*. New York: Dutton, 1990.

Frelinghuysen, Alice Cooney, et al. *Splendid Legacy: The Havemeyer Collection*. New York: Metropolitan Museum of Art, 1993.

Garb, Tamar. *Sisters of the Brush: Women's Artistic Culture in Late Nineteenth-Century Paris*. New Haven: Yale University Press, 1994.

Garfinkle, Charlene G. "Women at Work: the Design and Decoration of the Woman's Building at the 1893 World's Columbian Exposition." Ph.D. diss., University of California, Santa Barbara, 1996.

Gerdts, William H. *American Impressionism*. New York: Abbeville Press, 1984.

Griffith, Elisabeth. *In Her Own Right: The Life of Elizabeth Cady Stanton*. New York: Oxford University Press, 1984.

Groom, Gloria. *Beyond the Easel: Decorative Painting by Bonnard, Vuillard, Denis, and Roussel, 1890–1930*. New Haven: Yale University Press, 2001.

Gullett, Gayle. "'Our Great Opportunity': Organized Women Advance Women's Work at the World's Columbian Exposition of 1893." *Illinois Historical Journal* 87 (Winter 1994): 259–76.

Harper, Ida Husted. *History of Woman Suffrage*. Vols. 5–6. New York: National American Woman Suffrage Association, 1922.

Harris, Ann Sutherland, and Nochlin, Linda. *Women Artists: 1550–1950*. New York: Knopf, 1976.

Havemeyer, Louisine W. *Sixteen to Sixty: Memoirs of a Collector*. Edited by Susan Alyson Stein. New York: Ursus Press, 1993.

Higonnet, Anne. *Berthe Morisot*. New York: HarperCollins, 1990.

——. *Berthe Morisot's Images of Women*. Cambridge: Harvard University Press, 1992.

Huber, Christine Jones. *The Pennsylvania Academy and Its Women*. Philadelphia: Pennsylvania Academy of the Fine Arts, 1974.

Hutton, John. "Picking Fruit: Mary Cassatt's *Modern Woman* and the Woman's Building of 1893." *Feminist Studies* 20, no. 2 (Summer 1994): 318–48.

Kysela, John D., S.J. "Mary Cassatt's Mystery Mural and the World's Fair of 1893." *Art Quarterly* 29 (1966): 129–45.

——. "Sara Hallowell Brings 'Modern Art' to the Midwest." *Art Quarterly* 27, no. 2 (1964): 150–67.

Leach, William. *True Love and Perfect Union, The Feminist Reform of Sex and Society*. 2d ed. Middletown, Conn.: Wesleyan University Press, 1989.

Lindsay, Suzanne. *Mary Cassatt and Philadelphia*. Philadelphia: Philiadelphia Museum of Art, 1985.

Martin, Theodora Penny. *The Sound of Our Own Voices: Women's Study Clubs, 1860–1910*. Boston: Beacon Press, 1987.

Mathews, Nancy Mowll. *Mary Cassatt*. Washington, D.C.: National Museum of American Art, 1987.

——. *Mary Cassatt: A Life*. New York: Villard, 1994.

——. "Mary Cassatt and the 'Modern Madonna' of the Nineteenth Century." Ph.D. diss., Institute of Fine Arts, New York University, 1980.

——. *Mary Cassatt and Edgar Degas*. San Jose, Calif.: San Jose Museum of Art, 1981.

——, ed. *Cassatt and Her Circle: Selected Letters*. New York: Abbeville, 1984.

Mathews, Nancy Mowll, and Barbara Stern Shapiro. *Mary Cassatt: The Color Prints*. New York: Abrams, 1989.

McCarthy, Kathleen D. *Women's Culture: American Philanthropy and Art, 1830–1930*. Chicago: University of Chicago Press, 1991.

Moffett, Charles S., et al. *The New Painting: Impressionism, 1874–1886*. Exh. cat. San Francisco: Fine Arts Museums of San Francisco, 1986.

Newton, Stella Mary. *Health, Art, and Reason: Dress Reformers of the Nineteenth Century*. London: John Murray, 1974.

Nochlin, Linda. "Issues of Gender in Cassatt and Eakins." In Stephen Eisenman et al., *Nineteenth Century Art: A Critical History*, 255–73. London: Thames and Hudson, 1994.

——. *Representing Women*. London: Thames and Hudson, 1999.

———. "Why Have There Been No Great Women Artists?" In Thomas B. Hess and Elizabeth C. Baker, eds., *Art and Sexual Politics, Women's Liberation, Women Artists, and Art History*, Art News Series, 1–39. New York: Macmillan, 1973.

Norris, Pamela. *Eve: A Biography*. New York: New York University Press, 1999.

Peck, Amelia, and Carol Irish. *Candace Wheeler: The Art and Enterprise of American Design, 1875–1900*. New York: Metropolitan Museum of Art, 2001.

Peet, Phyllis. "The Art Education of Emily Sartain." *Woman's Art Journal* 11 (Spring–Summer 1990): 4–15.

Pellauer, Mary D. *Toward a Tradition of Feminist Theology: The Religious and Social Thought of Susan B. Anthony and Anna Howard Shaw*. Brooklyn, N.Y.: Carlson, 1991.

Phillips, John A. *Eve: The History of an Idea*. New York: Harper and Row, 1984.

Pollock, Griselda. "The Gaze and the Look: *Woman with Binoculars*—A Question of Difference." In *Dealing with Degas: Representations of Women and the Politics of Vision*, ed. Richard Kendall and Griselda Pollock, 106–30. New York: Universe, 1992.

———. *Mary Cassatt*. London: Jupiter Books, 1980.

———. *Mary Cassatt: Painter of Modern Woman*. London: Thames and Hudson, 1998.

———. *Vision and Difference: Feminity, Feminism, and the Histories of Art*. New York: Routledge, 1988.

Rewald, John, ed. *Camille Pissarro Letters to His Son Lucien*. Mamaroneck, N.Y.: Paul P. Appel, 1972.

Ross, Ishbel. *Silhouette in Diamonds: The Life of Mrs. Potter Palmer*. New York: Harper, 1960.

Ruyter, Nancy Lee Chalfa. *Reformers and Visionaries: The Americanization of the Art of the Dance*. New York: Dance Horizons, 1979.

Scott, Anne Firor. *Natural Allies: Women's Associations in American History*. Urbana: University of Illinois Press, 1991.

Segard, Achille. *Un peintre des enfants et des mères, Mary Cassatt*. Paris: Libraire Paul Ollendorff, 1913.

Silverman, Debora L. *Art Nouveau in Fin de Siècle France: Politics, Psychology, and Style*. Berkeley: University of California Press, 1989.

Smart, Mary. "Sunshine and Shade: Mary Fairchild MacMonnies Low." *Woman's Art Journal* 4 (Fall–Winter 1983–84): 20–25.

Solomon, Barbara Miller. *In the Company of Educated Women: A History of Women and Higher Education in America*. New Haven: Yale University Press, 1985.

Stanton, Elizabeth Cady. *Eighty Years and More: Reminiscences, 1815–1897*. 1898. Reprint, New York: Schocken Books, 1971.

———. "Our Young Girls." In *Papers of Elizabeth Cady Stanton and Susan B. Anthony*, ed. Patricia G. Holland and Ann D. Gordon. Wilmington, Del.: Scholarly Resources, 1998, microfilm, roll 45.

Stanton, Elizabeth Cady, and the Revising Committee. *The Woman's Bible*. New York: European Publishing Co., 1898. Reprint, Seattle: Coalition Task Force on Women and Religion, 1974.

Stanton, Elizabeth Cady, Susan B. Anthony, and Matilda Joslyn Gage, eds. *History of Woman Suffrage*. Vols. 1–3. Rochester, N.Y.: Susan B. Anthony, 1881–86.

Stanton, Theodore. *The Women Question in Europe*. New York: Putnam, 1884.

Sund, Judy. "Columbus and Columbia in Chicago, 1893: Man of Genius Meets Generic Woman." *Art Bulletin* 75, no. 3 (September 1993): 443–66.

Sweet, Frederick A. *Miss Mary Cassatt: Impressionist from Philadelphia*. Norman: University of Oklahoma Press, 1966.

Todd, Jan. *Physical Culture and the Body Beautiful: Purposive Exercises in the Lives of America Women, 1800–1870*. Macon, Ga.: Mercer University Press, 1998.

Webster, Sally. "Mary Cassatt's Allegory of Modern Woman." *Helicon Nine* (Fall–Winter 1979): 39–47.

Weimann, Jeanne Madeline. *The Fair Women: The Story of the Woman's Building, World's Columbian Exposition, Chicago, 1893.* Chicago: Academy Chicago, 1981.

Weinberg, H. Barbara. *The Lure of Paris: Nineteenth-Century American Painters and Their French Teachers.* New York: Abbeville, 1991.

Weitzenhoffer, Frances. *The Havemeyers: Impressionism Comes to America.* New York: Abrams, 1986.

Wilson, William H. *The City Beautiful Movement.* Baltimore: Johns Hopkins University Press, 1987.

Yeldham, Charlotte. *Women Artists in Nineteenth-Century France and England: Their Art Education.* New York: Garland, 1984.

INDEX

Under the Window (Greenaway), 88–89, *90*
Union des femmes peintres et sculpteurs, 11,
 71n74
United States, art education in, 12
United States Capitol murals, 117
Universal Exposition (Paris, 1889), 36–37, 40,
 40, 53, 62, 84, 96

Van Brunt, Henry, 118
Van Brunt and Howe firm, 41
Van Rensselaer, Mariana Griswold, 65, 81,
 113n22, 119
Vasari, Giorgio, 110
Vaux, Calvert, 40
Velázquez, Diego, 20, *21*
Vie moderne, La (periodical), 97
Villiers-le-Bel, France, 19
Vuillard, Edouard, 124

Wallace, Emma, 48
Walters, William, 116
Ward, Martha, 102
Watkins, Nicholas, 105, 124
Weatherford, Elizabeth, 4n3, 5n4
Weimann, Jeanne Madeleine, 45, 65, 66, 133
Weir, J. Alden, 23, 63
Weitzenhoffer, Frances, 116n78
West, Benjamin, 17
Wheeler, Candace, 59–60, 63, 79, 106, 133; "A
 Dream City," 100, 121
Wheeler, Dora. *See* Keith, Dora Wheeler
Whistler, James McNeill, 18–19, 22, 33n9, 61,
 63, 84
White, Stanford, 63
Whitney, Anne, 58
Wilde, Oscar, 84
Wilke, Hannah, 1
Willard, Emma, 78
Willard, Frances, 50
Wilson, William, 38
Windisgratz, Princess, 53
Woman's Bible, The (Stanton), 77
Woman's Building, 4, *45*, 45–50; African Ameri-
 can works in, 58; color scheme for, 60, 98,
 122; construction of, 54; content and purpose
 of, 45–46, 52–54, 57–58, 62; decoration of,
 58–60, 120–21; evolution of, 12–13; fate of
 items from, 133; Hall of Honor, 7, 54, 57, *57*,

58, 60, 79, 81, 98, 119, 120–21, 122; location
 of, 54; murals in, 7, 60–67, 118–19; plan of,
 54, *55*, 57–58; Siam display, *56*. See also *Mod-
 ern Woman; Primitive Woman*
Woman's Christian Temperance Union
 (WCTU), 50
Woman's World (magazine), 113n28
Women Artists: 1550–1950 (exhibition), 1
Women's Auxiliary, 48–49
Women's Centennial Committee, 47–48
women's education, 10, 14, 50, 77–79, 81, 83,
 132, 139
women's health, 81, 83, 84–88, 96
women's pursuit of fame, 10, 14, 84–85, 123, 139
women's rights and advancement, 11–12, 13–14,
 46–49, 50, 52, 67, 76–77, 85, 132, 139
Women's Rights Convention (Seneca Falls), 13–
 14, 76
women's suffrage movement, 13–14, 46–47, 48,
 50, 76–77
Worden, John, 138
World's Columbian Exposition, 36–41, *42–45*,
 45; Chicago and, 37–39; Children's Building,
 88, *89*; closing of, 132; congresses at, 53, 98;
 construction of, 39–41, 45; Court of Honor,
 37, *38*, 41, *42*; location of, 40–41; Manufac-
 tures and Liberal Arts Building, 41, *44*, 62,
 142n61; murals at, 41, 62, 117, 142n61; open-
 ing of, 39; Palace of Fine Arts, 41, 45, 60, 61,
 70n63, 71n67, 116n84, 133; Palmers and, 12;
 peristyle, 41, *42*, *43*; racial politics of, 69–
 70n51; sculptures, 41; significance of, 36, 37;
 size of, 41; temporary nature of, 45; women's
 participation at, 12–13, 47–49. *See also*
 Woman's Building
World's Columbian (National) Commission, 39,
 47, 48
World's Congress Auxiliary, 53
World's Industrial and Cotton Centennial Expo-
 sition (New Orleans), 47
Worth (designer), 81

Yandell, Enid, 4
Yerkes, Martin, 70n66
Young Women's Christian Association, 88

Zimmerman, W. Garbys, 138
Zorn, Anders, 62; *Mrs. Potter Palmer, 51*

SALLY WEBSTER is a professor of modern and contemporary art at Lehman College and the Graduate Center, City University of New York. She is the author of *William Morris Hunt* and the coeditor of *Critical Issues in Public Art*. Her essays have appeared in the *Art Journal, Smithsonian Studies in American Art,* and *Art in America.*

The University of Illinois Press
is a founding member of the
Association of American University Presses.

———————————————————————

Composed in 10/13.5 Janson
with Meta display
by Jim Proefrock
at the University of Illinois Press
Designed by Paula Newcomb
Manufactured by Thomson-Shore, Inc.

University of Illinois Press
1325 South Oak Street
Champaign, IL 61820-6903
www.press.uillinois.edu